Managing and Growing a Cultural Heritage Web Presence

A strategic guide

Managing and Growing a Cultural Heritage Web Presence

A strategic guide

Mike Ellis

facet publishing

© Mike Ellis 2011

Published by Facet Publishing
7 Ridgmount Street, London WC1E 7AE
www.facetpublishing.co.uk

Facet Publishing is wholly owned by CILIP: the Chartered Institute of Library and Information Professionals.

Mike Ellis has asserted his right under the Copyright, Designs and Patents Act 1988 to be identified as author of this work.

Except as otherwise permitted under the Copyright, Designs and Patents Act 1988 this publication may only be reproduced, stored or transmitted in any form or by any means, with the prior permission of the publisher, or, in the case of reprographic reproduction, in accordance with the terms of a licence issued by The Copyright Licensing Agency. Enquiries concerning reproduction outside those terms should be sent to Facet Publishing, 7 Ridgmount Street, London WC1E 7AE.

British Library Cataloguing in Publication Data
A catalogue record for this book is available from the British Library.

ISBN 978-1-85604-710-4

First published 2011
Reprinted digitally thereafter

Text printed on FSC accredited material.

Typeset from author's files in 11/13 pt Garamond and Frutiger by Facet Publishing.
Printed and made in Great Britain by MPG Books Group, UK.

*This book is dedicated to the three amazing people
I share a house and a life with: my beautiful wife
and two extraordinarily wonderful boys.
Your support and patience has meant everything.*

Contents

Acknowledgements

There are some people I'd particularly like to thank for helping me out as I put this book together. First, thanks to everyone who filled in the questionnaire or took the time to be interviewed: your input has been invaluable, and I really appreciate the time that you took to do this.

Second, thanks to the following for help well beyond the call of duty: Chris Book for the daily walk, ideas and inspiration as well as for input into the section on mobile web technologies; Nick Poole for a superb piece of proofreading and insight; Seb Chan for his incredible ideas and understanding about how metrics really work in a real-world scenario; Andy Powell for his input on Open Data; Frankie Roberto for his valuable contribution in helping me think about marketing from a more holistic perspective; and Peter Ellis for his indexing and proofreading wizardry. Finally, I'd like to thank my mum, who has been a rock and an inspiration for the last 38 years.

Glossary

AADL	Ann Arbor District Library
AI	Adobe Illustrator
AJAX	Asynchronous JavaScript And XML
AOB	Any Other Business
API	Application Programming Interface
app	application
AR	Augmented Reality
BBC	British Broadcasting Corporation
CEO	Chief Executive Officer
CIPFA	Chartered Institute of Public Finance and Accountancy
CMS	Content Management System
CMYK	Cyan, Magenta, Yellow, Black
CPC	Cost Per Click
CSS	Cascading Style Sheets
CSV	Comma Separated Values
DPA	Data Protection Act
e-GIF	eGovernment Interoperability Framework
FOI	Freedom of Information
FTP	file transfer protocol
GPRS	General Packet Radio Service
GPS	Global Positioning System
HEX	Hexadecimal
HR	Human Resources
HTML	HyperText Markup Language
ID	identification
IP	Internet Protocol
IPR	Intellectual Property Rights

IT	Information Technology
J2ME	Java 2 Platform, Micro Edition
JSON	JavaScript Object Notation
KPI	Key Performance Indicator
LBS	Location Based Services
MLA	Museums, Libraries and Archives Council
MMS	multimedia messaging service
Ofcom	UK Office of Communications
OxIS	Oxford Internet Survey
PDF	Portable Document Format
PESTLE	Political, Economic, Social, Technological, Legal, Environmental
POC	point of contact
PPC	Pay Per Click
PR	Public Relations
PSD	Photoshop Document
QT	QuickTime
RGB	Red, Green, Blue
RSS	Real Simple Syndication
RTE	Rich Text Editor
SEO	Search Engine Optimization
SLA	Service Level Agreement
SMART	Specific, Measurable, Attainable, Relevant, Time-bound
SMS	short messaging service
SWOT	Strengths, Weaknesses, Opportunities, Threats
TLD	Top Level Domain
TOV	Tone of Voice
UAR	Urban Augmented Reality
UAT	User Acceptance Testing
UGC	User Generated Content
UKOLN	United Kingdom Office for Library and Information Networking
URI	Uniform Resource Identifier
URL	Uniform Resource Locator
W3C	World Wide Web Consortium
WAI	Web Accessibility Initiative
WAP	Wireless Application Protocol
WCMS	Web Content Management System
Wi-Fi	Wireless Fidelity
XML	EXtensible Markup Language
ZIP	compressed file

Introduction

About this book

Running a web presence and making it grow in ways that benefit your organization is hard. Really hard. It is also one of the most fun and exciting things you can choose to do.

One of the reasons it is so difficult is that it requires a huge array of diverse skills. In turn this means one of two things: you either need to employ and manage a big team of people, get them aligned in one strategic direction and then make sure that you're all working together; or if you are trying to do this with a small team - or even just you! - you will need to understand a lot about a lot.

Both of these approaches are difficult in different ways. You either have a big team and it takes time to get them into shape and working together, or you have an almost endless issue with lack of resource.

Cultural heritage website management requires a range of skills. The process isn't wholly technical, and it isn't wholly artistic. The best website owners are those who have a high level understanding of what the web can do for an organization as well as a good technical grasp of what can be done and the best way of doing it. Knowing what content is likely to resonate with audiences - and where to get this content - is also a vital skill.

Cultural heritage organizations are equally diverse. The content is about as good as it comes: compelling, personal and rich. The people who look after this content - curators, archivists and librarians - are

passionate about what they do, and are about the most interesting people you could hope to meet. At the same time, these organizations aren't always the best at moving quickly, at responding to what they often perceive as being 'risky'. Out there on the web, small companies are born, grow and are sold on in about the same time as it takes to get a cultural heritage exhibition or collections management system commissioned, built and live on the web. Sometimes this can be frustrating, especially if what you're trying to do is actually quite simple from a content or technical perspective but made difficult by politics or stakeholders or just plain old 'institutional treacle'.

There is also – as always – the issue of money and resource, as beautifully articulated by Dan Zambonini in Figure 0.1:[1]

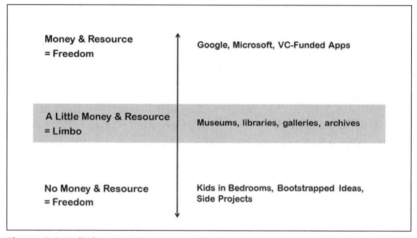

Figure 0.1 *'A little money & resource = limbo'*

As this diagram illustrates, if you've got huge budgets and teams or – at the other end of the scale – there is only one of you, you can move quickly. If you're somewhere in the middle (as many cultural heritage institutions are), with some people and some money, you're often in a 'limbo' state – stuck somewhere where you are unable to make things happen rapidly.

One of the key themes running through this book is the examination of the means by which you – as website manager, owner of website or interested staff member – can move yourself into a position in which you become more empowered. In some scenarios, this empowerment will

come from recruiting great people into a well rounded team. In others, perhaps those where big teams (or any teams!) aren't possible, this empowerment will be more about finding tools, techniques and approaches that will enable you to start making incremental improvements to the way that you and your organizational web presence works. These improvements may seem small when taken in isolation, but together they all point to a more strategic, complete and satisfying approach to the web.

What this book is not

There are many, many books out there to help people with the technical aspects of building websites. And there are thousands if not millions of web pages offering advice and techniques on how to write good cascading style sheets (CSS), make your website viable economically or appear higher up in Google. This isn't one of those publications. Each of these issues will be covered, but not from a tactical angle. The tactical stuff will always be more up to date online, and you'll probably get better advice by talking to peers than you ever could by reading, anyway. Instead, this book will look at the strategic issues, hopefully providing some insight into the day-to-day activity of keeping your sites up and running with fresh content as well as the longer term horizon of growing as your content, visitors and working environment changes.

There will be some technical information, but it will be less specific than the kinds of advice you'll find elsewhere. If you want to know – for example – which is the best content management system (CMS) to use, you won't find the answer here. If you want to know how content management can make a difference to the ways in which you work, and some of the challenges thrown up by a content-managed approach, you're in the right place.

In order to ground the content in the 'real world', this book has been written with the help of research from managers who are managing cultural heritage web presences on a daily basis. There is no one way to do this, of course, and certainly no one 'right' way, but the hope is that by understanding how other people do it, you'll come away enlightened and inspired. You should hopefully also gain some insight into how

people like you are dealing with the challenges of different sized and shaped organizations, or how a one-person team manages to do extraordinary things on zero budget.

Website

There is an accompanying website for this book which you can find at: **http://heritageweb.co.uk/book**. Here you'll find examples, templates and other downloadable information that you can take back into your organization and adapt for your needs. Throughout the book you'll find direct links to relevant places on the site. You can follow these, or just go to the address above and search by chapter, topic or keyword.

In this book. . .

The book is structured into ten chapters, each of which can be read alone or as part of a whole:

Chapter 1 looks at what you have now and begins to put some framing around your current operating environment. We'll look at the strategic landscape of heritage organizations online – and focus in on where you are in this context.

Chapter 2 gets down to the nitty-gritty of online strategy – ways that you can start to put your site into some kind of wider context. This chapter looks at some techniques to help you take charge of your site and begin to step outside of the reactive mode that often overcomes many website owners. It looks at the best way of articulating strategy, how to go about getting stakeholders on board and provides some simple templates to help pull your strategy into shape.

Chapter 3 delves into the content on your site; how to begin to get it into some kind of shape, how Web Content Management Systems (WCMSs) can be brought to bear on the content you have, and some of the challenges that you'll face when trying to keep your content fresh. We'll also look at what it means to have content *outside* your site, and how this makes your website into a web *presence*.

Chapter 4 looks at how you can most effectively get people to come along to your site by marketing it. We'll consider online marketing, social

media marketing and offline marketing, and try to understand how you can make as much impact as possible with restricted time and budget.

Chapter 5 considers policy and guidelines: the scaffolding that sits underneath your bigger vision for the site. We'll look at how best to determine policy priorities for your web presence, and then how to begin to articulate these in ways that support your online strategy.

Chapter 6 looks at traffic and metrics. Here we'll tie in various elements of your strategy approach – we will, for instance, put the question 'What does success look like?' into a strategic context – and then examine some of the tools and techniques that can help guide both you and your stakeholders in determining whether your online presence is demonstrating signs of this success.

Chapter 7 gives an overview of the social web, and places this in a heritage context. We'll look at a measured social media strategy and the various channels that you can use to reach out to new and exciting audiences. We'll also look at scenarios where issues like authority and brand are potentially threatened by these approaches, and examine ways in which these issues can be mitigated.

Chapter 8 focuses on the specific challenges thrown up by website redevelopment projects. Here we'll spend some time looking at how to go about writing the key documents you'll need to work with external agencies: website briefs, functional and technical specifications and project documents.

Chapter 9 looks at some of the incoming technologies which you – as someone who looks after a cultural heritage web presence – should be aware of. These include machine readable data, feeds, Application Programming Interfaces (APIs) and mobile.

Chapter 10 looks at how you can adapt and evolve your approaches as you go along, taking on board user and internal feedback and feeding this back into your strategy framework.

Reference

1 www.slideshare.net/dmje/the-benefits-of-doing-things-differently/71.

1 Evaluating what you have now

Introduction

Before you can begin to understand how to move your web presence forward, it is important that you understand what you have now. This not only means having a full knowledge of your current website(s) - their size, scope, number of authors, amount of content and so on - but also having a clear view of the current landscape within which your heritage organization operates, both online and offline.

The role of institutions on the web changes constantly, and has been changing since they first started being online. Initially, organizations often find themselves online almost by accident, usually as a result of an enthusiastic staff member spending some of their spare time uploading basic web pages to a server somewhere. Very often, the growth of a site follows an organic path, particularly in its early days: as enthusiastic and web-literate staff members arrive at the organization, interest and competency grows; then as they leave, the site stultifies.

Typically, sites move from this early phase into one where organizational perspectives about the web shift from niche activity into something else - if not core, at least *more* core to the day-to-day activities of the institution. As organizations began to understand the potential the web offered to widen reach and access to their assets, so the activity of 'doing the web' became more central, too. The stakeholders in these institutions now mostly (although not always - we'll come to that later. . .) see a strong web presence as being an integral part of the other activities they carry out day to day.

To make things more complicated, the 'new organization' online isn't any longer an X-paged walled-garden entity which has boundaries and well understood rules. Instead, with the advent of Web 2.0 and other third-party services, museums and heritage organizations are moving towards a much looser aggregate of pieces of content and functionality. Even if you don't actively engage in setting up these third-party sites, you'll probably find that someone else has – and here is one of the biggest challenges that the social web brings. Getting a handle on 'external' content like this is an increasingly important part of any web manager's role. Again, we'll look at this in more depth in Chapter 7 'The social web (Web 2.0)'.

Often as a website manager coming into a new organization, you'll find yourself in a position where you inherit a presence with this kind of history. In this or any environment, there are two things which will help you immensely when considering your web presence: first, finding ways of enumerating the physical, content and social assets of your online presence, and second, understanding how your particular context fits into the wider picture: the 'landscape' in which your content and assets exist. This latter consideration is one of the main areas where many sites (not just cultural heritage ones) often fail. It is all very well having a fantastic website, but if the audience – your audience – don't want it, or if it doesn't fit with their daily lives, you will almost definitely fail in your aspirations.

The web today

Before you can really begin to understand how your web presence can impact on, or play a part in, people's lives it is important to look at how your organization fits into a much bigger picture online.

Multiple analogies can be brought to bear on why this is important, but for now let's consider a newly opened shop, filled with wonderful and inspiring items. Never before have such items been seen: they are beautiful and engaging, and everyone who sees them is astounded at the quality and richness that they have discovered. There is a problem, however: the owner of the shop only has the money to open it twice a week. It is also situated in a quiet alley downtown: passing traffic is

minimal. The owner does what he can, but the small quantity of trade is barely enough to maintain him. Up the road, on the busy and high-rent high street, a global chain of supermarkets has opened a branch. It is full of low quality, low cost goods. Some things are even free. The supermarket is full of wide-eyed customers, dashing from aisle to aisle and filling their baskets with endless consumables.

This example, although hackneyed and rather obvious in the points that it makes, is actually rather useful at highlighting some of the issues that face us when trying to make an impact with our limited staff resources, time and budgets. Actually, in the real world, things are rather more extreme; it is – as we probably all know – incredibly cheap (often free) to create a website: we don't even have to find the minimal rent that the owner in our story has to find. We – as cultural heritage institutions – have wonderful and engaging objects. We have stories to tell that we think people will want to hear. But we're not the supermarket chain: we don't have anywhere near the budget, marketing power or brand that they have.

The point of this story isn't that the supermarket will 'win', or that the shop owner is destined to fail. Nor is it that you'll only find quality away from the rush and dash of the big brands. The point is that the web is mind-blowingly big: sprawling, changing, anarchic. Douglas Adams famously described Space like this: 'Space is big. You just won't believe how vastly, hugely, mind-bogglingly big it is. I mean, you may think it's a long way down the road to the chemist's, but that's just peanuts to space.'[1] This is an equally apt description of the size and scope of the web today.

Not only that, but the people who use the web use it in many, many different ways for a huge number of different things. More importantly – as we shall see as we go along – they will often use content in ways that surprise, too.

Let's have a look at some facts and figures in order to put all this into some kind of context. In June 2009, Microsoft launched a search engine called Bing[2] and in their accompanying launch blog post they said this:

In 1997 there were around 26M pages (URLs [Uniform Resource Locators]) on the Web. Today we estimate there are more than 1 trillion pages of content. In 1997 the Web was

mostly text. Today it combines video, images, music, with new data formats emerging every day. The amount of available data has grown exponentially. An average person would need six hundred thousand decades of nonstop reading to read through the information.[3]

In terms of audiences, Internet World Stats[4] suggests that, as of the time of writing, around 1.7 billion people are 'internet users' (anyone over two years of age who has been online in the last 30 days). Granted, this is only 25% of the world's population, but the growth is exponential, with mobile usage expected to have even more of an impact on these figures in the future. By the time you read this, of course, the figures will have changed dramatically – but it is easy for us to predict that both the amount of content available and the number of readers will have increased rather than decreased.

One of the major challenges facing organizations online – and one of the main driving forces behind taking a more strategic approach to the web – is that this environment becomes increasingly competitive as time goes on. Finding ways to ensure that cultural heritage is represented and promoted online is our job; a job that begins with understanding what we have and how we might fit with the daily lives of our web users.

Content and technology trends

Content on the internet is changing in profound and radical ways almost every day. This makes it an exciting and dynamic place to work, but also a frustrating one. Getting a handle on which trends are merely fads and which ones are important or even groundbreaking is at first examination a thankless task.

Technology company Gartner coined the phrase 'Hype Cycle' to describe the analysis of emerging trends. Figure 1.1 shows how this cycle looks.

The curve is interesting because it suggests how people often respond to new technologies: first, there is a trigger as a new technology enters the market; second, there is a peak of interest as the hype takes hold, a peak that over-inflates the potential of the technology; then there is a trough as most people decide that the technology doesn't live up to the

Figure 1.1 *The Gartner Hype Cycle*[5]

hype. If the technology is accepted, it then climbs the *Slope of Enlightenment* before finally settling into a gentle *Plateau of Productivity* when it becomes accepted, a part of the fabric – or, fades away into obscurity.

What does this mean to cultural heritage?

Strangely, one of the downsides of working in cultural heritage is also one of the upsides in this respect: as we are often cash-strapped or resource poor, our organizations rarely (there are exceptions) sit at the bleeding edge of new technologies. We have the frustration but also the luxury of being able to watch technologies emerging, blooming, sometimes fading or sometimes settling before we are in a position where we can use them ourselves.

Consider this with a time lag of anything from six months to two years, and you probably have a fair assessment of where cultural heritage organizations are. See Figure 1.2 for a depiction of the 'lagged' Gartner Hype Curve.

This lag allows us to assess incoming content trends, watch how other sectors and audiences are responding to them and then react accordingly.

Figure 1.2 *'Lagged' Gartner Hype Curve*

Time and again throughout this book, we'll stress the importance of maintaining a continuous level of understanding about what is going on out there on the web from the perspectives of content, trend and technology. Understanding the environment in which your web presence fits is one of the cornerstones of successful web management.

The internet as a ubiquitous medium

One of the important facets of the Gartner Hype Curve is the final settling of the curve to near-horizontal. At this point in time, the actual hype itself has settled, 'damped' if you will. The technology at this stage has become mature.

Tom Standage, author of a number of books looking at the sociology of the web, uses the phrase 'invisible technology'. In his 1998 book *The Victorian Internet*[6] he says '[invisible] technology has matured to become so embedded in, or integrated to, our everyday lives that we don't really notice it any more'.

He uses the telephone as his example. We no longer think about the underlying technology of the telephone, or compare models (at least not for landlines); what we are interested in is the facility that this technology gives us – not the technology itself. We use the telephone without even thinking: it has become invisible to us.

The web is starting to become ubiquitous. We aren't yet at a stage where it is invisible, but here in the Western world it is likely that we are minutes from a Wireless Fidelity (Wi-Fi) hotspot or a General Packet Radio Service

(GPRS), equally (and increasingly) likely that we are carrying a device with which we can access the internet (more on this in Chapter 9 'Away from the browser'), and – importantly – have the wherewithal to use the device and services that we can access.

The ubiquity of the internet hasn't yet translated – at least not now, in the early 2010s – into 'comfort'. We still for the most part 'sit forward' to browse. We aren't – yet – like Tom Cruise in the film *Minority Report*, pushing bits and bytes past us with the wave of a hand. At the same time, however, we aren't a million miles away: touch-screen devices are rising in prominence; the promise of voice and gesture control sits just around the corner; and mobile access is an increasingly important part of our lives.

Who is online and what do they do?

With this invisibility – and the changing context of technology in our lives – come changing requirements on us as content providers. Before we think about this, however, let's consider what people are doing online: who they are, where they're going and what they're doing.

Figure 1.3 shows the figures published by Pew Internet from their May 2010 survey:[7]

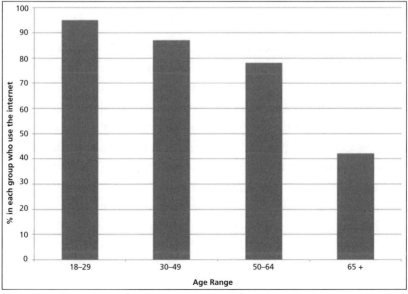

Figure 1.3 *Percentage of various age groups online*

Although Pew is US-centric, other surveys report similar findings; in the UK, for example, the annual OxIS survey reported that, in 2009, 70% of respondents were current users of the internet.[8]

Again, with both surveys there are similar trends when it comes to educational attainment and internet access. Figure 1.4 gives the figures published by Pew Internet on who is online by level of education:

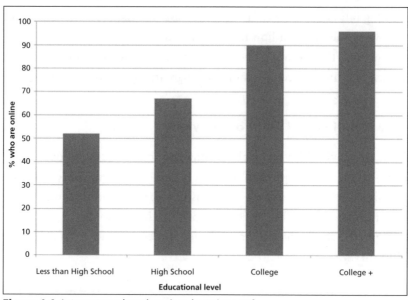

Figure 1.4 *Internet use by educational attainment*[9]

There have been many surveys carried out on how people use the internet in their daily lives. Figure 1.5 is from Pew Internet again, and shows the percentage of American adults (including both internet users and non-users) who carry out the activities listed on a typical day.

One of the main things to take from this graph is that many of the activities are utilitarian in nature: finding out about the weather, checking e-mail, banking. Pew have been conducting this same survey for nearly ten years. Online[10] they provide this trend data – it is interesting to see how social media activity is increasing over time. We'll look much more closely at social media in Chapter 7 'The social web (Web 2.0)'.

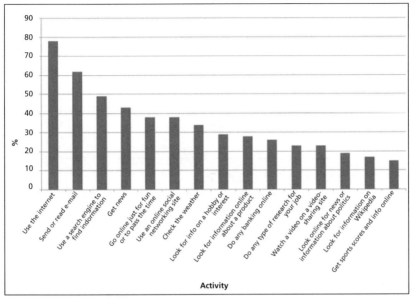

Figure 1.5 *Daily internet activities[11]*

How does cultural heritage fit?

In November 2010, Arts Council England, in partnership with the Museums, Libraries and Archives Council (MLA), published a report looking at online engagement with arts and culture in England.[12] Obviously, this is UK-centric but it gives some fascinating insight into how users are engaging with arts and cultural organizations online.

Some of the key findings are as follows:

- Over half of the (approximately 2000) people surveyed had used the internet to engage with the arts and cultural sector in the previous 12 months. This activity most commonly centred on events or fact-finding.
- People use digital media as a complement to a live experience rather than as a replacement for it.
- Social media has become a driving force for discovering and sharing information about arts and culture.
- Trust plays a large part for users: recognition of 'brands' (in this instance, known and trusted organizations) is important for many.

Statistics and surveys clearly mark opinions at a point in time – but although these kinds of results are always changing, our job stays the same: we need to try to understand where cultural heritage institutions fit into this picture. By doing this – by putting the user right at the centre of the equation – we will be in a much stronger position to build content experiences which mesh with the lives of real people. This is a recurring theme we'll come back to time and time again.

Cultural heritage and The Long Tail

During the mid-1990s, a theory called 'The Long Tail'[13] came into vogue. The basic idea was this: the sum total of people consuming content (as it will be for our purposes; it could also be sales or any other number of metrics) at the top, the most popular end of the spectrum, is ultimately eclipsed by the sum total of people consuming content down the 'tail' of the spectrum. Figure 1.6 shows how this concept is illustrated graphically:

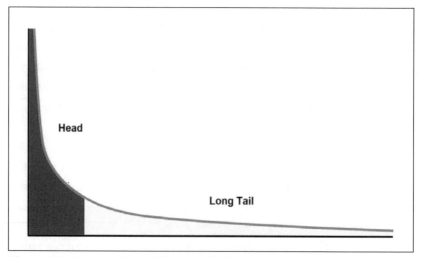

Figure 1.6 *Representation of 'The Long Tail' theory of content*

For people with an understanding of Power Laws, this is relatively unsurprising, but the articulation of the concept has profound implications for niche content providers. It challenges the notion – long held – that volume of traffic to the most popular is the key to success.

Instead, it suggests that the niche content and interests represented by the 'tail' is actually more important than anything else.

Cultural heritage organizations are uniquely positioned to understand the niche opportunities of the long tail. We have content that appeals on many levels: museums, galleries and other cultural heritage organizations have the potential to build passionate followers whose level of engagement far outstrips the 'pile them high, sell them cheap' metaphor which exists around other online destinations. A single person who believes in your content and who goes out into the marketplace being passionate about what they've seen, is far more valuable than scores of people who are ambivalent about what you do. We'll see this factor coming into play later on as we consider the power of the social web in Chapter 7 'The social web (Web 2.0)'.

For some institutions – the lucky few national museums, for example – reach is not a problem, and they are therefore in a place where they can lever a rich mix of niche passion and global audience. For smaller organizations, the leveraging of the niche is a key asset: finding the places, the experiences and the people to make this happen is vital. Later on, we'll look in much more detail at how best to leverage both user feedback and the social web in order to maximize the impact of specialized areas in our own organizations.

The internal context

Having spent a bit of time looking at the wider context of how people use the web, let's now turn inward to our organization by carrying out a simple audit.

What we're going to do in this section is to put some shape around your web presence by enumerating some key known facts and figures. There will probably also be unknowns, and we'll make sure that we determine ways to follow up on these later. By the end of this section you'll have a 1–2 page top level overview of your current internal operating environment which we'll use as the basis for – among other things – our strategy-writing. You might want to grab a piece of paper and begin to sketch out a mind-map or similar: even if you're in a small organization with very few staff and resources, you'll find that a visual aid will be very helpful.

On the website at http://heritageweb.co.uk/book/ch1/context-audit you'll find a simple template which you can print out and use to help you gather all this information.

Although this chapter might appear slightly formulaic, you should find it helpful to have a top level understanding of how you work sketched out in a simple form. As well as being a useful crib-sheet for you and your team, you'll probably also find it helpful to be able to get at these facts easily when stakeholders, trustees or funders ask for them.

Finally, before you start, don't be constrained at all by the template or the questions that are being asked. Make sure you get down any of the other particulars you think of as you go: make notes if there are subtle details which you think will be important later on.

Organization

Let's begin by looking at the organization you're working in. In this section, focus not on the web presence but on the physical. Try to answer the following kinds of questions (there well may be more which are specific to your sector or type of organization; don't let the following list be in any way restrictive):

- How big is your organization (staff numbers, buildings, sites, etc.)?
- How big is your actual audience (for instance, your public footfall each year)?
- Is there a mission statement or similar which succinctly describes what the organization is trying to do?
- Who are the key audiences?
- What would 'success' look like for your organization?
- Which kinds of financial environment are you working in? Are you wholly not-for-profit for instance? Are there areas that make money, others that lose money, or which require government funding?
- What are the levels of budget available, to you and your web team (more on this below) but also to the organization as a whole?

While you're answering these questions, you'll find it useful to gather together any documents such as organizational strategy, budgets and

mission statements. Put them all into a folder on your computer which you can get to easily.

Web team

Next up, let's consider the web team. This is sometimes much harder than it looks – cultural heritage web teams, because of the organic growth mentioned above, are very often spread around an organization rather than focused in a single, easily definable 'team' as such. If this is the case for you, don't worry – what we're looking to understand is the sum total of the people-resource the web team has available to it. If you work in a small organization and the 'team' is just you, then it is still worth highlighting where your skills and competencies lie, and also where you feel there are gaps. Here are the kinds of questions to consider:

> 'There's a web team for the Wellcome Trust (parent organisation) as a whole: the role of that team is primarily managerial/"technical". Then there is an editorial team, who contribute to both web and print projects. Some of these people contribute to the Wellcome Collection website. There's only one person solely dedicated to the Wellcome Collection website: me.'
> Danny Birchall, Wellcome Trust, UK

- How many people (full-time employees) are in the web team? How many part-time?
- What are their competencies? Are they writers, developers, designers...?
- What is the total budget allocated to paying for the web team?
- If the team is spread around your organization, where exactly are they located? If they are allocated to working with you on the web on a part-time basis, what other pressures are they under?
- What, if anything, do you outsource? Design, technical, editorial, content . . . ?

While you are doing this, you might also want to consider any of the sensitivities that might exist: If your team members provide content or work for you part-time and for someone else in the organization for the rest of their time, what political issues might this cause? Do you struggle to get the time from some of your staff? Where are the weaknesses in your team,

skills-wise? Where are the strengths? Are there any individuals who are indispensable? Are there any who who could be considered the opposite?

Stakeholders

Let's have a look at the people in the wider organization and beyond to try to get a handle on what effect they may have on how you work.

Much of the actual structure talked about here depends on how your particular organization is put together. If you're lucky, you'll work in a fairly flat structure where the hierarchy is less important, but for many institutions there is still a pyramid-shaped management structure. Even if your organization is nearly flat in these terms, the normal political workplace tensions can make a big difference to your working environment.

For some reason, whether it is the fact that the web has a visible presence which people can interact with or because everyone wants a part of it, it is often the case that stakeholders want to become involved – perhaps 'too' involved – in the running of websites. Sometimes, this kind of support is appreciated (and in many organizations, it is a breath of fresh air to find that the board or executive actually want to contribute), but sometimes it can be irritating, too. Either way, understanding who in the organization is a stakeholder, what the political pressures are on them, and how you might be able to work with them successfully, is an important part of running a cultural heritage web presence smoothly.

Start by making a list of all the senior stakeholders you can think of. This might include:

- the executive board
- heads of department, in particular Curatorial, Education, IT (Information Technology) and Marketing
- budget holders
- funders, both internal and external
- trustees.

Although it sounds over-political, it is well worth you taking some time getting to know your stakeholders. Get into as many meetings with them

as you can – make your presence known and begin to build the web and the web team into their consciousness as much as possible. For senior stakeholders it is often worth taking time to produce very short, very succinct descriptions and graphical representations of what you and your team does: trustees and funders are often much more concerned with budgetary implications and return on investment than anything else!

If you are in the position where you know your stakeholders already, sketch out their various motivations next to their names on your list. If you don't know them, find people who do and do the same as best as you can. If you're lucky enough to have well known trustees at the top of your organization, try doing some Googling – you'll be surprised as to what you can find out about their backgrounds, prejudices and motivations!

Later on, we'll find ways in which you can mesh your stakeholder motivations with the strategic direction that we'll define for your web presence. You'll find that the combination of a rock-solid strategy and background knowledge of your stakeholders will put you in a very strong position to push the web agenda.

Content

Next, let's have a look at the all-important issue of content. We'll come back to this in Chapter 2 'Building a strategic approach' and beyond, but our aim right now is to get a top level view of where you currently are.

Finding answers to the following questions will be useful to you as we move into the later sections of this book. You may already have done some kind of content audit, in which case use this to help inform the answers you provide here.

- Who authors the content on your site? Is writing done internally, externally, or is it a case of a combination of both? If at least some of the writing is done internally, how is the effort spread around your organization?
- If you commission content externally, how and when does this happen? In other words, do you regularly pay someone to write for

you, or do you commission content purely for specific exhibitions, openings and so forth?

- What kind of content workflow do you have? Do you, for instance, commission people to write and then filter what they have written through some kind of editorial process? If you have such a process, sketch it out.
- Do you have a style guide? If so, put a copy in your resources folder.
- What is the size of the content you have available to you? This is often difficult to quantify, but try to get a handle on things like the number of web pages, number of images and number of items in a digital collection.

As well as these, spend a bit of time asking some more general questions: How good is your content? Do you think it is popular, well received by your online audience and generally engaging? How could it be better?

Metrics

We'll look at metrics in much more depth in Chapter 6 'Traffic and metrics' – what should be measured, how to measure it, and how to improve both the quantity and quality of your traffic. For now, let's just make sure you've got the very top line figures available to you. We should also note here that web analytics is a bit of a black art – there is no easily attainable 'one size fits all' means of measuring success – but it is also true to say that some figures are always being asked for by funders, stakeholders and other interested people. Sometimes these figures are completely meaningless (the classic example – luckily, mostly an example which has disappeared into the mists of time – is 'hits', which mean precisely nothing. . .) – but are still asked for. Having them to hand can therefore be useful!

As before, get hold of your analytics source (or ask someone who can get these figures for you) and note down the following:

- month-on-month visits
- month-on-month repeat visits

- month-on-month page views (also called 'page impressions').

If possible, do this historically over the longest 'meaningful period' you can: if, for example, you had a large-scale redesign two years ago, then choose two years ago as your cut-off point. You can use your discretion here: use figures that will be useful to you as well as to those who might ask.

Do this for each 'web estate' you have figures for, taking care where possible that you don't overlap or double count. For many institutions, you'll have a single site, in which case use this. For bigger institutions or those with multiple web presences, it is worth dividing up the data for each one into spreadsheet tabs, and then aggregating totals into a master spreadsheet.

Use the spreadsheet template at http://heritageweb.co.uk/book/ch1/ stats-template to set this data out. You'll find it useful to work out averages and totals for each year. Adjust the year to match whatever your institution does: some work to a financial April to March cycle; others work to the calendar year.

Technology

We'll finish up with a simple technology audit. If you're non-technical, you may need to go and talk to your Head of IT or similar in order to get answers to these questions. Again, as per the areas above, don't be constrained if you feel there are important details unlikely to be thrown up by these questions but which should be noted.

- Do you have a CMS?
- If so, what is it (name of system) and what operating environment (Windows, Linux, or other? Databased, file-based, etc?) does it work in?
- What is the general feeling about the CMS? Are staff (and you!) happy working with it? If not, why not?
- If you don't have a CMS, how are you currently making changes to your content online? (Common answers include things like Dreamweaver, manual edit and file transfer protocol [FTP], sourced to an external company.)

• What technical issues do you currently have and/or do you foresee having in the next year or so? Are there issues with scaling your site? Are any hosting contracts coming to an end?

Summary

We've thought about two main things in this chapter: first, we took a look at the wider context of the web, and considered some important factors about this context; second, we turned inwards and did a top level audit of the internal operating environment in which you find yourself today.

You should hopefully find that this approach helps you in a couple of ways:

First, the audit should help you to understand exactly where your current web presence has got to, allow you to articulate what assets you have and how these might be used most effectively.

Second, it should help remind you that your organization operates in a wider context where people are spending most of their time online checking e-mail, sharing images, commenting and so on. Although this sounds obvious, a common criticism of many institutions on the web is that their approaches are organization-focused rather than user-focused.

Finally, this thinking begins to set the scene for thinking about what we do in a wider and more strategic framework: one which is less about reactive thinking and more about being proactive and measured. It is to this subject which we shall turn in Chapter 2.

References

1 Adams, D. (1979) *The Hitchhiker's Guide to the Galaxy*, Pan.

2 www.bing.com.

3 www.bing.com/community/blogs/search/archive/2009/06/01/user-needs-features-and-the-science-behind-bing.aspx.

4 www.internetworldstats.com.

5 http://en.wikipedia.org/wiki/Hype_cycle.

6 Standage, T. (1998) *The Victorian Internet*, Berkley.

7 www.pewinternet.org/Static-Pages/Trend-Data/Whos-Online.aspx.

8 www.oii.ox.ac.uk/research/oxis/OxIS2009_Report.pdf.

9 www.pewinternet.org/Trend-Data/Online-Activities-Daily.aspx.

10 www.pewinternet.org/Static-Pages/Trend-Data/Whos-Online.aspx.

11 www.pewinternet.org/Trend-Data/Daily-Internet-Activities-20002009.aspx.

12 www.artscouncil.org.uk/news/we-publish-digital-audiences-engagement-arts-
and-c.

13 http://en.wikipedia.org/wiki/Long_Tail.

2 Building a strategic approach

Introduction

In the previous chapter we considered two main themes: firstly, how people use the web as they go about their daily lives and secondly, how your organization is positioned in terms of technology, content, metrics and so on. Now that we've got this background information in place, let's start thinking about how to be more strategic with our thinking.

When you work in a busy, content-rich and resource-poor environment such as a cultural heritage institution, it is all too easy to become reactive. Everything needs doing now, or yesterday, or last week. Your inbox is full, as is your head. The last thing you probably want to do is take some time out from the coalface in order to 'think bigger-picture'.

Unfortunately, this is exactly what is required by strategic thinking. Hopefully, if you're putting in the time to read this book, you've already recognized that a reactive approach is rarely the route to either sanity or excellence, and will be prepared to invest some more time into planning.

The benefits of working more strategically are both short and long term. From a short-term perspective, you'll find that having answers to hand when they're asked for by people like your stakeholders saves you a huge amount of time. From a long-term perspective, you'll find similar time savings when you're thinking about how to respond to the myriad incoming projects and 'Can you put this on the web?' requests – the ones that are probably right now sitting in your inbox!

More importantly, having a long-term approach will ensure that what

you do online is relevant to both your audience and to your organization. You should hopefully find that a strong web strategy also gives you the means to demonstrate success – whatever your particular definition of 'success' is – and to then build and grow your online presence into the future.

A good strategy, embedded well across an organization, gives people momentum and a shared intellectual framework with which to move forward collectively.

You'll also see that a good approach is to align your online strategy with your institutional strategy: by doing this you not only build on work that has already been done but hopefully also demonstrate how the web can be a powerful adjunct to what your organization does already. More politically, you'll also find that getting powerful stakeholders to sign up to web strategies which clearly align to an already agreed institutional strategy is a much easier task than heading off on your own.

Don't despair if you *don't* have an institutional strategy, either. In some ways this makes your web strategy even more crucial and pertinent – you can help the organization give shape and focus to its overall aims by showing it how technology can be used to communicate its key messages.

> 'A strategy, like any process of change, will only be accepted if you give people the opportunity to engage with it, challenge it, rationalise it and ultimately make it their own.'
>
> Nick Poole,
> Collections Trust, UK

What is a web strategy?

A successful online strategy is – more than anything else – thinking in a particular way rather than a prescriptive set of documents or advice. Part of this is a framework of approaches, documents and measures which you will take in order to ensure that your institutional web presence has direction, growth and forward momentum. The single most important thing a strategy does is to encourage up front thinking and planning and as such the attitude that the web team takes is as important as anything else.

Your strategy should articulate a reasonably long-term view. A one-year strategic horizon is normally too short, and five years is probably too long, but somewhere in the middle is usually about right. You should remain adaptable – your strategy should evolve over time to match to changing technological and content environments – but it should also be stable

enough that it doesn't become simply reactive or in a constant state of flux. This balance between having a strategy which is designed for the longer term yet sufficiently flexible to adapt is sometimes a difficult one to maintain. Later on we'll look at some ways in which you can do this.

One thing that is important to think about very early on in strategy development is who owns it. Whoever this is - we're assuming here that it is you, but it may not be - should have the right connections, mandate, authority and respect in order to carry it forward. Obviously, this owner is very much dependent on context and environment, but deciding who this is forms a crucial part of the process and needs a fair amount of thought.

What should a strategy cover?

In the latter part of this chapter, we'll look at one possible way of structuring a web strategy document. Before that, let's look more generically at the main things your strategic framework should cover.

Vision

The strategic framework that you develop enables you to articulate your top level vision. This is your 'elevator pitch' - the short, punchy articulation of what your web presence is for. The vision should be agreed by everyone in the web team as well as senior stakeholders in your organization. Your vision becomes a kind of mantra, underpinning everything that you aim to do in the coming months and years.

You may well find - particularly if you work in a more complex organization - that you need to underpin your vision with a series of objectives. This will normally be the case where you need to flesh out your vision into finer, and yet still fairly high level, detail.

Probably the most important thing for your vision statement is that it is *brief, easy to understand* and *agreed upon*. Whatever you do, avoid jargon: make this a statement you

'Our mission statement is shown on the front page of our website as follows: "The UNCG [University of North Carolina] Department of Library and Information Studies (LIS) connects people, libraries, and information through research, teaching, and service to enrich living and working in a global environment."'
Amanda Goodman, Department of Library and Information Studies, UNCG, USA

would be happy to put on the front page of your main website without cringing!

Plan

Your website plan is the really detailed bit: it takes your top level vision and makes this into a real, tangible, *doable* series of actions.

Normally, your website plan articulates the upcoming activities of your organization in the year ahead, and shows how your web team is going to support the organization in delivering these. This plan is done with the vision in mind at all times, but allows you to identify the opportunities and risks which are likely to arise during the coming year.

It helps to bear the SMART (there are various different terms used, but commonly: Simple, Measurable, Attainable, Realistic, Time-bound)[1] mnemonic in mind as you put together your plan – it can help you to retain focus.

Audience

Knowing your users – both your current ones and the ones you'd like to encourage to visit – is one of the most important and powerful things a strategic approach can do for you. Consistently thinking about users (in fact, thinking *like* users!) will help drive almost everything you do: content, information architecture, design and marketing. A user-centred approach – as we hinted at in Chapter 1 'Evaluating what you have now' – will also be the thing that will most likely lead to your web presence being a successful web presence.

Content

Strangely – given the pivotal importance of great content – planning in this area is often overlooked. Content planning allows you to think strategically about what content you're going to have, how you're going to source it, whether you've got the right people in-house to write or photograph it and so on.

The second important area of content planning is the development of

'tone of voice' guidelines. These can be articulated in a document which can then be used with internal staff and/or with any external agencies when developing new content. The work that you do on audiences plays strongly into your tone of voice development.

Chapter 3 'Content' looks in detail at content – how to manage it, keeping it up to date and so on.

Policies

Website policies allow you to respond consistently and effectively to internal and external factors and requests. Once you have common policies in place you can use these to respond to the inevitable questions and requests that any normal operating environment is likely to throw in your direction.

Typical website policies cover things like: accessibility, moderation, design, sponsorship, data protection and so forth. These will vary in scope depending on your particular organization. We look in greater detail at policies and guidelines in Chapter 5 'Policies and guidelines'.

Budgeting

Understanding how you stand financially is important in a strategic web context. This covers people budgets as well as things like hosting, website development and design. You should understand fairly well how much your web presence costs to run, where any income streams come from and how your web presence might save your organization money.

Budget planning helps you to understand how your web presence contributes to the wider financial environment of your institution, but it also means that you will be in a position to respond proactively whenever the inevitable budget squeezes seem to be heading your way.

> 'Most of our costs online are operational, as well as some outsourced design and development support work. We have an online shop, e-ticketing and paid-for document delivery to help us cover these costs.'
>
> Paul Bevan,
> National Library of Wales, UK

Budget decisions made at specific points – for example, when you choose to spend money on a particular project – should always be made with your strategy as context. This is also the case for the bigger 'horizon' budgetary choices,

for example whether you tend towards Open Source, proprietary or bespoke-built technology, Microsoft solutions and so on.

Metrics

Obviously, understanding how people use your web presence is absolutely vital. Building metrics into your strategic approach helps you understand where you are going with your site, how it is improving, and what you might want to do with it in the future in order to respond to user needs more effectively.

Metrics sit hand in hand with the work you do on audience. Once you understand where people are going on your site, and who your audience is, you are in a much better position to carry out user testing and site improvement. In Chapter 6 'Traffic and metrics' we'll look at metrics in some detail.

Structuring your strategy document

Although the strategic approach we've outlined here is a framework and an approach, there is also a single document which sits at the core of this and allows you to pull together all the various strands. This is the website strategy document: it allows you to easily disseminate your approach to your web team and also to a wider audience as well.

Your strategy document should be made up of a number of key parts. In the next section, we consider one possible way of structuring this document. This structure has been chosen because it has a summary at the beginning, a section analysing the current environment, and then an in-depth strategic programme of work for the coming period of time – that is, it follows a narrative approach which tends to read well. A template is available for download from the accompanying website at: http://heritageweb.co.uk/book/ch2/strategy-template.

As with everything else in this book, however, don't be constrained by this template – your strategy document should be specific to you: add or remove sections and reorder as appropriate for your particular environment. If you have a specific structure, a style of formatting or particular language which is already used for other strategic or planning

documents in your organization, you should take these as your defining template and adapt as required.

Executive summary

The executive summary should be used as a starting point for the whole document. It should roundly and succinctly sum up the main content of the document in no more than one or two pages, outlining the vision, motivations and future direction of the web function.

Begin the executive summary with an 'elevator pitch', that is, a one-sentence description of the value of the web to your organization. Here are some fictional examples:

> Although the executive summary is found at the start of your strategy, you shouldn't work on it until you've written the rest of the document. It is only at this late stage that you'll really know what should be condensed down into the summary.

> Our library website exists to give our users the same high level customer service that they have come to expect from our physical buildings, delivered in a user-friendly, always-on and up-to-date way.

> We use our website to extend what we do so that it reaches far beyond the bounds of our physical presence, delivering high quality learning and teaching resources for free to anyone who needs them, worldwide.

> Our museum is recognized throughout the region as a valuable resource for local historians. The website gives us invaluable insights and opportunities to engage with these enthusiasts, enriching knowledge and lives as it does so.

There are some more examples on the accompanying website at: http://heritageweb. co.uk/book/ch2/vision-examples.

Below this, give a succinct overview of what you are going to achieve in the coming period: '*Over the coming year we are going to. . . .*' Make your statement precise, and hook it closely to your organizational strategy. If you know that you are going to be working to a new series of objectives in the coming period, make clear connections between them and what

you are going to do online. If budgets are being slashed in the coming year, then make sure you focus on how the web presence is going to deliver extra value, even in these difficult times. Remember that this short summary section is probably as far as a senior stakeholder (or anyone!) might get; make it punchy, connected to what is going on elsewhere, and objective-focused. Use the SMART technique mentioned above to help you with this if needed.

Finish your executive summary with one or two brief paragraphs (or a bulleted list) outlining the things that you have achieved in the past year. This will not only demonstrate that you are looking at what has gone as you think about the future, but will also be a valuable way of focusing your mind on what you need to think about in the coming period. If you can, focus on how your web strategy not only underpins other existing strategic ambitions but can also help your organization to identify new opportunities, markets and/or revenue.

Environment analysis

Next is an analysis of your current operating environment. There are two commonly used tools which fulfil this purpose: a SWOT (Strengths, Weaknesses, Opportunities and Threats) and a PESTLE (Political, Economic, Social, Technological, Legal and Environmental) analysis, but there are many others which you can use equally effectively in their place.

> The important thing in the analysis of your operating environment is to get people to share their ideas and knowledge both of the organization and the external environment. The process of thinking in this way is often as useful as the actual method you use for capturing the thinking.

You can use brainstorming fairly effectively to develop these analyses: many things ('We don't have any money!' or 'We hate our CMS!') are obvious, but if you brainstorm both with your team and with other stakeholders throughout the organization, you'll find a much richer series of factors which you can then prioritize.

A SWOT matrix is used to snapshot the current environment and can be used year on year to see how this environment changes.

A typical SWOT for a cultural heritage web team might look something like Figure 2.1.

STRENGTHS	WEAKNESSES
– a highly motivated web team, with a diverse range of skills – strong technology, and a burgeoning online audience. – support for, and awareness of, the importance of the web.	– inadequate funding – little understanding of the power of social media across the organization.
OPPORTUNITIES	THREATS
– e-commerce – online marketing.	– changing funding model – poor pay for web specialists within the organization.

Figure 2.1 *Typical SWOT for a cultural heritage web team*

Often, people find it difficult to understand how strengths/opportunities and weaknesses/threats differ. The crucial thing here is that strengths and weaknesses are *internal* factors while weaknesses and threats are *external*.

A PESTLE analysis is similar to a SWOT – if you can, do both but depending on your particular scenario you may want to choose one or the other. A typical PESTLE might look like Figure 2.2.

POLITICAL	ECONOMIC
– continuing interest in ways of providing Open Data – electronic standards.	– changing funding models as a result of shifting priorities – strong brand.
SOCIAL	TECHNOLOGICAL
– increasing use of mobile devices: potential to engage with a wider audience.	– ever-increasing access to, and speed of, broadband web access – 'Digital Natives' – people who have grown up with digital technologies and are familiar with online tools.
LEGAL	ENVIRONMENTAL
– increasing number of Freedom of Information (FoI) requests – Data Protection Act issues with our membership database.	– improving internal processes so that less paper is required to deliver content – re-purposing.

Figure 2.2 *Typical PESTLE analysis for a cultural heritage web team*

Your SWOT and PESTLE matrices allow you to focus on the things that you do well, the upcoming changing environment and the challenges that you have ahead of you. They also give a snapshot of this point in time which you can refer back to in future.

You'll find SWOT and PESTLE templates on the accompanying website at: http://heritageweb.co.uk/book/ch2/environmental-analysis. These are commonly used business tools, so you may want to have a look online to see other examples of how they have been populated.

Strategic plan

The strategic plan section of the document is the place where you lay out – in fairly considerable detail – what you plan to do over the coming year.

It is useful to begin this with a vision or mission statement, that is, one or two short sentences which clearly articulate exactly what it is you intending to do. Here are some fictional examples:

> Over the coming year, our web presence will change from being a purely one-way content delivery mechanism to focusing on user voices and opinion. We will therefore begin to position ourselves as a trusted platform for conversation and discourse.

> We will focus our attention this year on delivering e-commerce and personalization, building on the successes of the previous years and beginning to generate positive revenue by year end.

> We look to develop the collections area of our website so that 50% of all our collections are represented online by the end of the year in a sustainable, user-friendly and accessible way.

If your organization is not of the size or does not have the resources to do anything as ambitious as these examples, you should still look to articulate your vision:

> During 2010–11 we will launch our website and build a team of local volunteers to help us keep content fresh, growing our audience by word of mouth.

> Over the coming year we will work in partnership with local government, helping them to develop our online presence.

Your top level vision should – like the rest of the document – be revisited on a regular basis and compared to the reality 'on the ground'. If you find that the vision is not being realized over the medium to longer term then you should use this at your strategy review to help re-shape what it is you are trying to do.

One thing that is incredibly useful when developing and writing your online strategy is to tie it as closely as possible to any existing, non-web strategies. There is an obvious reason for doing this: you should make sure that what you do on the web reflects, amplifies and supports what the rest of the organization is doing. This doesn't mean – and it is worth stressing this – that online is 'just' an extension of what goes on elsewhere in the organization: you can make a very positive decision to be markedly *different* to the rest of the organization; however, your aims and goals should complement those of the institution in defined, well articulated ways. Where your online presence is very different, it often pays to describe why and how exactly: highlight the apparent mismatch rather than trying to hide it!

You'll find that drawing links between your organizational goals and your web goals helps you to articulate – both to others but also to yourself – *why* your online presence is important. From a political (sneaky, even!) perspective, this is vital. If you are in a position where *what the web presence does* extends and complements *what the organization does,* you'll find that battles about resource and budget allocation will be much easier to fight. Secure buy-in from your organization's leaders by presenting them with a vision of how the web can help them achieve their existing goals.

Let's look at an example of how this might work. If the institution in question had the following strategic goal:

'To increase and broaden our audiences.'

you could map this fairly unequivocally to such an ambition within the website strategy as:

'To increase our visits by X% over the coming year.'

Another example – if an institutional goal was:

'To develop our staff and collections.'

you could relate this to an item about provisioning web content:

'We will look to train all staff members in – and give them access to – our CMS in order to increase web content quality and quantity.'

You'll find that this kind of mapping is usually fairly straightforward: do it quite visually if you like, with the organizational goals as headings, and the detail – perhaps bullet points – under these as indications of how you will 'answer' them in the online environment.

Operational plan

Now you have articulated your strategy (the *what*), the next section fleshes out the *how* in some detail. This is the operational plan: a look at the detail – the tactics – that will deliver the high level strategy.

Again, the length and depth of this plan is almost wholly determined by your particular institution and scenario. If you belong to – say – a local library or a small museum and have little or no resource at your disposal, your vision may well be modest and your plan can therefore be summed up in maybe a single page. If you're part of a large organization and have multiple stakeholders, a large budget and resources to put towards your web presence, your plan will likely reflect this, maybe running to 20 pages or more. Do what feels right to you – the strategy document shouldn't ever be a burden, written because you feel it should be: make sure that it is a living, breathing and – most importantly – useful document!

Here's a fictional section of a website plan. In this example, one of the core institutional strategy points is to increase and broaden audience.

5.0: Increase and broaden our online audience
The website provides us with a powerful means to hit the institutional goal to increase the awareness and size of our audience. Typically, the

institution has struggled to find audiences in the 15–20 age range. We believe that we have the means online to begin to fill this gap with the following focused approaches:

5.1: Find new audiences
During the 2010–11 financial year, we will look to increase and broaden our online audience to 20,000 visits per annum (an increase of 50%), by focusing on the following activities:

- ensuring our core URL (www.oursiteurl.com) is included on all printed and marketing material, including new business cards, e-mail signatures, posters and flyers; we will look to track incoming traffic from these URLs where possible, using a trailing alias such as www.oursite.url/flyercampaign
- buying a short-run ad campaign in the local newspaper during March
- giving five free lunchtime sessions in the local library where we demonstrate the new features of the website to local people, and encourage them to write their own reviews
- actively encouraging mentions of our Twitter account by tweeting interesting content at least three times a week
- building and growing a Facebook page for our library, asking the question, 'What did you last read that made you cry?' and encouraging users to add their suggestions for a 'Cryworthy Top 10' poster for display over the summer holidays.

Although the example above focuses on external output, you should make sure that you give serious consideration to the implications of this work to staff within the organization. If your organization is like most (particularly those in a cash-strapped sector like ours), there will be near-continual drives for efficiency and cost-effectiveness. Make sure you consider these factors and reference them continually throughout your plan: this is important not only because the web genuinely offers some real opportunities to do things better, faster and cheaper, but because it also looks good to your stakeholders!

As an example, consider the following fictional extract:

6.0 Develop our staff

We recognize within the web team that the skills that we have are valuable and sought-after. Organization-wide we are looking to improve efficiency and staff knowledge. We will therefore do what we can to share our expertise with staff via the following routes:

- We will give a once-monthly lunchtime workshop on writing for the web, available to anyone who is providing content for our core website.
- We will blog about new technologies we are developing or have discovered on our intranet.
- We will continue to engage with staff who may have valuable ideas about how to improve what we do online. We will do this with face-to-face 'meet the team' sessions, and by also providing an 'ideas area' on our team wiki where anyone can contribute their thoughts. When an idea is taken up, we will attribute this on our website to the person involved.

The other areas you might cover in your plan include:

- **Archiving**: consider various strategies for what you are going to do with old content, and articulate this as part of your plan.
- **Updating of social media sites**: define strategies for how you will support and maintain any externally hosted sites such as Twitter, Flickr and Facebook. Map out who will do what and when in order to keep these sites updated and monitored, and tie-in how success (whatever 'success' is in the particular context: it might be more followers, more conversations, etc.) will be measured.
- **Process**: you may want to include some detail about how content moves around your organization; who is responsible for it at each stage of the process, who signs it off and what impact this might have on the time of anyone involved.

Risks

Towards the end of your strategy document, you should spend some time

outlining what risks there are on the horizon during the coming year. Against each risk, you should articulate the likelihood of it occurring ('low', 'medium', or 'high'), the impact it would have (again, rated as 'low', 'medium' or 'high') and what, if anything, can be done to mitigate it.

Here is a fictitious example:

Risk: Web content is not seen as an organization priority.

Detail: We have an ongoing issue with some teams in the organization who are producing rich content but not passing this on to the editorial team to put on the website. As a consequence, our visitors are missing out on some valuable detail about our newest collections items.

Likelihood: Medium.

Impact: High.

Mitigation: Work with the Collections team to demonstrate how easy our new CMS is to work with; website editor will set up some workshops during the first quarter (Q1) and provide ongoing support to the Collections department during Q2–4.

See the accompanying website at http://heritageweb.co.uk/book/ch2/risks-template for a downloadable template for this section.

> One good way of gaining an understanding of risk in a dynamic environment is to keep a *risk diary* for 4–6 months. Log any risks as you come across them, identify how you reacted to or controlled them, and then use this diary as a basis for your strategy review further down the line.

Financial summary

Your financial summary should outline:

- the operating budget and costs for the website, including things like CMS licences, hosting costs, maintenance and domain names
- any income, for example, from sponsors and/or e-commerce
- any project budgets (i.e. discrete redesign or development projects which have budgets allocated to them)
- salary costs (include 'on-costs' – the costs of employing that person outside of their salary – if this is how your organization does this elsewhere).

Resource summary

The final section of your web strategy should include an outline which describes how many people work on the site and what their roles are. Include full-time people but also those who provide resource into the web team – content editors, authors, curators, exhibition staff, marketing input, and so on.

Ideally, you should also work with your Human Resources (HR) team to move towards a scenario whereby a line is written into all job descriptions to support the development of your organization's web presence, so that, in the future, you can legitimately draw on support from across your entire organization.

Evolving your strategy

As we've seen, your strategy is a range of approaches, documents and measures which you will take in order to ensure that your institutional web presence has direction, growth and forward momentum.

As we've seen already, your strategy should lay out a long-term (1–3 year) horizon for what you do. At the same time, you should be careful that it doesn't atrophy. To help maintain flexibility and to help your strategy evolve over time, it is useful to set up a web strategy team.

The web strategy team

Develop a team who own the website strategy: a team of perhaps five people, but certainly not as many as ten. Having representation of a range of experiences and views is important, but remember that the more people you have in the team the more difficult it will be to get everyone together on a regular basis and to reach agreement about important issues.

It is vital that your strategy team is made up of the right people, and also that it has a well understood scope and authority. Define very early on what the team is responsible for, what connection it has to senior management, its authority and finally the duration of each individual's role in the team.

You'll sit on your strategy group – of course – and you might want to include one or, at most, two other people from your web team (if you have one!) – but you'll find a cross-discipline team much more useful. Not only will you make sure you get feedback and information from a

range of different angles across the institution, you'll also find that it is useful to have allies across the organization.

Here are the kinds of people who should sit on your group:

- Chair (you!)
- Education
- Curatorial
- Front of house
- Exhibitions
- Finance
- Management.

It is very important that the members of this group can see outside the technical day-to-day constraints of running a web presence – this is why the suggested membership is wider than your normal web team. You want to be able to use this group to consider wider and more strategic perspectives.

In terms of involving senior staff, you'll ultimately only be able to decide based on your own organization and the people you have in it. The rule of thumb is: as senior as you can get, but making sure that the members are motivated and available to meet regularly. It is beneficial to have people on board who have clout, politically, with the ability to make real decisions about the directions you are taking, but you also need to make sure that they are engaged with the topics and have a diary which allows them to attend regular meetings over a period of time. If people need to drop out to meet other commitments it could be detrimental; continuity of membership is important in maintaining momentum.

If you're lucky, you'll have a heady mixture of very senior (Head of. . .) and very web-motivated people. This is the ideal scenario. If you find – as is likely – that senior people are less interested in the 'coalface' activity of the web, there are likely to be individuals nominated from these teams. Having junior members of staff makes the inevitable political wrangling a bit harder further down the line but, on balance, enthusiastic, motivated and more junior is probably better than senior but bored!

Quarterly meetings are probably realistic with a group of this size and scope. Put appointments in the diary and be ruthless with members of

the group who fail to turn up and/or do not carry out the actions assigned to them. This can be hard, especially if you're not familiar with chairing a group like this – but it comes with practice!

Regular strategy reviews

One of the main jobs for your web strategy team is to make sure that your core strategy and approaches are reviewed at regular intervals: I'd suggest every six months, or every year, or somewhere in-between the two, depending on your particular environment. At these intervals, get your web strategy team together, preferably somewhere away from your normal place of work. Make sure that you're somewhere with lots of space, a Wi-Fi connection, whiteboards, pens and so on as appropriate.

The main focus of these review periods is twofold: first, to take a step back to examine how progress has been over the previous months against the previously determined strategic direction; and second, to look at the environment your web presence shall be moving in to, to determine any differences from the previous period of time, and to lay out plans for the near and mid-term future. Your response to technological change is important, and very much dependent on the organization you're in and the resources that you have at your disposal. This rate of response will determine the questions that you ask – and how you answer them – during your strategy review.

Use your strategy document to help structure these review meetings: take your top line vision for the previous period of time and compare it to what you've achieved. Be totally honest about which of your planning objectives you have met, and which you've failed to meet. Try to tease out why any particular objective has not been hit, and use this to inform how you're going to modify your strategy in the future. Use the SWOT and PESTLE grids (Figures 2.1 and 2.2) during your strategy review to try to understand exactly what the challenges and opportunities are at that point in time.

In Chapter 10 'Bringing it all together' we'll look at some ways you can encourage feedback about your site from users and other stakeholders. You should use this feedback as a core part of your strategy reviews, folding this input into your wider objectives where possible.

Summary

In this chapter we've looked at the heart of this book: a mindset and framework for thinking more strategically and the documents which help you to define this framework. Later on – in Chapter 5 'Policies and guidelines' – we'll look at how you can use policies and guidelines to support and 'scaffold' your strategic framework. This joined-up approach provides an extremely strong base upon which you can begin to grow your cultural heritage web presence into the future.

Next, however, let's have a look at content – the hub around which your entire online presence revolves.

Reference

1 http://en.wikipedia.org/wiki/SMART_criteria.

3 Content

Introduction

Content is, without argument, the single most important part of the entire equation when it comes to building a successful online presence. All the shiny technology in the world, all the latest social media tools, all the advertising, all the budget – none of it means anything at all unless you have good, solid content which your users want to see.

What is 'good' content? As ever, it depends. . . .

For one person, 'good content' might simply be an up-to-date listing of what is on at your cultural heritage institution over the coming weekend. For another, an in-depth academic paper on some aspect of your museum collection might be what they're looking for.

Determining how your institution can serve the best possible content to the audience you are looking to attract is a complex task. To do it effectively, you have to be in a position where you understand, among other things:

'What will draw audiences to your website, given the mass of content available elsewhere on the internet? What types of content are you planning to produce – how many levels of interpretation and narrative, in what media, from which sources?' [1]

*Mia Ridge,
The Science Museum, UK*

- who your audience is, where they are and what motivates them
- what content you have, where it comes from and how it moves around your organization
- what is going on content-wise outside your organization, and how

you might be able to make use of these sources
- how your content-delivery mechanisms work
- how your content fits with your wider strategic vision.

We'll spend the rest of this chapter looking at how content is created, how it flows around your organization, how you keep it up to date and some of the processes and systems that you can use to help you with these tasks.

Managing content

Managing content is a complex activity and entire industries have grown up around so-called 'Enterprise Content' and the way in which content moves around organizations. In this section we'll have a look at some of the issues which typically surround the management of this content.

Note that we will focus primarily on web content here, but that the lines between 'web content' and 'non-web content' often blur. A list of opening times, for example, is content which carries currency on a web page, but also on a poster on a front door or in a leaflet at a front desk. An effective system will make sure that this content is – at the very least – known about wherever it is required, and will allow a single source of information to be 'surfaced' (displayed to end-users) in multiple places.

Every organization requires a system for managing content. However, not every organization requires a Web Content Management System.

The former is some kind of understanding – usually articulated somewhere in a simple document or even just as a set of bullet points – which lays out where content is sourced in your organization, and how it moves through to the website. The latter is a *technical system* which helps you manage the flow of content from the source to the website. To make things easier, I'll refer to the latter as a 'WCMS', a widely used acronym for such a system.

Do you need a Web Content Management System?

To a large extent, the size of your organization will be directly linked to the amount of content that is produced by it; this in turn will determine

the complexity of the flows of content and, normally, whether you need
a WCMS. Small organizations with a low quantity of web content can
usually cope easily without a WCMS, and many do, very successfully!

One easy way of working out whether you need a WCMS is simply to
take stock of the speed with which content flows onto your website. If
you find yourself – as the web team – able to keep up with both content
supply and demand, then the chances are you can cope without a formal
WCMS. If you find, however, that information is frequently duplicated,
out of date or just plain wrong, then it may be that you should be
looking for some kind of formal system to help you manage your
content. It goes without saying that people-power plays a huge part in
helping you manage your content: a competent editor and project
manager will do a far better job at keeping content up to date than the
best WCMS, but it may be that your organization is of a size and content-
richness to require some technology as well.

WCMS systems and principles

Wikipedia gives the following definition of a Web Content Management
System:

> A Web Content Management System (WCMS) is a software system which
> provides website authoring and administration tools designed to allow
> users with little knowledge of web programming languages or markup
> languages to create and manage the site's content with relative ease.[2]

WCMSs are generally built around several fundamental principles.
Although systems vary widely (and there are many thousands of WCMSs
available), for the most part these principles hold true across these
different systems.

Reduction of duplication

You'll find that almost every web page that you produce can be divided
into 'the content' (the changing bit) and 'the design' (the non-changing
bit). More specifically, the content fits into what is generally termed

'templates'. WCMSs try – pretty much universally – to *separate content from design*, albeit with different levels of success. Conceptually, this isn't always possible: all blocks of text – for example – have some kind of formatting which could be construed as design; but nonetheless, this principle remains an important one.

Typically, a WCMS will have some kind of 'templating' system. A 'template' can be thought of as a 'shape' into which the content is inserted. A familiar analogy is the 'Mail Merge' approach taken by software like Microsoft Word. If you were writing a Mail Merge letter to go to many recipients, the core of the letter would remain the same but the address and name fields would be replaced by unique values. A template works in much the same way.

A WCMS will normally have a number of main templates (for example, home page template, search results template and gallery template) which define the look and feel of the page; the content is then injected in some way into the page.

By abstracting content and design (commonly called 'look and feel'), WCMSs provide the means for institutions to *repurpose* their content. This leads to a practice termed 'multisurfacing': the notion that content can be written once and displayed (or *surfaced*) in several different places across your site.

An example in a cultural heritage site may be something like a featured piece of artwork. This should have its own catalogue page of some description; to feature it on a home page shouldn't require duplication of information such as title and artist: the same information is simply accessed in raw form from the WCMS and used on both the catalogue description page and on the home page. Here, of course, the content can be wrapped in different designs as required.

Common templates – as well as allowing for multisurfacing – mean that site-wide changes in design or layout can be made purely by adjusting a single template: this design change will then be reflected in any page which uses this template, all the way across the site. Clearly this is a huge time and effort saver, particularly if the site is of considerable size.

Multiuser access

As mentioned above, it is unusual for an organization to require a WCMS if that organization isn't of a certain size and with a certain turnover of content. In this latter scenario, you will typically have a number of people involved in the content generation and editing process. One of the most important jobs a WCMS does is to allow several different people to access content during the production process. This access is typically restricted in some way unless the user is an administrator, in which case they'll be able to see – and make changes to – the entire system.

Alongside this, a WCMS will have user models which allow an administrator to add new users, change their *roles* (for example, 'editor', 'author', 'publisher', 'administrator'), change their access rights, reset passwords and so on.

Workflow

WCMSs usually add a layer of *workflow* – and, by definition, defined levels of security, to the way that content moves around the system (and by proxy, also to the way that content moves around an organization using the WCMS). Typically, and particularly in a larger organization, the content author will be a different person from the designer and web editor. Workflow and user roles allow the content to pass institution-defined checkpoints prior to go-live, within a defined and structured scaffold.

The simplest workflow might look like this:

Content authored > content checked > content approved > content published.

WCMSs have different ways of managing this flow, but typically you could set the system up to e-mail your content editor once the content author has *submitted* their content. The editor would then log in to the system, make the required edits and submit again, this time for the content to be published.

In a complex organization, this workflow can be set up to branch or adapt in much more complicated ways. In a typical cultural heritage

organization, for example, you may have content which is initially edited by a curator or librarian, submitted for editing to a website content editor, and then passed back to the curator for final sign-off before go-live.

In reality, experience shows that simpler workflows are much more likely to succeed: often the simplest four-stage workflow outlined above is the natural fallback for many organizations, and works perfectly well. As a busy web team, your aim is to get the organization doing as much content-inputting themselves but at the same time to maintain some level of editorial control. The workflow lets your editorial staff maintain this control; typically, all content which is authored around the organization is passed to them to approve: they become a kind of 'editorial gateway'.

Workflow by definition also supports the idea of different user *roles* – you might, for example, only want your Education team to be able to access certain pages on your site, or even to be able to access only certain parts of certain pages within certain time constraints. User roles can usually be defined in a fair amount of detail in this way: a typical mid-range WCMS will also support user groups and fairly granular permission level changes.

Management of assets

Text content is of course not the only content on a typical website. Usually you'll have images, logos, PDFs (Portable Document Format), video and other files. A WCMS will let you manage these – again, with varying levels of complexity depending on the particular system employed. Commonly, a WCMS will let you apply metadata to your various assets once you've uploaded them – you might, for instance, need to apply a particular caption every time a particular image is used on your site, or perhaps you need to insert a link to the website of the original photographer. More advanced WCMSs will let you make copies of an original file so that you can crop (cut to required shape) and size them – (or even let the system auto-crop and size for you); the particular capability depends on the particular system.

Usually, a WCMS will have some kind of *media library* which lets you manage these various assets; typically, you would upload a file or files from your desktop machine, but often there are automated systems which deal with assets that are held elsewhere.

Ease of use

One of the enormous potential benefits of a WCMS is that it gives non-technical users the tools to make changes to web content without requiring any technical knowledge. Most WCMSs today have a Rich Text Editor (RTE) which allows anyone to make changes to content without needing any knowledge of HyperText Markup Language (HTML). Figure 3.1 is a screen grab of a typical Rich Text Editor.

Figure 3.1 *A typical Rich Text Editor*

Usually, as you can see from the image, the interface is similar to a standard desktop word-processor with buttons for simple formatting such as bold and italic, and easy links to insert photographs and so on.

Some large WCMS systems also hook directly into existing word-processing software, allowing desktop users to make their edits in (for example) Microsoft Word and for these changes to be directly reflected on the website.

Procuring a content management system

The (Web) Content Management System market is huge, with a large number of companies which appear very similar, and offering what appear to be very similar products. At the bottom end of the market are solutions such as Adobe Dreamweaver[3] and Adobe Contribute.[4] These can be purchased for under $1000 and implemented easily, but have limited support for user and workflow management. Other common solutions at this low end of the market include the Open Source solutions Wordpress[5] (a well known blogging platform which has now become widely used as a simple WCMS), and Drupal.[6]

An excellent resource for comparing WCMSs can be found at CMSMatrix:[7] here you can compare systems by name, by specification and so on.

Working with a consultant

As a matter of course, CM companies have it in their interest to make these systems appear as comprehensive (and thus, often, as baffling!) as they possibly can. This is not an easy space in which to make decisions, and it pays hugely to begin your procurement process by understanding exactly what it is you need from a WCMS – and, in fact, whether you *need* a WCMS at all – before you begin the process.

If you are taking the leap to procure a WCMS, you'll probably have some budget, and if this is the case it is highly recommended that you look to specify your requirements prior to talking to any suppliers. Ideally, you should take on a consultant with experience working with cultural content management; someone who understands the complexities of the issues that are unique to cultural heritage such as copyright and Intellectual Property Rights (IPR).

As with anything else, nothing beats talking to your peers about the decisions that they have made – use mailing lists specific to your particular institution to ask other website managers what they use, why they've made certain decisions, what costs they incurred and so on. It also helps hugely to go and see the systems in action and to talk to some of the people 'on the ground', such as non-technical editorial staff.

At some point during the procurement process, you'll want to put together a specification for a new WCMS. Your peers will be invaluable in helping you with this – on the accompanying website at http://heritageweb.co.uk/book/ch3/procuring-a-cms you'll find a simple template which you can use as a starting point for writing this specification.

Depending on budget, timescales and other constraints, there are several big themes which you should keep in mind during your procurement process: articulate these themes within your organization and in your specification, and keep them at the heart of the process as you begin to procure a system.

Does your organization have a preferred technology?

Before you begin the procurement process – probably before you've even considered a WCMS at all – make sure you are aware of any incumbent technologies or approaches already in place at your institution. Make

sure you understand the capability of your IT team – if in doubt, ask them which technologies they can support – also, be clear right from the beginning of the process if there is a preference for Open Source software at your institution. Also try to understand what strategic approach is being taken by the organization in terms of IT: if, for example, you are a Microsoft house at this time but intend to move to Open Source in the next five years, you need to take this into account during the specification process. WCMSs require a medium- to long-term investment: in a reasonable-sized organization you'll find that a 3–5 year lifespan is probably realistic, so being aware of any 'horizon' thinking is absolutely vital.

Also – and this may sound incredibly obvious, but it is easy to overlook – make absolutely sure that your organization doesn't already have a WCMS! Surprisingly often, organizations have a deeply siloed approach to working which means that departments develop in isolation, procuring software or working in ways which are disparate and unconnected. Do what you can to at least be aware of how others in the organization move content around, and make your decisions accordingly. Start with the IT department, but don't assume that they know everything that is going on! Talk to anyone who has content or is interested in having that content online.

Who will be using the system?

It is an unfortunate fact that many WCMS systems are procured by technical people – *unfortunate* not because technical people are deficient in any way, but because it is very likely that your content is actually going to be provided and edited by non-technical people.

Make sure you identify not only *who* will be providing and editing content on a day-to-day basis but also the *type* of person they are, both now and in the future. If for the most part it is – say – your IT team who is editing this content, then you can probably make some assumptions about how comfortable these people may be with fairly complex interfaces and approaches. If – as is more likely – it will be curators, librarians, secretarial or other staff who will make up the bulk of your editing workforce, then consider very carefully the usability of the system that you are specifying.

It is almost inevitable that any technical system you buy is going to pit technical capability against usability at some level. Rarely are highly configurable systems the most usable; by the same token, rarely are the most usable systems the ones that are the most technically advanced. Working out how to deal with this tension in your environment is a major challenge – talk to colleagues in other similar institutions and find out what they are doing.

As we saw in the previous section, almost all WCMSs now offer a RTE which lets users change formatting without having to learn any HTML or other coding. It is likely, however, that users will require some level of technical aptitude in order to understand how to insert and resize images, how to link to other parts of the site and so on. WCMS systems vary in subtle ways when it comes to these activities; ask a potential vendor to see how they work or, even better, ask for a demo where you and your staff can have a play with the system and understand some of the positives and negatives of how it works.

What other non-WCMS systems are there?

It is highly likely that your WCMS will sit alongside a whole suite of other systems. Integration with these can range from shallow to deep. On the 'shallow' side are considerations like the standard desktop build which your IT team might roll out across the organization. If this includes – for example – Internet Explorer 6 only, then you don't need to consider cross-browser editor integration when you come to specify your WCMS.

On a deeper IT level, you may have systems which you need to interface with: for example, a workflow process might need to integrate with your Exchange server in order to book workflow into staff calendars or you may want to extract collections data from your Collections Management system and display these automatically on your site.

It pays to consider these scenarios even if you find that a WCMS which can fully integrate with everything you want is hugely expensive. By specifying the perfect scenario and then working backwards from there to something more feasible, you'll become aware of how integral the notion of content management is to your organization.

The outcome that you desire from the interfacing work might be as simple as having a web-viewable display of some internal content such as a catalogue or a database. In this particular example, you may be perfectly happy to have the web view of the data being refreshed on a daily, weekly or even monthly basis; if the in-house system drifts slightly out of date with the external view then nothing is lost: at the next sync, the databases are brought back into line.

It may, however, be much more complex. If you, for example, have an in-house ticketing system which manages orders for a particular event and you want to be able to sell tickets online in tandem, then the interaction is two-way and real-time. The in-house system in this example needs to know that a ticket has been sold online in order to update ticket numbers, and it needs to do this as close to instantaneously as possible.

The particular scenario – we've outlined two examples above – will absolutely determine how you go about interfacing the in-house and external (content management) systems.

The first example is – as you would expect – much simpler: the information flow is uni-directional and time is a non-critical component. In a typical IT environment, this kind of interfacing can be done with a simple data dump output > data dump input approach. The internal system, for example, might push out a file of data (for instance, Excel, XML [EXtensible Markup Language] or Text) and the WCMS then takes in this data, reformats it as necessary, and provides it on the web as required. The format of the data output and input is relatively unimportant as long as you can get something reasonably standard, for example, CSV (Comma Separated Values), Text, XML or JSON (JavaScript Object Notation) both out of the internal system and into the external one!

The second example is more complex: it requires bi-directional communication and is also time-critical: the last ticket bought on the website or the last book reserved in the library must be communicated back so that all systems know the current status. Expect real-time communication of this sort to be much more expensive to build or commission: it requires a different level of interaction, error checking, up-time guarantee and so on. With this in mind, only commission this kind of interfacing where it is absolutely necessary!

What does this teach us about our WCMS procurement? The single most important thing is that you need to be 100% confident that you can *get content in and out of your new WCMS* in a completely flexible way. Make sure you specify – as an absolute – that your WCMS can both consume and produce the kinds of common file formats outlined above, and any others that you require for your specific circumstances.

The ideal approach for your WCMS – in fact, for any kind of IT system being procured, is an *Application Programming Interface* (API).[8] This is the part of any technical system which will let you get information in and out of the software programmatically. You can read more about programmatic access like this in Chapter 9 'Away from the browser'.

An API – or at the very worst the ability to get data out in a standard, usable format – is vital when considering integration with other systems, but it also lets you plan for worst case scenarios: what if the WCMS company goes bust, for example, or stops making the particular WCMS product? Can you be sure that you can extract your content as painlessly as possible? You should make sure that your sustainability plan covers this by procuring systems which you can migrate content out of at a later date.

Scope

As soon as you start looking at a WCMS and how it interacts with other systems you have in-house, it is inevitable that you'll start thinking about the *scope* of the system: essentially, the extent to which it permeates the organization.

At one end of the spectrum, your WCMS is basically a *web* content system: it takes content that you have in your institution, purposes it in a way that is relevant and useful to an online audience, and then delivers it to the outside world.

In the middle of the spectrum, your WCMS becomes a *surfacing technology* as well as a web content system, interfacing where necessary with internal systems like your library catalogue or museum collections database, and delivering this content to the web, together with any additional web content which has been authored specifically for the online audience.

At the other end of the spectrum, your WCMS actually becomes a central piece of infrastructure which supports *all* content moving around your organization. In this instance, the WCMS delivers content to a multitude of channels; it becomes the main content store and way of working for anyone in the organization who writes or maintains content. In this example you might find the design department writing content for leaflets within the WCMS, and publishing simultaneously to the web and to the print agency. Content for internal customer-facing kiosks within the organization, for example, might also be edited within this kind of system.

The depth to which you want to take your WCMS will depend very much on your organization; it is likely that most people will mainly use the WCMS as a web content delivery mechanism but perhaps also use it to interface with some internal systems. This is particularly true for institutions such as ours, where we have existing systems such as library catalogues and object collection databases which we want to surface in some way to the public as well as internally.

Your WCMS into the future

Because – as already mentioned – a WCMS approach is likely to be long term, stretching over several years, it is sensible to think about horizon scenarios, however unlikely they seem right now. Begin this with an open-ended brainstorm: ask what you would like to be able to do with your content given an unlimited budget, zero institutional constraints and all the time in the world! Your brainstorm should include thinking about channels like in-house kiosk systems, mobile devices and multilingual support as well as considering total integration with all the internal systems you can think of.

The future of technology is absolutely unknown: this is one of the frightening and yet exhilarating things about it – yet what is absolutely certain is that your content will and should be used in ways you haven't even begun to dream of. If you can position your WCMS so that it can deliver content as flexibly and technology-agnostically as possible, you will save yourself and your team a huge amount of time, cost and angst in the future.

Empowering your organization

Typically, CMS systems nowadays are almost entirely web-based. The requirement for a user is therefore to have access to a web browser and an internet connection: standard for probably everyone in your organization.

If anyone in your organization can submit content easily and in a controlled manner via tools that they are familiar with, important things can start to happen: users begin to feel much more involved and empowered in the ongoing maintenance and care of their organizational web presence; furthermore you'll find that people are more likely to provide you with web content. You can do a number of things to help foster this empowerment.

> 'We don't actually have a web team – we all just share the job. We have an external company to design and maintain the site – content is managed internally via CMS. Around 12 people contribute regularly as bloggers, and maybe 30 on an occasional basis.'
> Shakespeare Birthplace Trust, UK

First, use your organization as you go through the WCMS procurement process. Talk to the people who are likely to be content stakeholders. Understand their needs and frustrations. Begin to map out how content could flow in the most effective way. Make this a part of your WCMS specification, and ensure that you put usability – particularly for non-technical users – right at the top of your specifications checklist.

Second, once you have procured your WCMS, make sure that you have provided training to the right people throughout the organization. Use the members of your web team to do this if possible: even better, do it yourself.

> 'We have many content contributors in total – maybe 50. Staff are responsible for specific pages on the site as well as social network sites and Twitter. We also have some short-term Bloggers. The web team of five people sits in IT but works closely with Public Services (Marketing).'
> Paul Bevan, National Library of Wales, UK

Finally, be proactive and granular with metrics for the various areas of your organization. If, for example, you have members of your Educational team writing copy for one area of the site, capture stats for that area and feed these back to the staff involved on a regular basis. Help them to understand what works for users and what doesn't by explaining the metrics you give to them; try to encourage them to see the link

between what they write and what users do. This can be incredibly empowering for people, especially if they're unfamiliar with the real-time impact of what they do.

Content outside your site

We've spent a fair amount of time covering the flow of content within your organization. Increasingly, however, the conversations about you and your content are taking place outside, too. This is why we're focusing throughout this book on the idea of a *web presence* rather than a *website*.

Social media – Web 2.0 – is covered in depth in Chapter 7 'The social web (Web 2.0)'. One of the fundamental ideas which is encapsulated by Web 2.0 is that of *distribution* – rather than one, central place where all conversation and content is managed, the web tends towards a distributed model. Islands of content, comment, feedback and user-generated content are constantly being generated and regenerated – not within your site but 'out there' on the wider web.

Furthermore, this content is often not content which your institution has written: people on Facebook might have set up pages about your institution; on Twitter they may well be talking about your exhibitions; on Flickr they are probably posting pictures they've taken of your galleries. As we'll see in Chapter 7 'The social web (Web 2.0)', this model leads to many issues around control and authority, but at the same time we have to accept that this is how the landscape is, and respond accordingly.

In an environment such as this, one thing you as website manager should be doing is as much following of these conversations as possible: you want to know if people are mentioning your organization, either praising it or criticizing it – and be in a position where you can choose to respond to this praise or criticism from a position of knowledge

With the advent of the social web and the use of sites like Facebook blossoming to become a regular feature in many people's lives, the volume of traffic centred on individual voices rather than that of the institution has increased hugely. As we'll see in Chapter 7 'The social web (Web 2.0)', the 'control' – if ever there was any control – has already passed from organizations to users. In this environment, you can choose

to ignore the conversations – or – as is suggested here, make sure you follow them as best you can. In Chapter 7 'The social web (Web 2.0)' we'll see ways in which you can use Web 2.0 to solicit this feedback actively; here, however, we're talking about passive monitoring of conversations and feedback.

There are several good reasons why you should do what you can to stay on top of this external content:

- First, you should do what you can to build and maintain awareness, both about your institution but also about the online space that you inhabit, or want to inhabit in the future. The more aware you are, the better positioned you are to respond strategically and effectively.
- Second, if you're aware of the conversations going on online about your brand and the topic areas that you represent, you put yourself in a much better position when it comes to understanding your users and how they might respond to what your institution has to offer.
- Third, following these conversations means you can pick up trends in negative (or positive!) feedback about a certain service you offer and respond proactively to the users who are providing this feedback.
- Finally, you'll also find that users are an invaluable resource when it comes to new ideas about what you could or should be offering them, either now or into the future. As you begin to move into the social media space, you might also find that users are enthusiastic test groups for the things that you might be offering online in the future.

Staying informed

How do you go about staying on top of such a dynamic, ever-changing content environment? Later on, in Chapter 7 'The social web (Web 2.0)', we'll learn about how engaging with social media can put your organization squarely at the centre of this content, and some of the techniques you can use to engage with users most effectively.

For now, however, we'll consider more passive monitoring – some ways you can keep track of what is being said about your institution or areas of content interest and thereby remain more informed and up to date, without having to spend a huge amount of time doing so.

Keyword monitoring

Web keyword monitoring is a very simple concept: you choose some keywords which are relevant to your particular interests and you then use various tools to watch for these particular keywords, and alert you should any matches appear. These matches might be new blog posts, news items, Twitter mentions, image descriptions or tags – basically, any (new) content on the web which matches your chosen words.

You can – of course – do this manually by inputting your keywords into individual services like YouTube, Flickr or Twitter and then looking at the results that are returned. The alternative – and much more effective method – is to set up *monitoring feeds* which you then subscribe to, either by e-mail or as an update in your feed reader. We look at feeds (in particular Real Simple Syndication [RSS]) and feed readers in more detail in Chapter 9 'Away from the browser'.

You can set up keyword monitoring on individual services like those mentioned above, or you can monitor search results on sites like Google or Bing.

On the website at http://heritageweb.co.uk/book/ch3/keyword-monitoring you'll find a detailed hands-on guide showing you how you can set this up with several popular web services.

What to monitor

At the simplest level you should check your *institution name* on Google and other search engines. Later on – in Chapter 4 'Marketing' – we'll look at how to improve search engine rankings to ensure that end-users are actually finding your institution – and the content you have online – when they search for these things.

For now, however, we're looking at the slightly less obvious results, for example comments on external sites, image results and review sites.

Google in particular allows you to filter your results in various ways: you can look for images, news items, blog articles, videos, books, places and so on. Furthermore, you can choose – among other things – to look for terms over a specific time period, from a specific site or in a particular format. Google Web Search Help[9] provides many examples on how to use the search engine to best advantage.

You can obviously monitor for any words you choose, but mentions of your organization, specific keywords, exhibition names or people are likely to be of most use to you. Broadly, you will probably be interested in two main areas: generic references (for example, institution or topic area); and specific references (for example, objects, galleries or exhibitions). Let's have a look at these in more detail by taking a fictitious example:

> Say you are the website manager of a made-up natural history museum in Oxford called the Museum of Natural Sciences, and you've just opened a new exhibition called Dino-bones. In this particular instance, you might monitor for the following generic terms: 'Museum of Natural Sciences', 'Natural History', 'Oxford museum', 'Day out in Oxford', etc. Generically, you should check that your institution name comes right at the very top of the major search engine results (later on we'll look at ways in which you can help this to happen); but you should also be aware of all local competitors (if your audience and market is mainly a local one).
>
> More specifically, you might also monitor for the exhibition itself: 'Dino-bones', 'Dinobones', 'Dinosaur bones, Oxford', 'New exhibition in Oxford', etc. Bear in mind that the more abstract your search, the more results you'll get, and the less focused your response is likely to be!

Keywords monitoring – when done effectively – is a very powerful technique for understanding and tracking where and when people are commenting about your institution or other areas of interest.

Syndicating content

The thing we've just been examining – the distributed nature of today's web – hints at some fairly fundamental paradigm shifts when it comes to delivering content to users.

The traditional content delivery model is of course that people come to your site to consume your content. This makes a lot of sense to you, but not necessarily a lot of sense to your users: although your website may be at the centre of your life, it is unlikely – however good it is – to be at the centre of theirs!

One way of delivering your content – particularly changing, 'news-like' content outside your site, is *syndication*.

The most common method for doing this is RSS – a simple XML format which people or other websites can subscribe to in order to read or display your updates.

Although it may seem counter-intuitive to provide content which people don't even have to visit your site in order to read, there are a number of tangible benefits which make RSS syndication an extremely popular means of delivering content.

Wikipedia explains it thus:

> Syndication benefits both the websites providing information and the websites displaying it. For the receiving site, content syndication is an effective way of adding greater depth and immediacy of information to its pages, making it more attractive to users. For the transmitting site, syndication drives exposure across numerous online platforms. This generates new traffic for the transmitting site – making syndication a free and easy form of advertisement.[10]

At a simple level, syndication of this kind particularly suits changing content which can be posted in a structured list – this is, after all, what RSS is. Examples in a cultural heritage context might therefore include news items (for example, press releases or general news articles), job listings, latest additions to your catalogue or collections database, and blog posts. Events (exhibition openings, etc.) can also be represented in this way, although there are some alternative formats which have been specifically designed for consumption by calendars, for example iCalendar.[11]

Once a user sees the familiar RSS icon on the page, they can then click on it and most modern browsers will redirect them to their feed reader so that they can 'subscribe' to the feed. The next time you update

something in the feed, they will see this in their reader. RSS can also be set in the <head> of your page HTML so that browsers 'autodiscover' the feed.

RSS has reached a critical mass in terms of use, and it is very well worth considering as a content delivery mechanism. It is not only humans who can consume feeds like this, but also technical systems which can consume, process and display using these formats. Blogs, Facebook, Twitter and Google are among many thousands of systems which can consume or produce RSS. As a consequence, many museums, libraries and archives are making use of RSS in this way: if you have a content management system then building RSS is trivial – many WCMS will have RSS output built into their templating system already.

As well as these more common uses of RSS, it can be extended to provide more advanced content. A great example of this is providing a feed for a search result listing. This means that anyone would be able to subscribe to that feed and use it – for example, to be notified when a new item matched their search. See Chapter 9 'Away from the browser' for further details and examples.

It is worth noting, although beyond the scope of this book, that there are alternative feed types (for example, Atom[12]) – and that there are varieties of RSS as well. Search online or ask your technical lead or peers if you need further clarification.

There are other ways of syndicating content – for example, using so-called 'widgets' which usually involves giving your users some 'embed code' which they paste into their site. This then displays custom content. An example of this is the Rijksmuseum object widget – see Figure 3.2.

Once you've embedded this on your site – a simple copy and paste into your HTML code – the widget shows regularly updated content from the Rijksmuseum on your site.

Figure 3.2 *Screenshot of the Rijksmuseum 'widget'*[13]

Summary

In this chapter, we've looked at how content flows around your organization and some of the tools that you can use to help keep track of this flow. We also looked at content 'out there' on the wider web and considered why this is important, how we can use it to keep informed, and some ways of tracking content over which we have no control. These approaches form a useful precursor to the in-depth view of the social web to be found in Chapter 7 'The social web (Web 2.0)'.

The next thing to look at now that we've got a handle on our content is how to get that content to our audiences. This is the essence of the next chapter where we'll look at the various ways you can promote your organization both on- and offline and also make your content more easily findable on search engines such as Google.

References

1 Chamberlain, G. (ed.) (2011) *Museums Forward: social media, broadcasting and the web*, Museum Identity, www.museum-id.com/books-detail.asp?newsID =168.

2 http://en.wikipedia.org/wiki/Web_content_management_system.

3 www.adobe.com/products/dreamweaver.

4 www.adobe.com/products/contribute.

5 http://wordpress.org.

6 http://drupal.org.

7 www.cmsmatrix.org.

8 http://en.wikipedia.org/wiki/Application_programming_interface.

9 www.google.com/support/websearch/?hl=en.

10 http://en.wikipedia.org/wiki/Web_syndication.

11 http://en.wikipedia.org/wiki/ICalendar.

12 http://en.wikipedia.org/wiki/Atom_(standard).

13 www.rijksmuseum.nl/widget.

4 Marketing

Introduction

Say you went out today, bought some web hosting and a domain name (website address). If you worked hard, you could easily get something on the web in a matter of days, possibly hours. In this time, you might have successfully adhered to all the required standards, done some design, written your copy, paid for the means to update it – maybe a WCMS or other technical system – and gone live.

If you did this and nothing more, you'd have – technically at least – built a website. But you are still a long, long way from establishing a successful 'presence'.

In this particular – rather extreme – instance, your site would receive no or almost no traffic. The analogy in Chapter 1 'Evaluating what you have now' of building a shop down a lonely street which never has any passing trade is hackneyed but nonetheless accurate. However beautiful, however well designed, however well thought out, however well staffed – your shop won't get anyone coming in to it unless people know about it, see the value in it, and are prepared to cross the threshold.

In this chapter we'll look more closely at how you can get people to come to your site, either through direct marketing or by focusing your SEO (Search Engine Optimization) strategy so that people find your site when they search for content contained within it.

From 'site' to 'presence'

Many people understand now that building a website is only the beginning of a much longer (and actually, much harder) process of encouraging people to visit that website; however, there are still endless projects going on all the time from cultural heritage organizations and others where all the effort and budget is in that first, initial 'build' effort, and very little is left over to do the important bit which follows: the marketing and traffic driving.

Although the example I've used is deliberately extreme, and it is unlikely that many people would launch a new website and then not tell anyone at all about it, the transition from *site* to *presence* is one which many institutions struggle with. This is partly perhaps because the web has changed things so radically in such a short space of time, but partly it is also because the word 'marketing' often has negative connotations within cultural heritage organizations.

The fact of the matter is that running a cultural heritage web presence today has become intimately tied up with marketing: many would argue that it *is* marketing. Understanding how your online offering fits with your offline, working out how best to service your audiences, being where your users are – these are all marketing functions, not technical ones.

When you consider that we live in a world where even back in 2008 there were an estimated 1 trillion web pages[1] – and growing at a vast rate – you'll understand how much of a challenge it is *getting* people to your particular site, let alone keeping them there or encouraging them to 'up-sell' to a visit or purchase.

There is an entire industry – that of the online marketer – which has sprung up around the activity of turning your site into a presence. There are whole industries which hang off online marketing, too – take, for example, SEO, which attempts to find ways of driving traffic to your site by following various rules about page layout, content and technical approach. If you do a Google search for 'SEO' you'll find hundreds of thousands of pages of advice, consultants and companies – all offering you services to help you improve your search engine traffic and ranking.

Successful marketing of your website is not just one of these things; it is rather a holistic activity which takes into account a range of approaches which span both offline and online. We'll see why shortly when we look at how Google and other search engines make use of links – the currency of the web. We'll also learn some techniques for increasing traffic to your site by working in particular ways.

> 'We have profiles on Facebook, Flickr and Twitter, and make extensive use of social networking sites to monitor and respond to conversations about our organisation. In terms of traffic driving, we find promotional information such as press releases and backlinks (particularly BBC [British Broadcasting Corporation] News) the most effective.'
>
> Paul Bevan,
> National Library of Wales, UK

Let's start by looking at one of the primary factors which make a difference when it comes to driving this traffic to your sites: how you are indexed and appear on search engines.

Search

Let's first of all look at the importance of search engines in the online context.

According to figures from Compete,[2] a web-traffic measurement firm, Google-delivered search was responsible for around 7% of all referrals to websites as of December 2009. Google – as of the time of writing – has anything from 64%[3] to 84%[4] of the search engine market. (Figures differ so widely because nobody knows how big the internet

> We'll focus on Google search as it is undoubtedly the most important search engine in existence, and many of the ideas and approaches we look at here are the same whichever search engine is used, but don't forget that there are a whole range of other search tools available to people!

is at any one time, nor exactly what people are doing. Typically, these figures are based on rough approximations from a number of sources.)

Search intention

Before you can really understand how best to leverage search engine traffic, it is important to have a handle on the *search intention* which these users might have. What are the likely cultural heritage user scenarios when searching Google or one of the other big search engines? At the very simplest level, it is probably one of the following:

To find out more about an institution

The first search scenario is where the user is interested in something about your institution itself. Maybe it is a place that they have heard of because it is well known or local to where they live, or maybe they've seen it on some marketing or are planning a visit.

In this instance, the institutional website should be the best resource for this information, and needs to appear high up in the search engine rankings for any likely searches. There are some subtleties here which you should be aware of: if you are *the museum of natural history* and everyone searches for 'natural history museum', for example, you will need to do a bit of work to make sure that search results return as you'd like. We'll look into this in more detail later.

In reality, particularly for smaller institutions with limited web presences, a Wikipedia or 'local listings' site can often appear higher up in the search listings than your own site, and will therefore more likely get traffic.

> 'Results for likely "institution name" searches should come higher up than any other in search engine results. Be better than Wikipedia: this is a good benchmark for your site.'
>
> Frankie Roberto,
> Experience Designer,
> Rattle Research, UK

To find out more about a specific subject

The second scenario is that the user is looking for some specific information on a particular subject. They may be wanting to know when a particular book was written, or who made a certain object. In this scenario, the user may well not care where the information comes from (although they will at some level be interested in indicators of *trust* and *provenance* – for example, your brand, design and tone). They may be casually searching, doing some in-depth research, putting together a pub quiz or merely browsing the web and following links. Searches of this kind can be a considerable driver of traffic – the scale of the web and the number of people doing these kinds of searches explains why.

> A casual user such as this may simply find the information they seek and then 'bounce' (see Chapter 6 'Traffic and metrics') immediately away – many sites try to offer them content which makes them 'stick' on the site for longer. Your strategy partly determines what it is you want to do for these users.

Part of your aim in this second scenario is to do what you can to provide interesting and engaging pages which the user will land on when searching for these topics.

Search engine mechanics

With these scenarios in mind, let's look at some of the underlying mechanics which drive how search engine results are determined.

Why links matter

Links - of course - provide the means for people to move from one page to another, either on one site or between sites. Links are in many ways the lifeblood of the internet, a revolutionary approach in presenting documents which allows concepts to be connected together in a way which now seems totally natural to us.

As well as providing humans with the means to travel from document to document or site to site, links also give web *spiders* - search engine software - the means to follow these paths too. Typically, a search engine such as Google will scan through a site looking for links which it then follows, copying content from each page to their database as it goes. This is the *spidering* process.

More importantly, Google considers links as being a form of currency. The way it works essentially is that a link from site A to site B is almost considered a 'vote' from site A for site B's content. A site with more inward links is considered a more valuable or popular site. A site with zero inward links - like our extreme example at the beginning of this section - simply won't be seen by search engines, and certainly won't figure high up in the results listings. Alternatively, a site which has multiple incoming links, particularly from popular sites, will begin to see its popularity increasing in search engines. This is - if we stretch our shop analogy - like a series of well marked paths heading inwards to our store: the more there are, the more likely someone is going to head down one and through our door.

The algorithm which controls the popularity of sites on Google is called the 'Page Rank' algorithm and is actually much more complex than the simple vote example above: it is weighted, for example, so that a link from a site which is itself of high Page Rank has greater value than one from a site which has a low Page Rank. There are many other factors which are also taken on board, such as position of text on page; we'll look at some of these later on.

The important point to take on board about Google is that inward linking is absolutely crucial to your website presence. This can be a very valuable piece of information to take on board as you think about how best to market what you do: it makes a difference to how you engage with social media, how you write content and so on.

Result position

The position of your site in search results will have a huge bearing on the amount of traffic that you get from search engines. Next time you are looking for something on the web, consider how often you find yourself clicking on something high up on the first page compared to the times that you click on something featuring on one of the subsequent pages.

Research carried out in 2005 and cited by usability guru Jakob Nielsen indicates that 42% of users clicked the top search result.[5] This is obviously a fairly old piece of research, but other pieces of research such as this one[6] seem to corroborate this evidence. The results from this latter research – see Figure 4.1 – also show that the tail-off from first position is steep, with the vast majority of users choosing a first-page result to any subsequent pages:

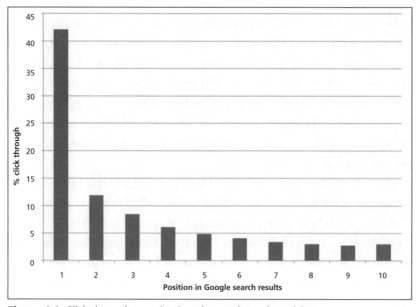

Figure 4.1 *Click through rates by Google search result position*

The lesson from a marketing perspective is very clear: to get the best possible traffic throughput you need your web presence to be consistently high up in the results – hopefully on the first page of returned results – and also to be a destination which the user sees as being a useful source of information.

SEO strategies

Search Engine Optimization is the name for a range of techniques that can be used to improve your search engine rankings. These techniques are changing all the time and, unfortunately, as mentioned above, it is an area of business which is saturated with companies offering advice, some of it contradictory and much of it confusing.

For the most part, this advice can be simplified into the areas discussed below – a fairly stable and standard series of recommendations which should improve your search engine rankings. As always, however, it is worth spending some time making sure that your strategy matches both your particular context and the most up-to-date advice available online. Ask your peers from other institutions what strategies have worked most effectively for them and adjust your approach accordingly.

Great content

The importance of having great content is hopefully obvious, but it is easily the most important thing by a long way, so is worth stressing. As with many parts of the web management equation, it pays to think like a user. Think about the sites you frequent on the web: it is likely that excellent, up-to-date content is a core motivation to you. Your content strategy is thus an absolutely crucial part of the SEO/marketing equation.

The other suggestions in this list are about *surfacing* your content as well as you possibly can. If the content isn't interesting, well written or useful in the first place then all the other suggestions fall down.

Content freshness and linking

Content freshness covers several things. First, make very sure that you

expire old content when it goes out of date. This is probably more important for your users than it is for search engines but either way nothing annoys people more than out-of-date content!

Second, update your site as often as you possibly can. There is a fair amount of evidence that Google (and probably other search engines, too) visit sites more often when they are updated more often. Certainly, the more quality content you have, and the more linking (inward and outward), the higher your Page Rank is likely to be. Internet guru Dave Taylor recommends that you also look to pass these changes around your site as much as possible, for instance by having a section on your home page with latest news headlines which is updated when the news section itself is updated. He calls this *content pollination*:

> What I suggest you need to do is figure out a way that when you update your weblog, something can change on the other pages on your site, esp. your home page. Then have a bit of patience and you'll find that all of the pages on your site are being spidered every day or two.[7]

You'll notice that in this instance he is talking about blogging in particular. In fact, the same technique works for any content changes – if when you change one area you can find a way to (meaningfully) update others, then you are more likely to present a fresh and interesting-looking site for both visitors and for search engines.

The frequency with which you update your site will depend on your institution and what you have going on in terms of content, exhibitions, new collections, acquisitions and other news.

Consider setting up a blog on your site – blogging is an excellent way of keeping your site fresh; blogs are usually well spidered by search engines, and you can choose to blog very short posts which will keep user attention but also encourage visits from spiders. See elsewhere in this book – particularly Chapter 7 'The social web (Web 2.0)' – for further details on how to use blogging in your organization.

Think creatively about how you can generate changing content rapidly and with the lowest effort–highest gain. If you are a library, you could consider a 'latest acquisition' panel which links through to your catalogue, for example. If you're a picture library, have an 'editor's picks'

panel which links to an image which changes daily. If you're a museum, you could have a curator's 'object of the week'. There are hundreds more ideas along these lines – have a look at what your peers are doing online, or even consider sites that are totally outside your sector: you'll still find many good ideas. Obviously, the specifics depend on your environment, but if you think laterally you can usually identify some content which can be turned around quickly in order to keep your site fresh.

While you are doing this, consider the sites that you visit, and – more importantly – continue to revisit, and see if you can spot what it is that makes you go back.

Many people like to also include a 'date last modified' line on the page: again, this is mainly for users rather than for search engines, but is something to consider if your WCMS or site software supports it.

The <title> field

One of the most important technical things to get right with your website delivery as far as search engines is concerned is having your <title> field correct on the pages of your site.

The <title> field is at the top of your HTML document, within the <head> tag of the page and before the main <body> content.

The reason that this particular tag is so important is that the contents are what shows up in the search results listing on Google and other search engines. Consider a bad usage of the <title> field, from a fictional library catalogue page for a single book:

<title>Book Detail page</title>

Google will not only display this (Figure 4.2):

> **Book Detail Page** ☆ ⌕
> Dickens, Charles, 1812-1870. A **Tale of Two Cities - Library**. | The entire work | Table of Contents for ...
> mylibrarycatalogue.com/search.html - Cached - Similar

Figure 4.2 *Example of how a generic ('bad') use of <title> field might appear in Google*

. . . but will also have returned results based on searches for 'book detail page' – not a terribly likely search!

Now let's have a look at how this might be better:

<title>A Tale of Two Cities: Charles Dickens – My library</title>

Firstly, this is useful information both for Google and for the user; see Figure 4.3:

A Tale of Two Cities: Charles Dickens - My library ☆ Q
Dickens, Charles, 1812-1870. A **Tale of Two Cities** - Library. | The entire work | Table of
Contents for ...
mylibrarycatalogue.com/search.html - Cached - Similar

Figure 4.3 *Example of how a specific ('good') use of <title> field might
appear in Google search results*

More importantly, the title field is relevant to the thing that the user is looking for. Not only this, but the recommendation is that the title field is – as much as possible – unique for each page across your site, and this particular approach fulfils this particular requirement.

There are no hard and fast rules for how you should format your page <title> field. Many people choose to include an institution name as well as the specific page name with some kind of separator in-between, for example:

National Library of Things – Opening Hours

The recommendation from search engines goes no further than to suggest maximum lengths for this field as well as the uniqueness outlined above.

<h1> tag positioning

Google – and possibly other search engines as well – pays attention to the actual content of your pages. The ranking algorithm is particularly concerned with the *positioning* of any <h1>s, considering this the 'most important' representative HTML tag on the page. The generally recommended advice is first to only have a single <h1> tag on your page and, second, to put this particular tag high up on the page. The Google Page Rank system considers this <h1> to be more indicative of the content of the page than anything else.

Although this tag isn't as important as the <title> tag, you might want

to consider it in the same way – make sure it contains content which is unique and important to the page. Remember as well that you can style it however you want: the default <h1> is pretty huge, and not particularly attractive!

Don't be tempted to hide the <h1> by making it white on white – even though in the early days of SEO this was a trick which seemed to work. There is some evidence that Google now considers this to be a trick so commonly used to generate spam that they may well consider pages that do it to be link farms like those run by spammers.

Offline marketing

Marketing your online presence offline is sometimes overlooked. Often institutions are so busy talking about their 'real-world' presence on the website that they forget that physical marketing material is a powerful potential driver to the website.

Increasingly, marketing professionals have experience working on the web. Sometimes, however, particularly with more entrenched institutions or staff members, the web can be a bit of an afterthought. One of your jobs in running the website is to find ways to work closely with marketing and press people in your institution and beyond, driving traffic from offline environments to online, and back again. To this end, there are some simple common sense rules which govern how best to promote your URL.

Domain names
Choose a good domain name

If you have the choice (and often you won't, because the domain name will already be chosen and probably entrenched), are there any guidelines for choosing what domain name to use?

There seems to be little solid data about this particular question on the web, but an informal straw poll on Twitter seemed to fall on the side of *memorable* domain names in preference to anything else.

This would, for example, favour:

thenationalstateartgallery.com

. . . over something like:

tnsag.com.

The first name makes 'sense' (to readers of English), would thus probably be more memorable to users and would thus be more likely to be recollected if seen elsewhere. Furthermore, there is evidence to suggest that Google treats meaningful domain names more favourably than nonsensical ones. Having said that – and as detailed above – it is likely that a large proportion of people will follow the practice of searching for your institution and then simply clicking the first search result. For them, memorability may be less important than ranking, and thus your ability to surface your institution high up in the results is important. Shorter domain names – if you can get them – make life easier by requiring less typing and less space on marketing material. This may sound trivial, but often marketing material has limited physical space: fitting a long domain name on a banner, e-mail signature or flyer can be a challenge. The ideal scenario is a short, meaningful and memorable domain name!

Put your domain name everywhere!

You should ensure that your website address is on *every single piece of marketing material* that your institution produces. Marketing material in this sense includes obvious things like posters, flyers, banners and newspaper adverts. It also includes some places that are less obviously earmarked as being 'marketing' such as business cards, e-mail signatures, presentation slides and relevant signs in your buildings!

Minimize the number of domain names you use

The general rule of thumb with domain names is to minimize the number that you use wherever possible. If you have very distinct websites which perform totally different functions, then of course these can and should be represented by alternative domain names, but where possible have a single core domain name and hang any other sites off this domain.

As an example – say your core domain is myinstitution.com and you have just decided to launch a new wing of the building called The Sponsor Wing. Rather than buying a new domain:

thesponsorwing.com

. . .and using this to promote the new wing, you would instead use your core domain as follows:

myinstitution.com/thesponsorwing.

If your sponsor or stakeholders insist on having their own domain, set it up as a *permanent redirect*[8] so that users arrive at *thesponsorwing.com* and are immediately redirected to a relevant path on your core domain.

There are very sane technical, marketing and user-focused reasons why this is an approach worth taking, not least of all because your 'link juice' is radically improved by consolidating under one domain. If you've spent time building up traffic, inward links and search to one domain, don't then go and buy additional domains for additional projects unless there is a compelling reason to do so. Instead, build up a policy of promoting via your core domain.

You will also find that your administration time will be much reduced by keeping the number of domain names you own to a minimum. Although most domain names only need to be renewed infrequently – usually annually – you will find that maintaining a long list of domains is quite time-consuming, and can often lead to mistakes such as mistakenly allowing an important one to expire.

Decommissioning old domains

You might find that you inherit a whole range of domain names from legacy services which need to be maintained, or you may find compelling reasons to launch new sites with completely different domain names because of – for example – pressure from sponsors. Either way, consider these environments to be imperfect, and push back against them as much as you can. With the case of legacy domains at strange and wonderful addresses, aim to – possibly over a period of months, or even years – fold these under a core domain as illustrated above wherever possible.

Choosing top level domains

So should you buy permutations of your domain name TLD (top level domain), and if so, which?

The answer probably is 'yes', and 'it depends'. Opinions differ – really there is no right answer – it depends on budget, time, how worried you are about cybersquatting (the nefarious practice of buying domain names prospectively in the hope that they might one day make a profit), what country you're in and so on.

In general if you're following the 'one core domain' rule, then the only reason for buying other TLDs is to redirect (for visitors who type the wrong URL in by mistake) or to prevent others from cybersquatting. Whatever you do, don't promote both myinstitution.com and myinstitution.org if they just end up at the same site. Choose one as your core domain, and use this domain – only this domain – and keep the other one behind the scenes.

Track real to virtual activity

The more evidence you have that a piece of offline marketing is driving traffic to the online destination of your choice, the more you'll be able to support your strategic claims that the website and physical presence of your institution are co-supporting.

What does this mean in practice? First, if you're running a particular campaign, consider giving unique identifiers to this particular destination which you can then track. If you are running a campaign which is marketing your new gallery opening, you might create the domain name like this:

myinstitution.com/newgallery

which would mean that you could immediately use your metrics package to see how many people are coming to your new gallery page(s). However, you can also go a step further by creating 'aliases' which point to any part of your site in your WCMS (or ask your IT team to do this for you) and then use this to track particular campaigns. So if you were promoting your *new gallery* in a local newspaper ad campaign, you might have this domain on the ad:

myinstitution.com/newspaper

or:

myinstitution.com/dailypress.

Anyone visiting the campaign address would be immediately redirected to your new gallery page. Your web stats package will be able to show you whether your campaign has worked.

The second option available to you is to offer vouchers, tickets or other unique identifiers which can tie in your various marketing approaches. You can very easily build a page on your site which has some kind of printable voucher for people to bring in to your institution. This could offer a cheaper entrance fee, free coffee, a discount in the shop, etc. Work together with your front of house and marketing teams to develop the campaign and make sure that they collect and keep the vouchers that are brought in – you can use these, again, to build evidence that traffic flows between virtual and real.

Online marketing

Once you've done everything you can to promote your domain name in as many free places as possible (in e-mail signatures, posters for exhibitions, and so forth), you might also want to consider doing some paid advertising online.

There are a large number of options available to you. Perhaps the two best known ways of paid promotion are paying for placement in search and banner advertising.

Paying for placement in search

Here the basic modus operandi is to pay a search engine (for example, Google) in order to have your site appear in the sidebar or at the top of the page. There are various ways that these are costed but typically they will be performance-based, for example, PPC (Pay Per Click)/CPC (Cost Per Click). Google's version of this is called AdWords.[9] Google has a

> 'We have an adwords grant (for the Wellcome Trust as a whole) which we use to promote exhibition-independent content, and spend a small amount on adwords promoting programmed events/exhibitions.'
>
> Danny Birchall,
> Wellcome Trust, UK

model where the cost of the ad is based around the potential of particular keywords and the likelihood that they will be clicked. When you set up this kind of advertising you normally get fairly detailed performance stats in order to understand which ads are working to drive traffic and which aren't.

Banner advertising

Banner ads fall in and out of fashion but still seem to be a fairly often used way of driving traffic. Typically, you join an ad network, get a banner designed and the network then places the ad on relevant parts of the internet. As with paid placement, you get reports telling you how a particular banner has performed over time.

There are many, many more means of advertising online, including things like *affiliate marketing*,[10] but these are beyond the scope of this book – if you want to know more, there are many books and websites entirely devoted to online advertising. See a relevant search on Amazon for further details.

E-mail newsletters

E-mail newsletters are another excellent way of reaching out to your website audience – not only is it cheap to send e-mails, but if you do it well you can target an audience who are genuinely interested in what it is you have to say. Furthermore, e-mail newsletters can be tracked in incredibly powerful ways: you can download lists of people who opened or didn't open the e-mail, see who clicked on links, visualize how subscriber numbers have changed over time, and so on.

Although some WCMS systems and IT departments can offer bespoke systems for sending bulk e-mails, the offerings available to you online now are so powerful and cheap (many are free at entry-level) that these should be your first port of call if at all possible. If your IT department offers you an existing system, you should point them towards one of the

online providers and ask them to provide you with a comparison of the features. Unless there are compelling reasons to use internal systems, don't!

Typically, you set up an account with an online provider, put a form on your website in order to let people subscribe to the newsletter, and then regularly send out a mailing.

One thing you should be incredibly careful about is the data protection credentials of the provider – ask them about compliance for your particular country and context. If in doubt, seek legal advice.

You'll find further detail on how e-mail newsletter systems work – together with details of some of the services available – on the accompanying website at http://heritageweb.co.uk/book/ch4/e-mail-newsletters.

Social media marketing

Weaving your web presence into your social media presence is one of the very best ways of driving people to your site, but it has to be done with a lot of care and attention. There is considerable – and understandable – resistance to a 'hard sell' via social media. Social media – as we'll see in much more detail later on in Chapter 7 'The social web (Web 2.0)'– is all about the *conversation*, and not about 'push'; this is a very hard thing for some more traditional marketing people to understand. The visible power of Facebook, Twitter, Flickr and so on is in the sheer volume of people you can touch at any one time, instantly: in reality, however, it isn't about quantity but about the quality of that interaction.

Perhaps the easiest way to use social media as a marketing tool is to not set about using social media in this way! Use your social media channels in a passionate, meaningful and conversational way, and the marketing of your content will follow naturally.

Jim Richardson from UK agency Museum Marketing has this to say:

> Let's face it, some Museums don't use Twitter for much more then broadcasting events listings, and press releases about upcoming exhibitions, but to attract a good following on Twitter, you need to create content that people really want to read.[11]

This point is as true for museums, archives and libraries as it is for anyone else, and it is also the same across all social media channels. The

quality of the content is what will truly engage people and make them appreciate and use your brand, not use of social media as a broadcast mechanism.

'News stories about major discoveries drive most traffic, but our social networking sites (especially Flickr and Scribd) and citations on Wikipedia drive considerable numbers of users. Visits from social networking sites and Wikipedia tend to spend much longer browsing than organic visits via Google.'

Tom Goskar,
Wessex Archaeology, UK

As you'll see in Chapter 7 'The social web (Web 2.0)', one of the main keys to social media is awareness – being aware of your audience, your goals and your strategy. Social media can be a very powerful mechanism to drive traffic, but only if it is done in a sensitive, coherent and sensible way. Talk to your peers about what they do – find out what works and what doesn't, and then build your strategy from there.

Summary

We began this chapter looking at a hypothetical – and deliberately extreme – example of a site being launched without any planned marketing around it. This example was used to illustrate that this initial activity – although often the focus of many web projects – isn't in itself any guarantee that anyone will come to the site. Instead, we saw that traffic driving is more successful if it is part of a sustained and strategic approach which takes into consideration what people are looking for, how they are searching and what the goals of the particular project may be.

Some of this marketing follows on almost automatically from other best-practice ways of working. As an example, a site which is optimized for SEO often has many of the features of one which is more usable and accessible to visitors. In the same way, a site which is regularly updated with fresh content is not only more attractive to users (and likely to encourage repeat visits), it is also better spidered by search engines such as Google.

References

1 http://googleblog.blogspot.com/2008/07/we-knew-web-was-big.html.
2 http://articles.sfgate.com/2010-02-15/business/17876925_1_palo-alto-s-facebook-search-engine-gigya.

3 www.ricg.com/marketing_articles/digital_marketing/yahoo_and_
bing_gaining_ground_in_search_engine_market_google_still_dominates.

4 http://marketshare.hitslink.com/search-engine-market-
share.aspx?qprid=4&qptimeframe=M.

5 www.useit.com/alertbox/defaults.html.

6 http://seoblackhat.com/2006/08/11/tool-clicks-by-rank-in-google-yahoo-
msn.

7 www.askdavetaylor.com/does_googlebot_visit_more_often_because_of_
my_blog.html.

8 http://en.wikipedia.org/wiki/URL_redirection.

9 www.google.co.uk/adwords.

10 http://en.wikipedia.org/wiki/Affiliate_marketing.

11 www.museummarketing.co.uk/2010/01/15/tips-for-creating-more-
interesting-tweets-for-your-museum.

5

Policies and guidelines

Introduction

Your strategic framework and the strategy approach are all about the horizon thinking required to keep your web presence headed in a forward trajectory in the longer term.

On a day-to-day basis, you also need some scaffolding to help support your operational activities. This is what we'll look at in this chapter: the policies, procedures and guidelines which are commonly needed in a cultural heritage environment.

Before we go any further, let's get a definition of these terms.

According to Wikipedia:

> Policies and procedures are a set of documents that describe an organization's policies for operation and the procedures necessary to fulfil the policies. They are often initiated because of some external requirement, such as environmental compliance or other governmental regulations.[1]

In contrast, Wikipedia defines guidelines thus:

> A guideline is any document that aims to streamline particular processes according to a set routine. By definition, following a guideline is never mandatory.[2]

These documents are all essentially used in an operational scenario to help you to act in a considered, consistent and measured way.

As with your strategy, your policy documents should be living documents: you should make sure that you revisit them on a regular basis, amending and developing when required. Because these documents change regularly, find a mechanism which allows you to update them easily – also, make sure that you use a visible and effective versioning system: you should know who updated each document, what changes they made, and when they did it.

A highly recommended approach when it comes to these kinds of document is to publish them as web pages – preferably externally on your main website (and password protected if individual documents are sensitive), or internally on an intranet or whatever your equivalent is.

> The BBC is an excellent role model for demonstrating how policies, standards and guidelines can be published effectively online. See: www.bbc.co.uk/guidelines/futuremedia.

Policies, procedures and guidelines

In this chapter we'll look at some of the common policies, procedures and guidelines that are useful in a cultural heritage online context. Some are meant for internal audiences; others are created for legal compliance or external audiences. The examples here don't represent a complete list – every organization is unique, and you'll need to approach this from your own individual perspective, but it should hopefully give you some sense of the areas you should be considering.

Make sure that you consult widely with legal professionals: many policies can be of a sensitive nature, particularly around data protection and accessibility.

Accessibility policy

An accessibility policy helps you to follow certain guidelines in best practice so that your website is available to as wide an audience of users as possible, including people with visual and other disabilities.

Your accessibility policy should refer to the main online sources of this information, particularly the Web Accessibility Initiative (WAI), to be found at http://w3.org/wai. As the person responsible for your web presence, you should make yourself familiar with as much of this content

as you can. These sources should form the main body of your accessibility policy, with additional content being restricted to guidelines and exceptions which have pertinence because of your particular context.

The section on the WAI site entitled 'Implementation Plan for Web Accessibility'[3] has the following suggestions for implementing an organizational policy for accessibility:

1 Address issues such as conformance level, scope of site, use of proprietary formats, milestones, etc.
2 The organizational policy should reflect at least the minimum accessibility requirements mandated by relevant government policies or industry associations, but preferably the internationally recognized Web Content Accessibility Guidelines from the W3C.
3 For organizations that have a general website policy, integrate an accessibility section into the existing policy.
4 Both a concise high level statement of commitment, plus a comprehensive implementation-oriented statement, may be useful, particularly in large organizations.

This page has links to other resources and sources of excellence. The BBC 'Future Media Standards & Guidelines' web resource as mentioned earlier also has a very comprehensive section on accessibility at: www.bbc.co.uk/guidelines/futuremedia/accessibility.

Make sure that you talk with any internal stakeholders about your particular environment. Some larger organizations have members of staff with a remit to make sure that accessibility guidelines are followed for your buildings, and they will almost definitely have some expertise on how to apply best practice to what you do online, too.

Data protection and privacy policy

A data protection policy helps you and your audience understand what approaches you are going to take to ensure that data – sensitive or otherwise – is dealt with in an acceptable, understandable and legal manner.

Your data protection policy will normally largely be governed by existing wider government policies: in the UK, for example, the Data

Protection Act (DPA) determines how – amongst other things – you should deal with any personal information you may hold about individuals.

Once again, it is worth looking at the BBC DPA guidelines here.[4] Although UK-specific, these provide a good overview of the issues that shall need to be considered, including:

- how user data is gathered, what it is used for and how it is stored
- whether and how cookies (small pieces of code left by a web browser on a users' machine to track information) are used to track user behaviour
- where data such as e-mail newsletter databases are kept.

In general, it is usually better for organizations to minimize the amount of information they hold about individuals. Where such information is required (for example, if you want to gather a database of e-mail addresses for your e-mail newsletter), then, if possible, make use of the services of a third party who are themselves familiar and legally aligned with the DPA or equivalent. If you do it yourself, make sure that you consult widely with legal teams about how the information should be stored, made available and so on.

As with accessibility, it is very likely that there are individuals or departments who are already dealing with data protection questions; consulting with them will not only save you time but will also help ensure a more unified and maintainable approach across the organization.

Commercial and sponsorship policy

A commercial and sponsorship policy helps to guide you and others in making the most of any commercial assets that may be held within your site whilst at the same time ensuring that the integrity and values of your organization are upheld.

Within this policy you should consider issues such as the following:

- Do we have content which could potentially be repurposed and sold commercially? Are rights issues clear about this content?
- Are we making the most of any assets which may have commercial

value, and how can we ensure that these assets are protected and promoted in ways which benefit the organization?

* Are there any existing sponsors or supporters of our organization who could provide financial or other support to our web presence? (This policy can help avoid any conflicts of interest which may arise.)

The policy should make it clear who in the organization is responsible for making decisions about commercial matters on the website, and also how incoming requests for content (for example, a journalist asking for a picture of a gallery) should be dealt with.

Within the sponsorship section of this policy, you should consider how any sponsors might be accredited on the website, whether 'in-kind' relationships are acceptable and so on.

Intellectual property policy

The domain of Intellectual Property Rights is a complex one, and a domain which has been made even more complicated with the advent of the internet.

The 'boundary-less' nature of the web, for example, means that Intellectual Property Rights applicable in one country may be irrelevant in another. The geographical and practical challenges of working in this environment make things even harder: even if you can prove that your copyrighted content is being used on another site, for example, you may have limited power to make anything happen if the site is hosted several thousand miles away.

UKOLN (United Kingdom Office for Library and Information Networking) has a useful (if slightly old) guidance paper about IPR in which they define the two main areas of interest for cultural heritage as being:

1 management of copyright of your own work
2 establishing ownership of third-party copyright.[5]

Things are made even more complex in a world where Creative Commons licensing is widely used, and issues around social media IPR ownership continue to be widely debated.

IPR policy should thus always be developed in line with guidance from legal experts who really understand both the IP and heritage environments. It is highly likely that considerable work will have already been done in

this area at your organization: seek out any internal legal teams or ask your peers in other cultural heritage organizations for advice on who can help.

There are some links to useful IPR resources on the accompanying website at: http://heritageweb.co.uk/book/ch5/ip-resources.

Web development policy

The web development policy is primarily meant for internal audiences and outlines how stakeholders in your organization can get involved with your web presence: it gives staff a sense of what they should and should not expect from you, and also draws some boundaries around what they can do themselves.

This policy tries to ensure that all the content within the organization which has value to external users is represented online; furthermore it outlines how the content will get online, how it will be maintained, and how it will eventually be retired and archived.

Typical elements of this policy include:

Content Representation

Everything within predefined boundaries *must* be represented on the institutional website in a certain way and within a defined timescale. An example for a museum site would be: all exhibitions which are taking place at the museum must be online by the time they open. For a library or archive: all books and archive material which are represented in the catalogue must also be available online.

Working with the web team

Stakeholders throughout the organization should make sure that they talk with the web team whenever a new content initiative is being discussed. If you have the sort of fragmentation that is sometimes found in large organizations, you may also want to be specific that all web projects must be discussed with you and your team, and that you are responsible for these projects!

Commissioning of web work

Depending on the particulars of your environment, you may want a section which specifies that your team should be the first port of call for any web work (editorial, design, development, etc.) and that if you have the skill sets and time available, you will work collaboratively with the stakeholder to develop whatever is required. This section could also specify that in the event of not having the requisite time or skills, you may outsource, but that all development work will be monitored by your team.

Sign-off and go-live process

Make it clear to readers of the policy exactly what the sign-off policy of your team is, and what pre-launch requirements there are. This may include things like user testing, design acceptance, accessibility testing and so on.

Box UK, an agency that does a lot of work with cultural heritage organizations, have created the 'Ultimate Website Launch Checklist'[6] which covers everything from technical issues to standards and validation.

Content development policy

This policy includes information about any legislation and best practice advice which is relevant in your particular field, including:

- standards, for example e-GIF,[7] Data Protection[8] and Freedom of Information[9]
- best practice, including things like cookie management
- who in your organization is responsible for writing, editing and uploading new content
- how content is going to be managed – via a WCMS or otherwise
- who makes decisions about the style, tone and extent of web content
- how content is dealt with when it reaches end of life.

Visual and content design policy

Design and style guides are likely to already be in existence for your organization. Your job is to make sure that the approaches – the fonts,

colours, styles and tone – which work for the physical presence of your organization can be adequately translated onto the online world.

This isn't as straightforward as it first seems: the web is a dynamic, interactive and changing medium, which doesn't necessarily make the translation from flat, traditional designs a straightforward practice.

'Digital projects often inherit branding and design from larger, architecturally or print-led projects. Transforming a flat print design to an accessible, robust implementation in mark-up and code can be a complex process.' [10]

Mia Ridge,
The Science Museum, UK

You should develop a style guide for your web presence, covering both the visual and written aspects of your brand online style. Often, this is something you can ask your design agency to develop for you: if you are going through a redevelopment project (see Chapter 8 'The website project process'), then you could ask them to develop this as part of the process.

Your style guide is designed for both internal and external stakeholders: you would use it when asking a designer or writer to deliver a new online interactive or section of the website; you would also use it in conjunction with staff who want to provide content for use on the website.

The style guide is a short, succinct document. A good way of writing this document is to split it into two main sections: visual style and editorial 'tone of voice':

Visual style

This section contains information such as the following:

- How your logo should be used (and not used) in any online environment. This normally covers things like the space that must be retained around the logo; variations of it for different uses (for example, colour variations for print or e-mail newsletters); and alternatives of the logo (such as marks and text only versions).
- Your style guide should also include examples of the logo(s) you use in various sizes and formats. Remember that the logo may be used in a whole range of places: printed material, black and white photocopies, social media sites and so on – do some research into each of these and define how the logo will work in these environments.

- Your official colour palette. This is normally represented as a series of colour swatches together with their HEX (Hexidecimal), RGB (Red, Green, Blue) and CMYK (Cyan, Magenta, Yellow, Black) representations. The section on colour palette may well also have some text describing how the colours should be used together and whether there are any secondary colours which can be used. It should also describe how (or if) you are going to be using web-safe colours, and how your primary palette translates to these.
- You may also want to include some detail about the overall look and feel of the site, either as pictorial representations or in text form; for example: 'Our online presence has a mainly "retro" feel, employing muted colours throughout except where the X sub-brand is being used. Here, the primary colours Y and Z are used to highlight the vibrancy of this sub-brand.'
- Link relevant sections of your style guide to defined locations of your logo in PSD (Photoshop Document) or AI (Adobe Illustrator) format. Often, it is useful to have these online on your website so that external agencies such as journalists can access them. Ditto, it is advisable to have your style guide available for download as a PDF, too.

Tone of voice

This section of your policy is an articulation of how your brand should be represented in the written word. It should be aimed at authors and editors who are unfamiliar with your brand, providing them with a good understanding of how to write for this particular context.

Normally, this document begins with a statement which describes the brand and how it should be perceived online. This is often something which you will have already described in your strategic documentation, or something which is broadly understood at an organizational level, so you will probably be able to copy this from there!

This statement might be something like:

'The library wishes to promote an image of being an authority, yet a friendly authority which is open to the views of its users.'

Or:

> 'We have become known as the place to come to discuss science education in an open manner.'

Sometimes, a TOV (Tone of Voice) document can be explicit about the words and phrases that should or shouldn't be used. For example, you may want to provide a list of terms that could be considered 'jargon' and should thus be avoided (perhaps detailing acceptable alternatives). Words such as 'curator' may be very familiar to you and your colleagues but not necessarily familiar to your users. Employ user testing if you are struggling to work out what would be the most appropriate terminology to use.

Social media guidelines

As social media has moved from being a niche, experimental activity to something which is rather more central to many organizations, so the need to provide guidance about how best to use it has intensified.

There are a fair number of social media policies from cultural heritage organizations which have been published online. They vary a fair amount in consistency, quality and coverage but there are some common themes.

Many of these themes are articulated by Chris Boudreaux, who maintains an excellent online database of social media policies.[11] From this database, he has compiled a report on best practice across all 50 or so policies. These are from both commercial and not-for-profit companies but, nonetheless, his research is incredibly useful and summed up as follows:

1 Be clear to employees about how they deal with personal social media (that which they are involved in in their own time) as opposed to professional social media (that which they are involved in as part of their job).
2 Work hard to make sure that your employees understand where the boundaries lie.
3 Create workable, clear and relevant documents which employees are likely to consume.

Post these documents (publicly) where employees can find them, and provide relevant links to further information as well as contact information for the document owner(s).

The distinction that Boudreaux makes between *institutional* and *personal* social media use is one that is echoed in most of these policies, and is a good way of thinking about how they should be approached. You can choose to publish a single set of guidelines which contains both institutional and personal social media scenarios, or publish them separately. Boudreaux recommends the latter.

There are accompanying links and downloadable social media policy templates for you to adapt for your own use at: http://heritageweb.co.uk/book/ch5/social-media.

> Coca-Cola recently published their new social media guidelines at: www.thecoca-colacompany.com/socialmedia. These are interesting to look at because they capture – very succinctly – the differences between institutional and personal use of social media: *'There's a big difference in speaking "on behalf of the Company" and speaking "about" the Company.'*

Institutional social media use

Institutional social media use is that which is set up by the organization and has content which is directly related to the activities of the organization.

Social media – as we'll see in more detail in Chapter 7 'The social web (Web 2.0)' – should, like any other online activity, happen in alignment with an existing organizational strategy and approach. The tendency to 'do it because you can' – rather than because you should – is strong in this area, and should usually be resisted.

General guidelines

Your guidelines should describe how social media activity fits into the wider picture of organizational web activity. In this part of the guidelines, you should identify the processes by which this activity should be governed.

Example points include:

- Social media should only be considered when it displays a clear 'fit' with the existing web strategy.

- Social media accounts are only set up with the agreement and authorization of the web team.
- Content, sustainability and workflow should be discussed and agreed with the web team to ensure that this isn't a 'fad' use of social media but rather has a medium- to long-term horizon and is relevant to our vision.

Content guidelines

From a content perspective, the following are the kinds of points to include in order to guide institutional users of social media in what they write and how they write it:

- Be transparent with anything that you write. Declare that you work at [name of institution]. If you are commenting on other sites, use your real name, identify where you work and be clear about your role.
- Always use common sense and sound judgement; consider any social media conversation to be a 'real' one – be polite, considered and appropriate.
- If the conversation becomes heated or negative, walk away and ask for guidance from others in the organization rather than getting involved yourself.
- Don't disparage other organizations or individuals: be constructive with your comments and content. Even if you are being critical, be professional.
- Remember that you are an envoy of your organization – you will be seen by others as a voice of your institution. Do not disclose anything which might be sensitive or confidential.

You should reference any wider guidelines into which these fit – for example, any existing code of conduct agreements and/or outlines of disciplinary procedures.

It is common to provide some 'boilerplate' disclaimer text for use on institutional blogs (and other social media sites) in order to set the context for the content on these sites. Here, for example, is the disclaimer from the Powerhouse Museum (in Sydney, Australia) blog policy:[12]

This site is for discussion purposes only and does not represent the official views of the Powerhouse Museum. Any views expressed on this website are those of the individual post author only. The Powerhouse Museum accepts no liability for the content of this site.

On any public-facing blogs, you should also make it clear how you deal with matters such as moderation of any comments provided by users – something like this:

All comments on this blog will be moderated by the editor, and should appear within 24 hours of posting. Any comments which are deemed to be unlawful or abusive in any way will either not be published or will be removed within a reasonable time span.

Personal social media use

Personal social media guidelines cover activities which individuals within your organization might be involved in: for instance, if they have their own personal blog or Facebook page.

On many guidelines (for example, the BBC 'Social Networking, Microblogs and other Third Party Websites: Personal Use'[13]), the distinction is made between online sites which directly identify the institution or an individual as working for that institution, and those that don't:

Blogs, microblogs and other personal websites which do not identify the author as a BBC employee, do not discuss the BBC and are purely personal would fall outside this guidance.

New and existing blogs, microblogs and other personal websites which do identify the author as a BBC employee should be discussed with your line manager to ensure that due impartiality and confidentiality is maintained.

Having said this, it is worth making it very clear to institutional users that the distinction between a personal profile and a professional one is often blurred. The following example guidelines help articulate this:

- Be aware of potential conflicts: even in a personal context, your social media activity may be seen as a reflection of your business activity.
- Be responsible: use sound judgement and common sense, and remember that there is often a fuzzy line between personal and institutional social media.
- Remember that 'the internet is permanent': even if you do post some content and then immediately delete it, there is every possibility that it remains somewhere on the web.

As with other guidelines, you will want to refer to your HR department and any existing policies which they have about conduct, and reference these where appropriate.

Summary

There are many excellent examples of policies and guidelines available online for you to use as a starting point for your own institution. Ask your peers for help in developing your own policies, and then publish them online so that others can read, reference and adapt them for their own use. As mentioned at the beginning of this chapter, do make sure that you run all policies and guidelines past a trained legal specialist to make sure that they fit with your institutional requirements.

A strategic approach which is supported by a well-written and considered set of guidelines and policies puts you and your organization in an excellent position to move forwards with your web presence. In the following chapter, we'll look at how you can work out what 'success' is in your particular context and put some practical tools in place to begin to measure whether success is being realized.

References

1 http://en.wikipedia.org/wiki/Policies_and_procedures.
2 http://en.wikipedia.org/wiki/Guideline.
3 www.w3.org/WAI/impl.
4 www.bbc.co.uk/guidelines/futuremedia/policy/tech_implement_dpa.shtml.

5 www.ukoln.ac.uk/interop-focus/gpg/IPR.

6 http://boxuk.com/blog/the-ultimate-website-launch-checklist.

7 www.cabinetoffice.gov.uk/govtalk/schemasstandards/e-gif.aspx.

8 www.ico.gov.uk/for_organisations/data_protection.aspx.

9 http://en.wikipedia.org/wiki/Freedom_of_information_legislation.

10 Chamberlain, G. (ed.) (2011) *Museums Forward: social media, broadcasting and the web*, Museum Identity, www.museum-id.com/books-detail. asp?newsID=168.

11 http://socialmediagovernance.com/policies.php.

12 www.powerhousemuseum.com/dmsblog/wp-content/powerhouse_museum_blog_policy_2007.pdf.

13 www.bbc.co.uk/guidelines/editorialguidelines/page/guidance-blogs-personal-summary.

6 Traffic and metrics

Introduction

One of the increasingly important things to take into account when developing a strategic approach for your web presence is – ultimately – to determine, measure and communicate how effective it is.

'Effectiveness' is a highly subjective measure. It is subjective not only to a particular context but also to a particular user and occasion of use. For a user who is looking for opening times and nothing else, an 'effective' web presence is one which provides this information in as few clicks as possible. For a researcher who wants to collect as much information about a specific topic as possible, effectiveness is about the depth of content available to them, the completeness of an archive. For a schoolteacher putting together a lesson plan, effectiveness might be something to do with the quality of downloadable resources that are available to them.

The way in which you understand your audience is therefore crucial when it comes to building user experiences which are relevant and effective for them.

Using metrics effectively is a cyclical process: it is about *improvement* of the service that you offer based on an iterative feedback loop in which you measure, compare and refine. This improvement only comes about if you understand what you are measuring and why.

> 'We report our web metrics not only to our web team but to other places internally. We have a cross-departmental group, a Library Board, and will shortly be delivering these metrics to the public through a "zeitgeist" report.'
> Paul Bevan,
> National Library of Wales, UK

In this chapter we'll look at web metrics generally and examine how you can get these, how you can interpret them, and how you can disseminate them. You should bear in mind, however, that these general approaches mostly just scrape the surface and only provide a 'top-down' idea of how your site is performing. These figures are probably the only ones your stakeholders will be asking for or interested in, but you should always bear in mind that true insight requires an understanding of your audience, and of your particular context and 'success', whatever that may be.

> Longer term, one of your goals is to help change the 'virtual visits are everything' mindset and begin to educate stakeholders in the value of really understanding the value that your web presence brings to your organization.

Measurement techniques

There are two main techniques of measuring the movement of traffic to and around a website. There are some pros and cons to both methods – historically, log file analysis was the most common, but this has been largely superseded now by JavaScript-based page tagging. The latter is generally considered to be more accurate and can also deliver results in real-time, but there are advantages to keeping log files (for example, for archiving or historical analysis). In general, however, log files are more useful for IT functions like monitoring and audits and less useful for gaining a real insight into user activity.

> If you have the means at your disposal (particularly for log files – enough disk space and the means to manage large quantities of data) then there is no reason whatsoever to not use both methods of log file analysis and JavaScript-based page tagging. Use software that reports on tagging for your metrics and back-up log files should you ever need them.

Log file analysis

'Log files' are basically text files which are created on your web server whenever someone uses your website. Typically, there is a log file for each day (and normally numbered with the date), although some server configurations may vary.

This log file contains details of every single 'transaction' that takes place between the 'client' (the end-user's browser) and the server which

hosts your website. Whenever – for example – a user clicks to go to a new page on your site, a request is sent from the client to server to fetch that page. This transaction is logged as a request. The details typically logged are: time and date of transaction; type of transaction; referring URL; and IP address of requesting machine.

As you'd imagine, these log files can become huge, particularly on busy sites where many thousands or millions of transactions are happening on any given day. You will probably therefore need to have a conversation with your IT administrator about how to archive, retrieve and use these log files. Often, because of the sheer size of these files, even moving them around a network can be challenging!

Normally, you don't need to know the details about what is actually going on in these files – instead, you'll have a piece of software which can work through these files and extract useful information and reports.

Page tagging

Nowadays, log file analysis has been largely superseded by what is called 'page tagging' – a technique where a piece of JavaScript is embedded or referenced in each page such that it captures the transactions which are going on and feeds these back to a database for analysis and reporting.

Normally of course, websites have a common header or footer, so this piece of code can be embedded once and will then appear across your site, ready to start gathering visitor data.

Page tagging tends to be much more accurate at reporting on real human activity (rather than search engine spiders and other automated 'bots'). This is clearly a good thing – you are mainly interested in what users are doing on your site – but this also means that figures reported by tagging software are almost always lower than those reported by log file analysis. For institutions who have been reporting stats to funders using logs over a period of years, a sudden drop in figures is sadly sometimes enough to stop them from switching to the more accurate page tagging approach!

Metrics software

There are many different software packages available to you to do your website metrics analysis. Some of these packages are hosted locally (in other words your IT department installs them), although many nowadays are hosted on the web. Some of the better known systems are listed on the website at: http://heritageweb.co.uk/book/ch6/metrics-software.

One of the best known systems is called *Google Analytics* and is rapidly becoming the de facto choice of analytics tool for many people running websites, including cultural heritage ones. There are a number of easy to understand reasons why this is the case: it is easy to implement, incredibly powerful and – possibly most importantly – it is free. You can find out more about Google Analytics at: www.google.com/analytics.

When making a choice about which tool to use, you should consider several factors. These include the obvious ones like cost, availability, back-ups and so on; but you should also spend some time talking to your peers about what system they use and how they use it. These systems often measure stats in subtly different ways and it is useful to try to align yourself with what others are doing.

'We use Google Analytics for most parts of our site and web logs for others. Web metrics are reported to senior management and CIPFA (the Chartered Institute of Public Finance and Accountancy).'
Paul McIlroy,
Warwickshire Library and Information Service, UK

Often it is useful to be able to compare your figures with others in your sector: not only will you be able to look at things like how long people spend on your site in comparison with others, you will also find it useful to compare and contrast longer term trends such as which are the busiest days of the week and what are the levels of activity during holiday periods.

What should you measure?

For most organizations, the primary aim of a web presence is usually something to do with *reach* – the web is a remarkably effective, cheap tool to get to a – potential – worldwide audience. As time goes on and internet usage increases, the demographic of internet users also advances: technology and access to that technology becomes cheaper and hence more widespread. With this take-up, the demographic split between users and non-users flattens.

Determining which particular metrics of reach are important to your organization is a challenge which requires a fair amount of work, and is very much tied into your overarching strategy. If your cultural heritage organization is one which revolves around people coming to visit for example, then you may be most interested in metrics which provide evidence of *visiting intention*: for example, pages which give details of opening hours or location information.

Seb Chan from the Powerhouse Museum in Sydney has written extensively about how to use statistics more effectively and is widely regarded as an expert in this domain. He suggests a *segmented web metrics methodology*[1] based around the following:

Segment your content

By isolating visitor types into 'visitors, searchers, browsers and transactors'[2] you can begin to understand what the various areas of your site are for. As Chan says:

> Each part of your Web site has a core purpose. The information about your location, opening times, hours and charges, exhibits and events are there to attract real-world visitors. . . . Other parts of your Web site, your collection and interactive learning resources, may be intended to operate independently from a real-world visit experience.

These areas of your site can probably be defined reasonably easily, and their purpose determined. You can use your strategy to help inform you here - break down your site as much as is relevant given the size and context of your environment, and consider what success would look like and how you might measure it.

Set user filters

Chan suggests removing non-human traffic (which you may find has been done already by metrics software) in order to remove search engine spiders and other bots (an autonomous piece of software which follows links around the web), and also visits to the site which are only of very short duration - under 5 or 10 seconds. This kind of filtering is often

unpopular because it can radically reduce figures, but does lead to a much more accurate understanding of what is really going on on your site.

Set targets for segmented data

Once you've filtered your stats so that you're reporting only on real people and meaningful visit timespans, Chan then suggests you set targets for each of your segments:

> [Real world visitors] . . . should be able to quickly find what is on and where you are located and be able to act on this information. Lack of clarity on these parts of your site will directly impact upon your real-world visitation. Education resources and collection areas accessed by browsers and searchers should show longer visit lengths.

The targets, as you can see, are based on the specific success criteria for that particular user and content set and – as always – should continue to be influenced by what your strategy has determined is a 'successful' outcome.

Measure and track traffic sources

Most metrics software provides the means to measure and segment by location using geolocation techniques[3] such as GeoIP (a way of determining the location of a user based on their Internet Protocol address). Chan suggests that you keep an eye on where traffic is coming from for each of your segments: 'Your real-world visitation traffic should predominantly originate from geographical locations close enough to your location to make a real-world visit possible.'

Chan's strategy provides a simple way to break down your website and visitors into discrete chunks where specific success criteria can then be applied. Your decisions about site architecture and content can therefore start to be based on specific activities of the visitors you value most, rather than on the aggregate sum of all your visitors.

Metrics definitions

One of the things that you'll find whenever you delve below the surface

of web-based analytics is that you are exposed to a huge amount of data. Effective analysis of metrics is as much about deciding which pieces of data are going to give you true insight into user activity as anything else: decide what it is you want to measure early on, before even looking at any of the figures!

Even once you've done the filtering approach suggested above, some of the metric names used can be confusing. Here are some of the more common ones together with their definitions.

Bounce rate

The 'bounce rate' is a measure of the percentage of single-page visits to your site, that is, those visits where someone comes to your site and leaves from the same page they arrived on. A high bounce rate is mostly considered a bad thing for e-commerce and media sites – the implication being that failing to visit other pages is indicative of low user-engagement. To give a sense of perspective, Google Analytics' specialist Avanash Kaushik says this: 'It is really hard to get a bounce rate under 20%; anything over 35% is cause for concern, 50% and above is worrying.'[4] The common exceptions are those sites which service information needs: Wikipedia or Google for example will have high bounce rates because people are finding information, reading and leaving.

You should also correlate *bounce* visitors against *repeat* visitors and identify what percentage of visitors *keep coming back* for 'information snacking'. Repeat visitors who bounce a lot probably *are* engaged with your content: they know you as a useful information source, find what they need and then leave before coming back again another time.

Page views

Page views (sometimes called 'page impressions') are exactly as they sound – a measure of how many pages have been viewed over the selected time period. Often this is divided by visits (see next section) in order to give a 'pages per visit' metric – another way of measuring engagement. A higher number of pages per visit implies that people are more interested in your content – although be wary of making too much of this without

further analysis: it could just mean that your visitors can't actually find what they are looking for!

Visits

Visits (also known as 'user sessions') are the number of times that visitors have been to your site. With Google Analytics (and this standard is widespread, although check with your particular software vendor), if a visitor is inactive for a period of *30 minutes or more* then their session will be counted as a new one: they become a new visit.

Many sites and analytics tools today use *cookies*[5] to keep track of who has been to the site before. Cookies help track *unique visitors* and thus give you some idea as to who has been to your site before and who is new. Repeat visits are another metric which is commonly used to give some indication of a user's level of engagement with your site.

Hits

Luckily, use of the word 'hits' seems to have stopped for the most part! A 'hit' is the total number of times that the server returns an asset to the client. Simply, therefore, a page which has nine images on it would produce ten hits (the page + the nine images). Hits were used for some time, and particularly during the dotcom boom, possibly because the figures are huge even for a modest site and sound suitably impressive! They are, however, completely meaningless as a metric, except possibly when considering factors like server load.

Time on-site

Time on-site is pretty much as it sounds – it shows how long each visitor spends on your site. This is a very important metric to watch out for as it identifies if visitors are really engaging deeply with your content. It isn't a completely foolproof metric, however; if a visitor leaves your site open in a tab or window which they don't use for a period of time, the stat will be skewed accordingly.

Loyalty

As mentioned above, *cookies* help analytics software to identify which visitors are new and which are repeat visitors. *Loyalty* is a measure of the repeat visitors. Typically, loyalty is illustrated by showing the percentage of visitors who came to your site once, twice, three times, and so forth, in the measurement period. High numbers of multiple visits indicate that your users are engaged with your site or brand.

Goals and funnels

Many bits of web analytics software allow you to set up *goals* and *funnels* - predetermined paths through a site which you'd like to track. A common example would be on a shopping site where you could follow how a user progressed from searching for a product to adding it to their basket to the final purchase stage.

In cultural heritage there are often paths, albeit ones which are slightly less tangible - for example, the tracking of a user as they search for and shortlist a book from the library catalogue. The analytics software usually allows you to visualize how people have moved along these paths, and - more importantly - when they have deviated from them. This deviation can often be indicative of problems in the design or user experience and so can be useful intelligence for you as website manager.

Referrers

One of the pieces of information which your web server picks up is where the visitor 'came from'. This may be an internal page referring to another, or an external resource - Google, for example. Referrer information is incredibly useful for tracking how people got to your site as well as how they move around once they have arrived.

Referrer data can be used to give you some idea of who is linking to you as well as which country, area or even city visitors have come to your site from. This, coupled with the filtered approaches discussed above, can give you some incredibly valuable insights into how users are interacting with your site.

Watching your metrics

With all of your metrics, look out for trends and for troughs or peaks which seem to go against those trends: try to analyse the reasons for these by considering both local events (for instance, the opening of a new building or gallery) and global ones (news items, strikes, holidays, and so forth). Make a note of patterns and their possible interpretations as you go, and use them to describe the performance of your site when you carry out your regular Key Performance Indicator (KPI) reporting (see below).

You will find that things like site visits will ebb and flow in what are normally very repeatable patterns from week to week, month to month and year to year. Figure 6.1, for example, is a typical visit profile for a museum site over two consecutive years – the first year is shown as a solid line, the second as a dotted line.

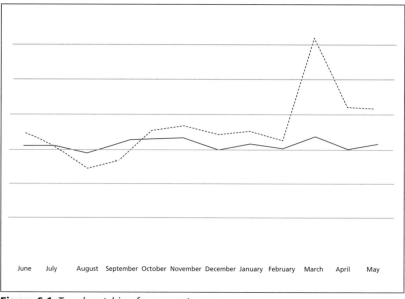

Figure 6.1 *Trend watching from year to year*

You'll find – as in the chart above – that many trends are repeated over various time periods: for example, you might have a daily peak of visitors at 11 a.m., a weekly peak on a Wednesday, a monthly peak in the third week, and so on. Annually, you can also track back over trends to see how things like school holidays, weekends, strikes and so on make a difference to your visits.

Over time you can start to use this information to help you plan website upgrades and downtime for quieter periods, and announcements and launches during busier ones. The longer term trends can be used to help you plan your metrics narrative.

When your stats buck the trend, drill down into them to try to understand why. Software like Google Analytics allows you to set up gateway conditions for alerts – so you can, for example, set up an e-mailed alert if a particular page or area of the site gets x% more or less visits than usual. Look for things like spikes from referring sites that are driving traffic to you, and follow links back in order to begin to build up a picture of where you get traffic from, where it goes, and how referred visitors move around your site.

Reporting

The main reason for spending time on your metrics is of course that you want to understand exactly how it is that people use your web presence and then use this to help you understand whether or not your strategy is proving successful. The secondary reason is to communicate success to your stakeholders, internally and beyond. This will help them to understand what you are doing with your web presence and where it is going. Probably the easiest and most effective way of doing this is to set up a KPI document, which you can use to log and disseminate top level web metrics.

It is worth stressing that this document isn't where you do the detailed analysis and filtering outlined above; the function of this document is to provide *very top level figures* to stakeholders. The reality is that many of our institutions are still beholden to funders, government and others who want to know top level details about who is coming to their sites.

Web metrics KPI document

The KPI document will normally be a spreadsheet – depending on your preferred way of working, this could be Excel or could make use of a hosted service like Google Docs.[6] The former is probably easier in this particular instance: as you'll see below we are going to be e-mailing these

stats around the organization at regular intervals, and you want the barrier to entry to be low, especially for senior stakeholders.

The following are some suggestions for how to set up this document. There is a metrics KPI template available at http://heritageweb.co.uk/book/ch6/kpi-template – but as with everything else in this book, it is advised to use this template as a starting point only and to feel free to modify it for your own needs.

Monthly reporting works best for a KPI document – it is about the right balance between being interesting and useful and being overwhelming. You should then total or average figures annually such that the year matches what your organization does elsewhere: fiscal, academic, calendar, etc.

Include figures for as far back as you can. The more history you include, the better you will be able to see the trends year on year and begin to see how your presence has changed over longer periods of time. Although you will undoubtedly see a net increase year on year as more and more people use the internet regularly, it is the trends at similar times of the year that you are looking for: things like school holidays, bank holidays and so on. Highlight these on the graphs if you have room.

If you have more than one core website or want to report on some of the third-party sites mentioned above, you will need to choose how best to display these figures on your executive summary sheet. It is usually best to have separate sites as data in different tabs, and then use the summary sheet to sum and display the necessary data as required, but be guided by the figures you want to disseminate.

What to include

Here are some of the metrics which you should measure and report on to your internal stakeholders using your KPI structure. Report by segment where you can – for instance, have separate figures for different audiences such as national visitors, local visitors and educational visitors.

Visits: Provide figures for visits to your site as a whole, together with any breakdowns as relevant. If, for example, you have a core site which gets X visits of which Y are visits to your collections area, give both figures and describe any detail in your report.

Page views: Give page views per time period (so for example 'X pages were viewed during the past month') as well as the average page views per visitor. A higher figure of page views per visitor obviously suggests a higher lever of engagement with the content of your site.

Bounce rate: Give a bounce rate figure for the site as a whole, and any breakdowns for relevant sections.

Financials: If your site has a financial element – for example, an online store or means for users to buy tickets – you should include this information as part of your regular reporting procedure. Typical top level important information for e-commerce transactions includes:

- total revenue
- number of transactions and hence average value of transaction
- number of items per transaction.

You may also want to look at some more detailed goal-based metrics for any transactions that are taking place on your site, for example looking at how many people added items to their basket and then didn't go through with the final stage of the transaction (so-called 'drop-out rate'). If you have particularly high drop-outs it may well be symptomatic of usability issues at the basket level.

> 'Web metrics are reported to the Head of Communications, Executive Management Group, and the Boards of Directors and Trustees. We also spend a fair amount of time looking at Twitter followers, Flickr views, Scribd reads and Facebook likes.'
> Tom Goskar,
> Wessex Archaeology, UK

Other metrics

Given that much of our focus is about the fact that your web presence is becoming much more devolved to third-party services and other networks, you should also do some tracking and analysis of what is going on in your wider presence. In Chapter 7 'The social web (Web 2.0)' we'll look at some of the more subtle qualitative things you can report on; here, we'll focus on the easier, quantitative measures.

Each of these services and networks do different things, obviously, but here are some suggestions as to what you might want to measure on some of the more common ones:

Twitter: Number of followers, number of tweets, number of re-tweets.

Flickr: Number of images, number of comments, number of favourites.

Facebook: Number of friends, number of 'likes'.

Mailing lists: Number of subscribers, number of new messages.

RSS feeds: Number of subscribers to any feeds you host.

There are some attempts to build dashboards and other means of measuring impact and metrics across sites like these. Normally these are paid services and it is unclear at this point in time whether they provide any useful information beyond that which you could fairly easily gather yourself.

As with many of the questions around metrics, compare with what your peers are doing – ask them what measures they find valuable and which techniques they're using to track over time.

Dissemination of KPIs

'We use Google Analytics and measure visits to the site but we also report on things like the number of Facebook friends and Twitter followers we have, or online RSVPs to our various events.'
Amanda Goodman, Department of Library and Information Studies, UNCG, USA

Effective dissemination of your KPI document will help you in your strategic goal of building awareness of web into the minds of senior and other stakeholders. Not only will regular circulation of web metrics help keep the online world in the hearts and minds of these people, if you do it effectively then you will also help educate these people as to what figures are important and why.

Once you've created your KPI document, take the following steps to help ensure that you use it to maximum impact:

Set up a KPI mailing group

If you haven't done it already, identify people in your organization who are likely receivers of your key performance indicators. These people should include your web strategy group, your web team and your senior managers. You should also include the people at the top of your organization: your director, Chief Executive Officer (CEO) and trustees. Set up an internal e-mail group for these people using Outlook or whatever your e-mail client is.

'We circulate our web metrics to Trustees and senior management. "Visits" is the metric we use most.'
Shakespeare Birthplace Trust, UK

Run an introductory session

Invite your KPI mailing group to an introductory session before you start sending out your monthly e-mailing. If at all possible, have a laptop with internet access and projector set up for this session. Show the group your analytics package of choice and talk them through some of the high level metrics that you can measure for them. Use this group proactively – ask them which metrics are most useful for them, and if possible work these into your KPI document.

Send out the KPIs

Put a repeating reminder in your calendar to send out website metrics monthly. Typically, you'd e-mail in the first few days of each month with stats reflecting the month just gone, so allow yourself enough time to compile and analyse your figures: for example, aim to send this e-mail on the fifth day of each month or thereabouts.

Send out a copy of your updated KPI document to the group with this e-mail. Make sure you include a high level commentary on the figures within this e-mail: bear in mind that senior staff may not even open the attachment! Your e-mail may look something like this:

> Website visits this month are up 12% on last month, from 32,329 to 36,208. The education section has seen strong performance, with 224 downloads of our spring booklet. Membership to our e-newsletter is up from 2309 to 2509, an increase of. . . .

Do what you can to analyse the figures – work with your web team if you see anything unusual: many pieces of web analytics software will highlight spikes or troughs.

You should also include some other snippets of information in your KPI mailing – for example, if you've had complimentary (or otherwise!) feedback from users or Twitter followers then include these. This kind of qualitative approach helps to build a sense of the impact that your web presence is having on real people.

Be proactive in dealing with queries

As you start to engage with your in-house community, you will find that people start to question why certain online activities have worked and why others haven't. Be proactive in answering these questions where you can. If you are asked things which you don't know the answer to, don't hesitate to ask the cultural heritage community: ask the question on a relevant mailing list, blog about it, e-mail some experts or send out a tweet (a post on social networking site, http://twitter.com) asking the question.

The changing face of metrics

It is worth noting that the art of web metrics measurement is very much a moving target. Not only is the way in which users interact with websites changing at a rapid rate, but the technologies are too. Here are some of the factors which make a big difference to these interactions:

- Technologies such as AJAX (Asynchronous JavaScript And XML)[7] are creating more fluid and user-centric experiences by not requiring the user to refresh the page as often. From a usability perspective, this is good, but it means that some of the more traditional metrics aren't as meaningful as they once were. If you consider some modern web applications (take for example webmail providers like Hotmail, Gmail and Yahoo!), many of the transactions between client and server happen all on one page. This makes measurements such as 'visits' or 'page views' very much less meaningful. You should make sure you understand which pages of your sites use this kind of approach and take this into account, or build tracking into the technology so that you can continue to measure meaningful activity.
- Off-site content delivered via widgets, RSS feeds and other mechanisms also skew how users interact with your site. If you provide a feed of your latest blog posts, people who read this content won't necessarily (in fact, normally don't!) click through to read them on your site. If you do have RSS on your site, you can use FeedBurner[8] to keep track of the number of subscriptions, click-throughs and so on.

- You should probably also factor in the reporting of mobile browsing (i.e. users viewing your site on a mobile phone). Mobile content delivery is growing at a huge rate and is changing how people interact with your site.

Summary

As we've seen in this chapter, although web metrics can at first glance appear fairly overwhelming in their scope and quantity, the trick is to filter as much as you possibly can early on in the process, possibly even before you look at the range of figures available. Make decisions about which figures are useful to you based on some solid, strategic grounding. Ask things like what 'success' looks like, how you'd like people to move through your site, and what you'd like them to do along the way – and then use your metrics to hone in on these factors. This way, you'll develop a series of measures which genuinely give you an insight into user activity – measures which you can then feed back into your strategy in a cycle of continuous improvement.

Now that we've looked at some of the quantitative measures of success, we'll turn our focus to an area of web content which is much more about the qualitative: the social web. Here, as we'll see in the next chapter, 'success' is often as much about building a dialogue and developing relationships as it is about measuring success in 'pure' traffic terms.

References

1 www.archimuse.com/mw2008/papers/chan-metrics/chan-metrics.html.
2 www.archimuse.com/mw2007/papers/peacock/peacock.html.
3 http://en.wikipedia.org/wiki/Geolocation_software.
4 www.kaushik.net/avinash/2007/08/standard-metrics-revisited-3-bounce-rate.html.
5 http://en.wikipedia.org/wiki/HTTP_cookie.
6 http://docs.google.com.
7 http://en.wikipedia.org/wiki/Ajax_(programming).
8 http://feedburner.com.

7 The social web (Web 2.0)

Introduction

Over the past few years, the web has been dominated by so-called *Web 2.0*. The phrase has now been either replaced by the term *social media* or accepted as simply being a core part of the web. The term is closely associated with Tim O'Reilly following an O'Reilly conference called 'Web 2.0' in 2004, although Wikipedia takes it back to as early as 1999:

> The term 'Web 2.0' was coined in 1999 by Darcy DiNucci. In her article, 'Fragmented Future,' DiNucci writes:
>
> The Web we know now, which loads into a browser window in essentially static screenfulls, is only an embryo of the Web to come. The first glimmerings of Web 2.0 are beginning to appear, and we are just starting to see how that embryo might develop. The Web will be understood not as screenfulls of text and graphics but as a transport mechanism, the ether through which interactivity happens. It will . . . appear on your computer screen . . . on your TV set . . . your car dashboard . . . your cell phone . . . hand-held game machines . . . maybe even your microwave oven. (http://en.wikipedia.org/wiki/Web_2.0)

Interestingly, many commentators, including Tim Berners-Lee, the 'inventor' of the web, have suggested that the phrase is meaningless (Sir Tim called it a 'piece of jargon'). His reasoning for this – and one shared by a fair number of people – is that what Web 2.0 represents is entirely

what the web does anyway, and certainly from Berners-Lee's point of view, exactly what he'd envisaged in the first place.

Furthermore, as with all new approaches, Web 2.0 was at the centre of a fair amount of hype and commercialization during the early part of the noughties. As the hype dies down, Web 2.0 – as with many approaches – becomes more 'invisible' as we become used to it, as we saw in our Hype Curve graph in Chapter 1 'Evaluating what you have now'.

One of the milestones of the social web was undoubtedly the launch of Facebook,[1] the social networking site. Facebook launched in 2004 but wasn't made available to the public until late 2006. Facebook quickly became a viral success and helped to define and popularize what 'social' meant to many people. As at time of writing in late 2010, much of the web is now 'social', and it becomes hard to remember a time when this wasn't an important part of our daily lives on the web.

Whether you believe all of the hype, use the phrase 'social web' or 'Web 2.0' to describe it, it is still very much worth spending some time looking in depth at what is represented by the 'social web' and how we, as cultural heritage organizations, can respond to the opportunities and challenges that this represents. The central tenet (we'll look at these in more detail in the proceeding sections) is one of collaboration and participation, and this is very different to what has gone before. It also, as we will see, offers up some interesting – and sometimes quite difficult – questions to institutions such as ours.

What is 'the social web'?

Let's first of all try to articulate what we mean by 'the social web' or Web 2.0. Wikipedia gives us this:

> The term 'Web 2.0' is commonly associated with web applications that facilitate interactive information sharing, interoperability, user-centered design, and collaboration on the World Wide Web.
>
> http://en.wikipedia.org/wiki/Web_2.0

This point – that the web is being used as a collaborative or participative space – is probably the most important one. Users – who in a non-Web

2.0 environment were consumers of content – are, in the Web 2.0 world, now also producers. This is neatly encapsulated in the portmanteau 'prosumer': a two- or three-way dialogue where users are contributing back to websites or engaging with each other rather than being passive consumers who simply read what is on the page. The stuff that is produced by end-users in this environment is commonly called User Generated Content or just UGC.

The participatory aspect of Web 2.0 is easily the most important one and we'll devote most of this chapter to looking at what this means to cultural heritage institutions.

Here are some ideas which are often associated with Web 2.0. Some are taken from an early (2005) O'Reilly definition of 'Web 2.0' (http://oreilly.com/web2/archive/what-is-web-20.html):

Idea 1: Users are 'prosumers', not consumers

The idea that web users aren't just passive readers of content but rather active participants in the creation of that content is possibly the most important principle, and the one which has had a profound effect in the shaping of the past five to ten years of internet history as well as the shaping of the services which make up that history.

For cultural heritage institutions, this is of particular importance: as we'll see later, it challenges long-held notions of 'institution as authority'.

Idea 2: User focus

Without a doubt, Web 2.0 – certainly when it first gained traction – also took a number of interface approaches which could be considered hallmarks. The 'forever beta' token, rounded edges, large text all became incredibly common as the social web first blossomed.

More importantly, Web 2.0 heralded in a new era of usability, or of being more 'user-centred'. This was partly because of the interface design – friendly, big, usable, colourful – but also because the content was becoming more social. As the users became more sociable, so companies started to express themselves to their users in ways which were much more personal, too. Here, for example, is the page you get on Wordpress

(providers of blogging software) when their site has a bug: 'Goshdarnit! Something has gone wrong with our servers. It's probably Matt's fault. We've been notified of the problem. Hopefully this should be fixed ASAP, so kindly reload in a minute and things should be back to normal.' And this from the flickr.com Terms of Service: 'Don't be creepy. You know the guy. Don't be that guy.' (www.flickr.com/guidelines.gne)

Idea 3: Collective intelligence

The notion of the *collective intelligence of the crowd* – another Web 2.0 indicator – was effectively summed up in a catchphrase – 'We is greater then me' – and a book by Clay Shirky (2008), *Here Comes Everybody: the power of organizing without organizations.*

The principle is simple: the combined intelligence of the nodes of a network is incredibly high. Tapping into this intelligence becomes increasingly important. For cultural heritage organizations, this might mean, for example, that user expertise is brought on board to help curators develop a sense of a wider social history, or by getting users to help tag images or objects.

Idea 4: Web as platform

With the growth of fast data transfer and powerful in-browser capability such as the new generation of JavaScript, web applications ('apps') become much more like their desktop counterparts. We can now effectively log on to a web server and edit pictures, read e-mail or compose documents much as if we were using desktop software.

Behind this much more 'platform'-oriented focus is often an approach called *AJAX* which is also tied fairly intimately to the Web 2.0 approach. AJAX (Asynchronous JavaScript And XML) is a technological approach (usually using JavaScript) which allows calls from the web server to the browser without requiring a page refresh. From a user perspective, an AJAX approach makes the experience very much slicker and faster. By removing the need for visible return trips to the server, the software appears much more responsive to the end-user, again helping make the web and desktop experiences more similar.

Behind the scenes, these approaches often also have an API: a programmatic way of allowing data exchange between applications or parts of applications. The existence of an API rapidly became a Web 2.0 hallmark, too. To a certain extent, the software running behind the scenes has become sociable and collaborative, too! We'll look at APIs and other approaches in Chapter 9 'Away from the browser'.

Idea 5: Open and distributed

Alongside more open dialogue as delivered by community and 'prosumer'-based approaches to content, openness has become a cornerstone of Web 2.0 in terms of data access as well. A typical Web 2.0 application has an underlying API which allows anyone to draw data from that application. Typical examples include Flickr, Twitter and Google: all have powerful APIs upon which many hundreds of third-party applications have been built.

Following from a wider distribution of Open Data, one of the key changes in the landscape has been towards a more *distributed* internet, where sites provide a more *platform-like* approach than a *single-site* approach. Sites are no longer considered in isolation but instead as being part of a wider, more distributed series of content experiences. More on this later.

Why social media?

So then why should cultural heritage organizations engage in social media?

One very powerful reason is that this engagement is about the social placing of your institution and the friendliness of your approach and tone of voice. Increasingly, companies and institutions are seeing the value of being less 'stuffy' and formal. By engaging more closely with the people who are your users, you are much more likely to be able to engage in a dialogue with those

'We have a presence on Flickr, Twitter and Facebook. So far we have had limited interaction with social networking sites, however we ran a live-streamed event in November 2010 at which we believe these sites contributed to our traffic a fair amount. We also find more traditional avenues like ListServ (http://en.wikipedia.org/wiki/LISTSERV) are effective at driving traffic to our site.'
Amanda Goodman, Department of Library and Information Studies, UNCG, USA

users and have an honest conversation about what works and what doesn't.

Here are some more suggestions (in no particular order) taken from a range of workshops, surveys and interviews with cultural heritage professionals:

Different audiences

Many cultural heritage organizations are looking to engage with new – often younger – audiences. Social media provides organizations with this opportunity. Although demographics vary between the common social networks, it is true to say that the common ones – Facebook, Twitter, Flickr – have a demographic that is skewed to a younger group.

The social media audience doesn't *have* to be a younger one in order to be of interest to you, of course. The fact that it is typically *different* is enough for many institutions to be interested in these particular channels.

Feedback

One of the definers of social media is the fact that the communication becomes multidirectional. No longer is your institution pushing information at users who passively read and follow along: now the users have a voice, not only to engage with you but also with each other.

This kind of engagement obviously lends itself very well to feedback: once you have opened a channel with your users you can listen to their thoughts, fears, frustrations and congratulations about the service that you offer. Furthermore, and as many institutions are beginning to find, the enormous network of users interacting with your content can often be used to find out more about your content and collections; information which a savvy organization will feed back to curatorial staff to filter appropriately.

Social media as 'web entry point'

Although search dominates as the main entry point to the web for many people, the vast quantity of material available means that many look

closer to home when seeking recommendations for how to filter this content.

Kevin Kelly, in his wonderful article *The Bottom is Not Enough* sums this tension between the quantity of content available to us (the 'bottom-up') and our need to filter via editorial authorities (the 'top-down') like this:

> Here's how I sum it up: The bottom-up hive mind will always take us much further than even seems possible. It keeps surprising us in this regard. Given enough time, dumb things can be smarter than we think.
>
> At that same time, the bottom-up hive mind will never take us to our end goal. We are too impatient. So we add design and top down control to get where we want to go.[2]

The editorial authority in the case of social media is our friends and colleagues. Social media leverages the age-old truism that personal recommendation is key to how we respond to content and products that have been presented to us. If a friend 'likes' a gallery or museum on Facebook, we are much more likely to follow their recommendation than frequent the place because we have seen a direct advertisement.

Immediate, active participation

Tools like Facebook and Twitter enable us to engage rapidly with our audiences: the conversations can happen (provided there is resource available!) in real-time or near real-time. There are some risks associated with this of course (see section 'Risks and mitigation'), and a certain amount of expectation management is required when you interface with your users, but nonetheless the rapidity of these channels is an important consideration.

Perception-changing

Engaging proactively with social media gives the impression (hopefully not a false one!) that an institution is interested in its users and able to take part in an open and friendly ongoing conversation with them. Traditionally, museums, archives and libraries are sometimes seen as being

slightly stuffy, conservative and boring, particularly by younger audiences. Social media can help to break down these perceptions.

Rapid, cheap marketing

Although social media isn't best seen as a pure marketing tool, it is undeniably true that a powerful aspect of these tools is the ability for *viral marketing* – a rapid spreading of news, ideas and information through the network of users. If a single user updates their social stream with a reference to your organization, a percentage of their followers then republish this reference, and a percentage of *their* followers do the same – and so on; the possibility of reaching a large audience with minimal effort is very clear.

> 'We have Facebook, Flickr, Twitter and YouTube accounts – we find that creating engaged communities is a powerful way of driving traffic to our sites.'
> Shakespeare Birthplace Trust, UK

Social media is where the audience is

Here are the top ten sites worldwide from demographics company Alexa, who compile web visitor figures (data for September 2010):

1 Google
2 *Facebook*
3 *YouTube*
4 Yahoo!
5 Windows Live
6 Baidu.com (Chinese language search engine)
7 *Wikipedia*
8 *Twitter*
9 *QQ.COM* (Chinese social portal and Instant Messaging client)
10 MSN[3]

The five sites in italics above are primarily social media sites (they revolve around social interaction or have socially produced content at their heart). The other five all, arguably, also have strong social media elements in their makeup.

Let's have a look at another set of figures, this time for the UK Office of Communications (Ofcom) report on Communications Market 2010 (August) (see: www.ofcom.org.uk/static/cmr-10/UKCM-4.4.html).

Here is part of the Ofcom commentary on this statistic:

> Social networking now accounts for a quarter of all time spent online. . . . Perhaps an even more significant indicator of the growth of social networking is the increase in the proportion of total internet time that it accounts for. Figure 4.4 shows that in April 2007 social networking and blogs accounted for 9% of UK users' total internet time, according to audience data from UKOM/Nielsen. By April 2010, this had risen to 23%.

The interesting thing about this particular stat is the level of engagement which comes with social media. During August 2010, media commentators became particularly excited about the fact that time spent on Facebook – for the first time ever – exceeded the time spent on Google.[4] This is hardly surprising when you consider that Google – as a search engine – exists to pass users to third-party sites as quickly as possible, but nonetheless it makes an important point about how long people are spending on social media.

This is important as far as our institutions are concerned because however successful our own online real-estate is, the vast bulk of audience is always going to be somewhere else. The nature of social media makes this very much less depressing than it first appears: we can capitalize on these sites by having a presence on them and by engaging with the users *who are already there*. This is in part why we keep stressing the idea of a web presence rather than a website!

Choosing when (and when not) to use social media

One of the biggest challenges you will come across when it comes to social media is choosing when it is relevant, or identifying instead when a 'plain old' web page will do just fine.

As with any technology, gratuitous use is often worse than no use at all; the problem with many forms of social media is that they are fairly visible in both success and failure: an empty forum or blog that is never

commented upon looks worse than a standard, static web page!

It goes without saying that social media is like any approach you take on the web and elsewhere: it has a time and a place and isn't always relevant or necessary. As with any burgeoning technology, there was – and still is – a danger that it is done simply because it can be. As the hype around social media reached a peak, many funders started to add a social requirement to their bids; this was great in terms of the social aspect of the web being acknowledged, but a measured approach to applying these techniques was not always adopted.

In some scenarios and contexts, a more traditional approach – more formal and static pages for example – is absolutely what is required. Adding the ability for users to comment on these pages is gratuitous. On the other hand, social media has added a huge amount of value to many of our institutions' web presences.

So how do you go about choosing your social media approaches? The answer to this will lie partially in the general direction the rest of your strategy takes. If key themes in your strategy are – for example – about engaging more closely with your users, or finding new audiences, then social media approaches will fit closely and easily with your strategy. If your strategic aim is purely to get more people to perform X function on your website or to buy Y product, then social media is arguably *less* fundamental. Having said this, the benefits of working more closely with your audience in a collaborative way in *any* context are so widely recognized that it is almost always worth considering.

The second part of the equation is about building your own personal experience with social media tools. Knowing this environment inside out is the best way of spotting when a social media approach is likely to be successful.

Developing a social media strategy

As with everything in this book, social media is at its most effective when it is placed within a wider, strategic context. Taking the decision to engage with social media is a big decision: to do it properly requires thought, resource and understanding:

Several other [not for profits] are dabbling in social media – often because
a younger staff member 'gets it' and takes the initiative to start a blog or
set up a Facebook page – but don't have a plan for coordinating or
integrating their efforts. This is almost as bad as not using social media at
all, because it means they are missing out on the powerful cross-pollination
that occurs when you employ a strategic suite of social media tools.[5]

For some organizations, their social media strategy is a big and important
enough constituent of their general web strategy that it almost *becomes*
their web strategy. For others, social media is only a minor part of a wider
approach. You need to decide in the light of your own organizational
strategy exactly what role social media should play.

One of the interesting tensions with social media tools is that they are
almost all free to implement in capital terms and also usually incredibly
easy to set up; however, this ease and lack of cost belies the fact that all
social media come with resource and effort costs.

In simpler terms: social media is not a golden bullet which will get
your organization something (marketing, Public Relations [PR], instant
visitors) for free. It does, however, with carefully placed resource
investment, have the opportunity to provide a huge return on this
investment if you are prepared to put in the effort.

A five-step social media approach

Approaching social media in a measured and informed way will not only
help you to mesh it in to your strategy, but will also help you deliver
relevant, timely and joined-up content which best leverages social
approaches.

There are many suggested approaches to how to do this – a web search
will uncover lots of possible ways of developing a social media strategy.
Here is one possible 'five-step' approach which I have developed over a
decade of working with museums and various other cultural heritage
organizations.

Listen and learn

This first step is arguably the most important one of all. Before you begin to get involved with the conversation, listen to that conversation first. Think about this much as you would if you were approaching a circle of people talking at a party: engagement comes from a slow, empathetic approach (spending some time listening to what other people have to say before providing your own thoughts) rather than a fast, aggressive one (barging drunkenly into the middle of the circle and shouting!).

The great thing about the web, and social media in particular, is that these conversations are of course going on in public: you can spend as much time as you need lurking on the edges before beginning to take part. Bear in mind that this 'lurking' activity is what most people are doing anyway: even though it is old in web terms (2006, with a 2009 update), the seminal post by usability guru Jakob Nielsen describes the now-famous '90-9-1 rule' thus:

> In most online communities, 90% of users are lurkers who never contribute, 9% of users contribute a little, and 1% of users account for almost all the action. . . .
>
> All large-scale, multi-user communities and online social networks that rely on users to contribute content or build services share one property: most users don't participate very much. Often, they simply lurk in the background.
>
> In contrast, a tiny minority of users usually accounts for a disproportionately large amount of the content and other system activity. This phenomenon of participation inequality was first studied in depth by Will Hill in the early '90s, when he worked down the hall from me at Bell Communications Research.[6]

As you spend time getting to know your potential communities by lurking, notice the following things:

- What approaches are particularly successful at getting users to contribute? Notice the particular traits of these approaches. You'll probably find that they all have some things in common, for example personality, reciprocation and interesting content. Try to

see how these traits could fit with your content and strategy; begin
to build scenarios on paper which you think could work for you.

- Who is involved in these transactions: is it the users who start the
 conversation, or the institution?
- What is the role of the institution in the conversation – is it acting
 as an arbiter, a source of information, a collaborator?
- When do the interactions take place? Can you spot trends: are there
 times when some of the community is more involved than others,
 or when the conversation waxes or wanes?
- What doesn't work? Look for scenarios where the conversation isn't
 going smoothly, either because users aren't interested (there isn't a
 conversation) or where there is animosity. Find scenarios where the
 user isn't happy – for example, if they've had a bad time at an
 exhibition or feel that they've been charged too much for entry to a
 gallery. In these scenarios, watch how the institution reacts, and in
 turn see how users respond.
- Are there any groups and sub-groups which begin to form? Do
 these coalesce naturally or would they be more likely to come
 together if you prompted them in some way?
- Which particular channels are being used? Are organizations using
 one channel for one type of conversation and another for another,
 or do they duplicate across channels? What works?

Once you've begun to get to know how the various communities hang
together, go back and visit them over a period of time. Choose some of
the more dynamic channels – or the ones that fit your strategy more
fully – and revisit these on a regular basis. You may also want to put in
some social media monitoring, for example some Google Alerts (see
Chapter 3 'Content') or Twitter searches for specific keywords. The
important thing about revisiting communities like this is that you should
also get to know them over time: notice who joins the group, who leaves
and how the conversation changes.

Begin to get involved

Once you've lurked in the background and spent some time listening in

on the conversations, start to gently get involved. The 'circle of people at the party' analogy continues to hold true: take it slowly – be aware of how people are reacting to you and what you say. This is more like a dinner party than a student one!

Define your audience

Once you're at a stage where you're beginning to get involved in the conversations and communities that interest you, you fairly quickly need to define who exactly your audiences are.

Some – perhaps surprising – statistics exist around the age demographics of social media sites. A piece of analysis[7] from monitoring company Pingdom on the average ages of US users gives us the following highlights:

- The average social network user is 37 years old.
- LinkedIn, with its business focus, has a predictably high average user age: 44.
- The average Twitter user is 39 years old.
- The average Facebook user is 38 years old.
- The average MySpace user is 31 years old.
- Bebo has by far the youngest users . . . with an average age of 28.

'We looked at the demographics on Facebook and others. We didn't have a target but found 66% were female, mostly aged 25–36 – which is interesting as it's a good target for us, one we find hard to reach in person.'
Shakespeare Birthplace Trust, UK

Work with your peers and your metrics to determine which of the various channels available to you best fit your social media approach – and of course, your wider strategy.

Plan

Many people working on the web today suggest that your social media plan is a subsection of your web strategy, or even replaces it altogether. For the purposes of clarity, we'll consider them separately but it goes without saying that they are very much supporting, entwined approaches.

Determine some outcomes

The central part of your social media plan should be about determining some outcomes for the interaction you want to have with your audiences. This in turn is of course influenced very strongly by your particular strategy.

As with other web metrics, it is easy to become obsessed with quantitative measures of success. Seeing a similar organization to yours with thousands more Twitter or Facebook followers is always going to be galling and the natural tendency is to chase these figures for yourself. It is also likely that your CEO or senior managers will be looking at these quantitative measures too, and asking you to come up with strategies to increase followers.

While follower numbers are always going to be considered important, it is equally (if not more) relevant to look at the more difficult to measure aspects of social media measurement.

Ask, for example:

- Do we want to have more *meaningful* interactions with our community? What does *meaningful* mean in our context, and how might we go about identifying this?
- Do we want to *nurture* our community and keep it niche, small and closely connected or do we want to grow it and accept that the bonds between members and our organization are almost definitely going to weaken because of this growth?
- Are we looking to obtain information *from* our community? Do they exist so that we can find out more about our collections, our institution or our way of interacting with them?

You will probably find that the outcomes you come up with will adapt over time and also with the channels that you use to engage, but you should from the very start use these outcomes to measure whether you are being successful in your endeavours.

Work out resource and budget limitations

Once you have a particular audience and some outcomes mapped out, you should start to think about what you have available to you in people and budget terms.

Social media takes time, and to do it well requires a consistent approach over a period of time. As we saw earlier, the ease with which you can set up a Twitter or Facebook account belies the time investment required to really make these work for your institution. Setting it up is one thing: getting and maintaining an engaged audience is something else.

Develop an editorial calendar

Once you've determined your outcomes and the amount of resource available to you to do social media, put a regular slot in a calendar to actually do the work. This can be either your main calendar or a shared one if you have other members of staff who will be developing content. Create recurring appointments for the activities which you have decided to carry out: you should have some time put aside for writing, some for reading, and the remaining time for monitoring and responding. The split and time spent on these activities will obviously vary according to which channels you are choosing to engage with and your outcomes.

It helps to have these appointments in your main calendar, mainly because it should (in theory. . .) prevent other members of staff booking you up for anything else during these times. Be strong about doing social media in these times – commit to it – but also be strong about finishing on time, too. On the other hand, don't let your calendar totally define your timings: be flexible enough that if you have a pressing or contentious matter to deal with, such as a difficult comment to reply to, you can take the time to do this. If you make a note of when such occurrences typically happen, over time your plan can be begin to be informed by them.

Engage and refine

Once you've determined your audience, got to know the environment and spent some time planning your timing and resource, it is time to get started!

The best advice for getting started is to start small, and start with content which is engaging. Determining what is engaging will be a much

easier task if you know the environment and how people use it: hence the advice to immerse yourself where possible.

One of the best ways of getting started with social media in cultural heritage organizations is to begin with knowing how much time you have available to you and fit whatever social media you can do into this time. The benefit with this approach is that you can start small and begin to grow outwards from there. If you find that your approach is working and that you need to expand your social media outreach, then you can do so in the future once you understand better what works and how long it takes.

In time you can turn this slightly 'cart before horse' approach around so that your resource begins to fit the social media you want to do – a more strategic angle – but at the beginning it is unrealistic to expect there to be enough resource available to do this.

In the first instance, put aside whatever time you can – even if it is just an hour a week – and plan for your activity to fit into this time.

Nina Simon, in her excellent blog on participatory online experiences has an excellent post entitled *How Much Time Does Web 2.0 Take?*;[8] here are some of her ideas, adapted slightly:

If you have 1 or 2 hours available to you each week:

Limit your planning to commenting on third-party content.

Use the various monitoring tools discussed elsewhere in this book to keep an eye on what people are saying about your institution:

- Look for blog articles written about your museum, gallery or archive. Your plan should allow enough time to respond to as many of these as you can.
- Search for pictures on the well known photo sharing sites such as Flickr: again, comment where relevant.
- Do the same searching for videos on YouTube. Use your time to build awareness but also for commenting where appropriate.

If you have 2 to 5 hours available to you each week:

Plan to maintain some of the 'easy win' social media channels.

- Set up a Twitter account and plan to use this time to follow, monitor and respond to any queries which come through this channel.
- Set up a Facebook page and plan to use the time to add new followers, comment on relevant updates of others and maintain content such as event and exhibition information.

If you have 5 to 10 hours available to you each week:

Become a content provider.

- Set up a blog, and plan to update it at least once, possibly twice, a week.
- In your plan, allow time to promote this blog, using some of the channels identified above such as Twitter and Facebook.
- Allow time to respond to comments, research and link to other blog articles. Factor in time to comment on other blogs, too, as this will build interlinking and awareness of your own.

If you have more than 10 hours available to you each week:

Develop community platforms.

- Set up a community on your own website: commission others to write content for your site and build personalized, social experiences around this content.
- Put together more ambitious programmes of social media activity, for example by including some offline meet-ups, mini-conferences and/or workshops.

However long you have: factor in enough time to read!

In your planning, you should factor in sufficient time to continue the

first of our steps identified above: listening and learning. To take part in social media with any authenticity, you have to be on the receiving end as well as on the institutional end – make sure you spend as much time reading other people's blogs, Twitter feeds and Facebook updates as you do generating your own. This will ensure that you remain on top of the topics of conversation as well as the techniques and technologies being used.

Measure

If you find that you are consistently taking longer to write blog posts or to respond to comments than you had originally planned, adjust your timing accordingly. After a few weeks of this you may find that you've taken on too much; in which case, sit down and reassess your priorities and remap your timing.

You may find – and this is often the case – that some elements of social media take longer than you expect and others far less time. Try noting down the amount of time you spend on any one activity and compare it with your expectation: this will help you to be more realistic the next time you need to do any social media planning. Also – of course – try to identify which of the approaches give you the most 'bang for buck' in terms of your strategy and then focus your attention most closely on these.

Rinse and repeat!

Even when you become more confident at engaging with social media, keep coming back to the five-step approach (or something similar to it), always listening to your audiences, lurking in new communities and constantly reassessing your audiences. Develop as you go, and feed back into your strategy group, using social media to help inform which direction you should be taking your organization online.

Social media channels

The participative environment can take many forms and the nature of

the interaction is incredibly varied too. It is therefore impossible to provide a complete view of the kinds of tools and channels available. One of the important things about social media is to not be afraid to try different things: if something works, build on it. If it doesn't, stop doing it and move on. 'Fail quickly' is the maxim to live by when it comes to social media!

Let's have a quick look at some of the best known channels in which social media interaction is core, together with a few cultural heritage examples of each. Further examples can be found on the accompanying website at: http://heritageweb.co.uk/book/ch7/social-media.

Blogging

By now, almost everyone is aware of blogging. The phrase originally came from the words 'web log'. Wikipedia describes blogging as follows:

> Blogs are usually maintained by an individual with regular entries of commentary, descriptions of events, or other material such as graphics or video. Entries are commonly displayed in reverse-chronological order.
> . . .Most blogs are interactive, allowing visitors to leave comments and even message each other via widgets on the blogs and it is this interactivity that distinguishes them from other static websites.[9]

Over time, the use of blogs has extended: whereas originally blogging was often about individuals writing a personal online diary, now blogs have been taken up and are being widely used by institutions, corporations, individuals and charities, among many others – and museums, libraries and archives have been fairly active in seeing the benefits of blogging too.

Blog traits

The line between a blog and a website is sometimes blurred. To make matters more complicated, some blogging software – particularly Wordpress[10] is used by many as a Content Management System for whole sites (not just blogs). In the same way, as blogs become more a part of

the daily activity of many institutions, so their presence online becomes more entwined with 'the main site'.

Having said that, there are a few traits which blogs tend to have which can set them aside from 'normal' web pages:

Rapid – usually, blogging is about producing content that changes and can be updated more quickly than other content. This speed is made possible in part by the fact that blogging software is usually *lightweight* – simple, and focused on usability and users – but also because blogged content often has a tendency to be time-specific in some way (e.g. when watching a TV programme at a certain time).

Time-stamped – typically, blogs show the most recent posts first – either as a home page feature or listed with the most recent at the top. Entries are usually dated, tagged and categorized so that the user can scroll back through the archive, looking at similar or earlier posts.

Personal – arguably (although there are some exceptions), blogs are often focused on a personal voice or voices. The content tends to be more opinionated and less institutional than the copy written for 'normal' web pages. Usually, posts are tagged with the name of the author: very often the content is written in the first person – '*I* . . .'.

Two-way – almost all blogs allow users to comment on posts, usually with an initial moderation period for the first comment but then freely after that. Comments not only allow people reading the blog to interact with the blog author but also with each other.

Feeds – blogs usually have RSS feeds which allow users to 'subscribe' to the blog using feed-reading software. This means they don't have to come back to the blog in order to read it: their feed reader shows any new content when it is published.

Content

Blogging from within an institution can take any number of forms. Some of the most compelling approaches are those where the staff are blogging 'from behind the scenes', talking about the little known processes that go on daily. Here are a few ideas:

- a curator blogging about objects that are hidden away in-store – highlighting why these are not out on display
- staff talking about why they make certain decisions about the requisition or repair of objects
- the web team discussing their latest decisions about which tools they are using, or even their approaches to social media
- the CEO/Director writing about how they are driving innovation and strategic thinking in the organization
- the educational team writing about the workshop techniques they are using
- a gallery team writing about how they choose objects for an exhibition, how they position objects, how labels are written and so on (which could be illustrated with photographs)
- staff around the organization interviewed on what they do, how they do it and what their day is like (particularly compelling if the same five questions are asked each time – with one rather off-the-wall question included!)
- a blog from the point of view of an object or book, talking about the life it has lived since its creation or publication; and ultimately how it came to be at a museum or archive.

These ideas are only scratching the surface – really, the world is your oyster: the more imaginative your approach, the more likely you are to find a way of writing which strikes a chord with your users.

Examples in cultural heritage

Blogging has taken off across cultural heritage in a fairly big way: there are lots of great examples of original and interesting content being produced. Here are just a few:

Brooklyn Museum

Brooklyn Museum in the USA engages widely with social media and has a rapid and innovative approach to many of the social media channels we are considering here. Brooklyn Museum bloggers write about a huge

range of different things, from improvements to their website to interviews with artists to guest posts from museum volunteers. Find the Brooklyn Museum blog at: www.brooklynmuseum.org/community/blogosphere/bloggers.

The National Archives

The US National Archives have a number of blogs which cover a range of topics. The Archivist of the United States, for example, writes a blog with posts which cover topics ranging from archive policy to historical audio interviews with Alcatraz prisoners.[11] Other blogs by the Archive are pitched specifically at educational and other audiences. See the full list at: www.archives.gov/social-media.

Talis

Although not a cultural heritage organization, Talis works closely with libraries in the UK and Ireland – providing management systems, for instance – and maintains a number of blogs looking at trends in data storage and dissemination as well as recent conferences and events. See http://blogs.talis.com/panlibus as an example.

Exploratorium Explainers

At http://explainers.wordpress.com, staff write about their experiences working at San Francisco Exploratorium in the USA. In their words:

> All too often, we spend the better part of our work days scattered throughout this big black box, and each of us has experiences, interactions, thoughts, and sees things that no one else will. This blog originated from a desire to share all that, from the mundane, to the funny, to the grandiose, and in the meantime provide a slice into life at the Exploratorium.

You can find some other examples of interesting cultural heritage (and other) blogs on the accompanying website at: http://heritageweb. co.uk/book/ch7/blogging.

Twitter

Twitter is a so-called 'micro-blogging' service – it allows users to post short and rapid-fire updates of 140 characters. Here is technology author Steven Johnson describing the basic mechanics of how it works:

> As a social network, Twitter revolves around the principle of followers. When you choose to follow another Twitter user, that user's tweets appear in reverse chronological order on your main Twitter page. If you follow 20 people, you'll see a mix of tweets scrolling down the page: breakfast-cereal updates, interesting new links, music recommendations, even musings on the future of education.[12]

The value and power of Twitter is near-impossible to communicate unless one has spent some time immersed in it: only then does it begin to become clear how it can help brands, institutions and individuals communicate, discuss and promote in a completely new and very powerful way.

At the heart of this power is the personal engagement that Twitter enables: it is this, of course, which lies at the heart of the social web. Used properly, Twitter enables institutions like ours to directly relate to and converse with real users about things that they care about.

Twitter – as of June 2010 – has around 190 million users sending out 65 million tweets a day, according to their CEO, and as reported in a recent post by TechCrunch.[13]

The growth of the micro-blogging platform has been fairly astonishing, not least of all because it has heralded in an entirely new paradigm of always-on, near-instant content delivery. It seems likely – at least at the time of writing – that Twitter isn't merely a fad but a new communication platform which museums, libraries and archives can use to communicate with their users in powerful and meaningful new ways.

With the volume of users now using the Twitter platform, it has also become a key player in traffic driving, particularly if a particular tweet has a *viral* element to it: Twitter enables messages and links to be spread at a vast rate due to the network effect (the inherent value of the network to each of the nodes on that network) it encourages; one institution's tweet might be read by, say, 5000 people: if 10% of these people *re-tweet*

the message then each of those tweets may reach another X people, of whom another percentage might re-tweet again, and so on.

Another vital thing to note about Twitter is that it is widely used to pass links around this vast community: links to blog posts, news articles, images, videos and so on. It can thus be an incredibly effective way of pushing content out to large numbers of users.

> Because it is so effective at pushing users to content elsewhere on the web, Twitter is often a primary referrer to your blog and other sites. Have a look at your blog and site metrics if you start using Twitter, and see if this holds true for you too

Using Twitter effectively

One of the key things to using Twitter effectively in an institutional context is to keep the personal nature of the medium and not allow it to become just yet another direct marketing channel. This is not to say that Twitter isn't an effective tool for telling people about the things that are going on at your institution, but it has much more power when used as a tool for conversation rather than as a tool for broadcast.

To this end, it is essential that – as with any form of social media approach – you have the resource and means to maintain this conversation on an ongoing basis. If you don't have the people or the time to do this, consider very seriously whether you want to use Twitter at all.

Examples in cultural heritage

There are many great examples of cultural heritage organizations using Twitter in interesting, effective ways. Many organizations are posting straightforward news-like updates about opening times, new exhibitions and so on, and more importantly responding to comments and criticism from their followers.

There are some other fascinating and original examples from a cultural context, for example http://twitter.com/samuelpepys (and the accompanying blog at www.pepysdiary.com) where the tweets and posts are written as if from the 17th-century diarist. Another great original example is London's Tower Bridge, which has an automated Twitter account which posts each time the bridge is opened: http://twitter.com/towerbridge.

Facebook

Facebook – the world's largest and best known social network – boasts more than 500 million users[14] and accounts for a huge amount of web traffic. According to Hitwise figures from November 2010, the site accounts for one in four page views in the USA.[15] As we can see from these kinds of figures, the popularity of Facebook makes it an interesting proposition for institutional use.

Facebook revolves around networks of friendships: users create a personal profile, add their friends and contacts, and can then interact with them by posting messages, images and other material onto the site.

One of the key Facebook concepts is the so-called *wall*, which is described by Wikipedia thus:

> The Wall is a space on each user's profile page that allows friends to post messages for the user to see while displaying the time and date the message was written. One user's Wall is visible to anyone with the ability to see his or her full profile, and different users' Wall posts show up in an individual's News Feed.[16]

The wall provides users with a constant stream of updates from their friendship network, and is thus an effective way of moving users around the site.

One of the most interesting facts about Facebook is that *30 billion pieces of information are shared each month.*[17] This includes pictures, status updates, events and links. This is the main social element of Facebook and because it is driven by users who are part of trust networks, these updates have much more currency than they would 'out there' on the wider web. The network effect – as mentioned above – is guaranteed because of both the size and the interconnectedness of that network.[18]

For organizations, one of the pivotal parts of Facebook is *Facebook Pages*[19] which allow you to set up an organizational rather than personal profile. Pages can be used to display things like visiting information, events, comments, reviews and photos. In interaction terms, institutional Pages act much like individual profiles – content can be favourited, commented upon and so on.

As well as Pages, there are also *Facebook Groups*. The difference between Groups and Pages is a source of some confusion – they have an

overlapping feature set. Groups, however, tend to be more about the discussion of ideas or topics.

Facebook apps

Facebook *apps* are discrete pieces of functionality – applications – which can be embedded within the Facebook ecosystem. Some apps revolve around gameplay, others provide specific functionality for use on your Pages or profile. There is, for example, a Flickr app,[20] which can be used to pull in your Flickr photos as a tab within your Facebook Pages, and one called ArtShare,[21] which displays works of art from a number of museums worldwide.

Facebook beyond Facebook

Facebook has started to extend itself beyond the walls of facebook.com with the implementations of 'like' buttons, Facebook authentication and widgets:

Like buttons enable any website owner to embed a simple piece of code which, when clicked on, passes an 'x person liked this' status update back to Facebook. See: http://developers.facebook.com/docs/reference/plugins/like.

Facebook authentication allows users to login to your site using their existing Facebook username and password. See: http://developers.facebook.com/docs/authentication.

Various widgets are available which can be embedded on your site to drive more traffic and engaged users. See: www.facebook.com/badges.

Flickr

Flickr is a social photo-sharing site which allows users to upload and tag pictures, follow friends and comment on other people's pictures. As of September 2010, they reported that they had passed 5 billion picture uploads[22] – an incredible 3000 image uploads every minute.

Flickr is particularly important for cultural heritage organizations that have rich image and/or object collections and are looking to get more exposure to these. The site provides a rich API,[23] which means that you can upload images and then use them in your own sites and services, thereby providing multiple routes for users to engage with your content.

Flickr Commons is of particular interest to cultural heritage; it is a special approach which allows organizations to set up a partnership with Flickr for images in their collections:

> The key goals of The Commons on Flickr are to firstly show you hidden treasures in the world's public photography archives, and secondly to show how your input and knowledge can help make these collections even richer.
>
> You're invited to help describe the photographs you discover in The Commons on Flickr, either by adding tags or leaving comments.[24]

The important thing to note here is that organizations can leverage the power of the social graph to get more information about objects that are in their collections. As George Oates, senior programme manager at Flickr, explained: 'The Library of Congress has updated 176 records in the Prints & Photographs catalog, "based on information provided by the Flickr Commons project, 2008", with more to come.'[25]

The challenges of the social web

For cultural heritage organizations, 'web2.0-ness' offers some fundamental – and sometimes quite difficult – challenges. The very nature of prosumerism, of distribution, of openness – means a lack of control. This may be the future, but it is not necessarily a wholly comfortable future when it comes to long-held notions of authority, copyright and intellectual property; it fundamentally repositions institutions as being part of a democratic conversation online, rather than as a pure source of authority.

Although the tension that this creates is lessening over time as more successful cultural heritage examples appear, it is still a tension that exists in many institutions.

Risks and mitigation

Working with social media is at first glance inherently risky. Fundamentally, most social media activities are about individuals having a *voice*, either on your site or elsewhere. The opinions that are given by these individuals are useful, interesting and engaging but – as with anything in life – will never be 100% positive. Social media encourages conversation about your organization and content – it moves the *centre of control* away from the organization and towards your users. These may be people who likely have no formal curatorial or authoring skills, but may have strong opinions about what you do!

As with a face-to-face conversation, social media is about engaging with people when the conversation is rough as well as when it is smooth. It is therefore useful to have strategies for dealing with negative user-generated content, and a good idea of what risks are associated with social media, and the corresponding mitigations of these.

Some common examples of risks and how they could be dealt with are given in Table 7.1 on the next page – although this is by no means a complete list, and you should look to develop your own.

As you may well know already from your own experiences, social media often isn't easy to implement when you work within local authority organizations who are often resistant to these new approaches.

Rick Lawrence, Digital Media Officer at the Royal Albert Memorial Museum and Art Gallery in Exeter, UK, writes about his experiences persuading his local authority about social media in *A Local Authority Museum's Path to Facebook*.[26]

What is interesting about Rick's experience is that his success centres on the building of a solid, strategic business plan to support his access to – and use of – these services.

Summary

Social media isn't – as we've seen – without risks. The activity of connecting with your users, for example, isn't one that can be done quickly or carelessly. As with any compelling content or relationship-building, social media activity is often a 'slow burn' – it takes time to build up both competency and content which are befitting your organization. At the same time, the 'do it because you should, not because you can' maxim is strikingly important. As of time of writing in late 2010, many organizations have set up social media profiles because it is *what everyone else is doing* and not because it is *something that they should be doing*. Consider first of all how you want to engage with your

Table 7.1 *Examples of risks associated with social media and corresponding mitigations*

Risk	Mitigation
Need to ensure that we safeguard young people.	Write appropriate guidelines into the policy documentation.
People don't care enough to take part.	Make sure that we post new content frequently according to our editorial timetable.
Unwanted followers.	Monitor on occasional basis and clear out.
Content may be taken out of context.	Monitor, and reply.
Not enough time!	Be disciplined; use tools to help; get buy-in from the organization that this is worth investing resource in.
Issues around trust and provenance.	Roll out training to give staff a heads-up.
Risk of 'Bad associations'.	Policy, and also monitoring/awareness.
Third-party inaccurate information.	Correct it or write disclaimer/comment.
Other content on the site you're linking to could be inappropriate.	Wording and Terms of Service to make users aware (see the BBC for example). Be careful and sensitive when linking to third-party sites.
Inappropriate use and spam.	Monitor, delete, be aware.
Censorship and context issues.	Use policy and judgement to work out when to be reactive to these kind of problems.
Brand hijacking.	Get in there first and cybersquat your own names/accounts even if you aren't going to use them in the near future. If someone else is impersonating you, contact the service provider.
Phishing (the activity of defrauding an online account holder of financial information by posing as a legitimate company).	Be aware, follow general rule of never providing information like passwords unless you are 100% sure of authenticity.
Negativity.	Be proactive: respond to it as quickly as you can. Have a policy for timings/response.
Arguments/flaming.	Walk away; write advice into social media guidelines.
Unrealistic user expectations.	Manage this through simple wording; be honest about your capability to respond.
Risks of using third-party software.	Be aware of Service Level Agreements (SLA) – or lack of SLA – on any sites you use. Consider buying up to 'premium version' in order to get this. Be aware of the risks, create regular back-ups, have alternative services ready to go should others fail. Do a benefit analysis of the low/no cost approach vs. risk and consider the angle that 'short term gain is ok'.

users and make your decisions based on strategy rather than on a whim!

Having said that, the growing acceptance of social media is potentially one of the most exciting things to happen to cultural heritage online. Arguably, our organizations are here to enable social change and to connect users more closely

with our objects and stories. Social media – as we have seen from the examples and approaches here – is all about personal approaches, and as such is uniquely placed to bring our incredible assets – collections, galleries, archives, books and stories – closer to the lives of real people.

In this book so far, we've focused particularly on the daily business of running your web presence. In the next chapter, we're going to look at a specific web *project* – a discrete activity with a start and end – and try and tease out how this differs from the day-to-day activity of website management.

References

1 www.facebook.com.

2 www.kk.org/thetechnium/archives/2008/02/the_bottom_is_n.php.

3 www.alexa.com/topsites.

4 www.readwriteweb.com/archives/google_losing_ground_as_users_
 spend_more_time_on_f.php.

5 http://spurspectives.com/why-every-nonprofit-needs-a-social-media-strategy.

6 www.useit.com/alertbox/participation_inequality.html.

7 http://royal.pingdom.com/2010/02/16/study-ages-of-social-network-users.

8 http://museumtwo.blogspot.com/2008/04/how-much-time-does-web-20-
 take.html.

9 http://en.wikipedia.org/wiki/Blog.

10 http://en.wikipedia.org/wiki/WordPress.

11 http://blogs.archives.gov/aotus/?p=1741.

12 http://en.wikipedia.org/wiki/Twitter.

13 http://techcrunch.com/2010/06/08/twitter-190-million-users.

14 http://blog.facebook.com/blog.php?post=409753352130.

15 http://weblogs.hitwise.com/heather-dougherty/2010/11/facebookcom_
 generates_nearly_1_1.html.

16 http://en.wikipedia.org/wiki/Facebook_features.

17 www.facebook.com/press/info.php?statistics.

18 http://en.wikipedia.org/wiki/Network_effect.

19 www.facebook.com/FacebookPages.

20 www.facebook.com/myflickr.

21 www.facebook.com/artshare.

22 http://blog.flickr.net/2010/09/19/5000000000.

23 www.flickr.com/services/api.

24 www.flickr.com/commons.

25 www.slideshare.net/george08/uk-museums-and-the-web/45.

26 http://museumscomputergroup.org.uk/2010/08/13/a-local-authority-museum%E2%80%99s-path-to-facebook.

8 The website project process

Introduction

If you're part of a team helping to look after a cultural heritage web presence, you will probably at some stage have to go through some kind of development or redevelopment process. This might be small scale – for example, the build of some kind of microsite or subsection of your existing site – or it might be big – a complete reworking, redesign and re-launch of your entire website. For the purposes of this book, we'll think about a wholescale redevelopment of a website, including web design, technical build, new content writing and so on, but – obviously – adjust according to your particular needs. The process outlined here – analysis, specifying, building, testing – is similar no matter what sized project is being delivered.

Whichever kind of redevelopment you are considering undertaking, you should – of course – do it within the strategic framework we've been discussing throughout this book, making sure that you consider your users, your strategy and your existing approaches in a holistic way.

Given this, however, the process of working through a specific project, particularly a website redevelopment one, is fairly different from the daily approach you're already taking. You'll probably have a set timeline against which you need to deliver; you might also have a budget as well as external agencies involved. Once you're working with (and paying!) people outside of your organization, you will need a brief and possibly a specification, and in all likelihood some form of contract as well.

'In a rapidly changing environment, creating excellent digital projects requires comprehensive planning, an understanding of the audiences, goals and content, a modicum of luck, and flexibility in implementation.'[1]

Mia Ridge,
The Science Museum, UK

The specific approach you take to the project will depend very much on the scope, and also on how you work as an organization. Some institutions have very formal project management approaches, using methodologies such as Prince 2[2] – others use internal or external project managers and outsource all the work that is required to hold a project together from start to completion. Software development has its own complex set of approaches – again, the chosen one will be dependent on a number of factors: the agency that you choose, the size of the project, internal preferences and so on.

These various methodologies are well beyond the scope of this book – see the web or Amazon for more detailed information. Instead, we'll look at a generic web project process from a generalist's perspective, teasing out the various phases, document shapes and processes as we go.

Project phases

For the purposes of this chapter, the 'client' is you and the 'agency' is the team producing the work. Obviously this depends on context: sometimes the agency might be an actual web design and development agency; sometimes they might be an internal team who are delivering the project for you.

A typical web redevelopment project follows a number of fairly distinct phases. These are sometimes broken down in different ways but the general flow of the project is usually the same, no matter what size or scope. Let's have a look at what each of these phases entails before diving in to more detail later on in the chapter.

Analysis

The *pre-project* or *analysis* phase part of the project is where the client identifies that something is wrong or missing with the current site. They then put together evidence which supports the need for a discrete project to fix what is wrong.

The analysis phase is often underpinned by user testing, metrics of

current usage, informal feedback from web forms, stakeholder surveys and so on. Here is where your web strategy comes into play very strongly, too – you can use this to help identify the strengths and weaknesses of your current site by comparing performance against whatever you have defined 'success' to be.

Brief and specification writing

Once you have identified what the problems are with the current scenario – in other words, what needs to be fixed or improved – the next phase is to describe what needs to be changed, and how. Typically, this is done by writing a website *brief*. We'll look at the structure of a typical brief later in this chapter.

Once the brief has been written, it is given to the agency that is going to do the work. This may follow some kind of competitive *pitch process* in order to choose the agency. The agency then takes the brief and writes a *specification* as a response back to the client. The specification is the *how* in response to the *what* of the brief. Specifications can be *technical* or *functional* – again, we shall explore the differences later.

Usually there will be a fair amount of collaboration and negotiation as the client and agency work on the specification together. This is informed by things like constraints in budget, audience research and the technical environment.

For some projects, the brief and specification are merged into one document which describes both the problem and the proposed solution to that problem.

Design and build

When the specification has been agreed, the agency begins working.

This phase obviously depends very much on what is actually being delivered, but for a full website redevelopment which includes front-end visual design and technical build, it might follow a path which is something like this:

1 Several versions of visual designs are produced on paper by the agency.

2 Collaboration between the client and agency takes place to work towards a final design which is acceptable to the client.

3 Electronic 'flats' (basically, image files) are produced by the agency and again 'signed-off' by the client.

4 The agency takes these flats and turns them into code – usually some flavour of HTML. Often these are also 'passed' through the client for acceptability.

5 Finally, the agency does the technical build, in line with what was agreed with the specification, and includes the visual design on this build.

This is a very simple outline of the process – in reality there is usually a huge number of meetings, discussions and changes. Working on a web project is very much an iterative process, particularly if the scope is large.

Testing

Once the agency has finished work, they will deliver the project – often on some kind of test server which is hidden from public view. Now the client will do some testing in order to make sure that the delivered product matches what has been agreed in the specification.

Sometimes this process is called *User Acceptance Testing* (UAT): the testing process is usually iterative and can be very complex, following defined 'scripts' which lay out what should happen. For simpler projects, testing is usually more informal, and involves common sense more than anything else!

Launch

Once the testing is complete, and the client is clear that the project has been delivered according to the contract, brief and specification, there is usually a period of *handover* when the work is deployed. Final payments are made, and perhaps a project closedown meeting is convened to wrap everything up.

Writing a website brief

Now we've had a whistle-stop tour from beginning to end of a typical web project process, we'll look in more detail at some of the key documents which help to support this process.

The first is the *website brief* - the document which you use to outline exactly what it is you want the project to cover. This is mainly used when working with external agencies, but it is also useful internally as a 'checks and balances' document for your own use. It is also useful internally as a means of communicating with stakeholders exactly what you are doing and how you are doing it.

Structuring the brief

Let's have a look at how a typical website brief document is structured. Note that the example here is based on a generic 'website redevelopment' project – you will obviously need to add to or shorten this structure depending on you own particular context, but the example here provides a good starting point for your own document. You can download a template from the accompanying website at: http://heritageweb.co.uk/book/ch8/website-brief. A typical brief document is structured into four main sections:

Introduction

The introductory section provides readers with a high level outline of the project. It includes a summary of the current problems or issues and the objectives or outputs of the project which should solve these issues.

Executive summary

The introduction of the website brief should give a one or two paragraph outline of the entire project, explaining in 'executive summary' format exactly what the project entails. This allows receiving agencies the opportunity to overview the document rapidly before deciding if they are interested in proceeding with the pitch process.

Current issues

Here, outline exactly what is wrong with the current scenario. You'll typically focus on different things depending on the specifics of the project:

> '. . .the current website is visually disappointing, not at all in-line with our new branding. . . .'
> Or . . .
> '. . .we often get reports that the search function is inadequate, and wish to look at the process by which users find, retrieve and then save books.'
> Or. . . .
> '. . .the Information Architecture requires a huge amount of work: users are often confused about the difference between the core areas of the site and as a consequence our enquiries desk receives many more calls than it should.'

Be honest with the current issues that you know you are dealing with, but at the same time be forthright if there are areas of the site which you know *are* working as they should:

> '. . .although we get a lot of negative feedback about the look and feel of the site, the navigation works well for most users. . . .'

If you've had any work done on evaluating the current site (and it is highly recommended that you do), reference this work from your brief, citing examples, statistics, quotes and so on to reinforce what you believe is wrong with the current scenario.

Project objectives

Once you've outlined the issues with the current site, now articulate what you want the project to do. You can be quite general or specific with these objectives depending on the particular context; for example:

> '. . .the redevelopment project should not only answer the issues outlined in the section above, but should also seek to enhance the visitor experience by delivering a new online brand and brand guidelines.'

Be focused and high level with your objectives: the detail can come later on, either in your technical specification document (if you write one), or in conversation with the agency as you tie down the specifics.

Background

The background section should give the agency everything they need to know about your organization, both from a web and non-web perspective. Working on the background section is one time when you will find it invaluable to already be in a strategic position: it will mean that you can easily lay your hands on things like mission statements, policies, facts, figures. . . .

Your background section should include the following:

Organizational background

Outline what your organization does and what the mission statement or vision of the organization is. You can copy and paste in any existing mission statements, or refer to them as external documents if need be. If you haven't yet been through the strategic process, you'll more than likely be able to find someone in your press office or similar who can give you some stock words to drop into the document which outline important facts and figures such as collection size, number of visitors per year and turnover.

Website background

Give some information about how the main web presence was put together and how it has grown or changed over time. If you are redeveloping your main website, include things like when the site was first launched, how many visitors you expect to get over the course of a year, number of pages and other core metrics. You can include your KPI document (see Chapter 6 'Traffic and metrics') if you feel it is relevant, or just provide the metrics that are of most importance to this particular project.

The website

Once you've covered the general background, you should also provide more information about the specific site or site area that this piece of redevelopment is all about.

Website objectives

Include your top line strategic objectives for the website. Outline how the website objectives fit into the wider organization objectives, but also highlight if and when the two diverge.

Be clear about how the website objectives will be met (or helped) by the project outcomes: if for example your website objective is to engage more fully with audiences then you might want to include something like this:

> 'This project will deliver a look and feel which is more in-line with our current institutional design. One of our main objectives is to make users feel more at home on our website; therefore we are looking for a design which is colourful, engaging and likely to encourage people to sign up for our membership scheme.'

Current site

You may want to spend some time looking in some depth at the current site, critiquing where it works well and where it doesn't. You can of course do this from a design, structural or technical perspective. You might find that it helps to include diagrams or screenshots of the current site, annotated or otherwise commented to show what needs changing or leaving the same.

If some or all of your redevelopment project is about visual aspects, you might well want to include examples of the existing design, again focusing on what works and what doesn't work from this perspective. Include URLs where possible so that the reader can see on their own browser exactly what it is you are referring to.

Competitor sites

It is very worthwhile including a fairly detailed section in your brief which identifies other sites which have managed to provide an experience which you admire. Don't be constrained to your sector: if Amazon or eBay have a particularly compelling way of allowing the user to do X, don't hesitate to cite them as an example, even if it isn't directly applicable to your particular user case.

You can also include examples which you feel really *don't* do the job well: again, include any kind of site – both similar and dissimilar to yours – which fail to deliver.

Explain in either case why you feel that a particular way of doing something works or doesn't work, and identify what you'd like the agency to do about your suggestion: *'Please consider the basket functionality of site X: we feel that this is a powerful analogue for the Y area of our site'* or *'We feel that the design exhibited by site Y is very attractive, and would like to see a similar treatment on our own site'.*

Audience and evaluation

You should include as much information as you can about both the existing audience and also about the one you would like to appeal to following the redevelopment.

If possible, do some user testing of the site with various audiences prior to the redevelopment. If you have the budget to do this with a professional agency, then include this research. If you don't, it is well worth taking some time out to identify who your main audiences are and doing some *ad hoc* user research with them. You can do this informally and still gain a huge amount of value from the process. Ask your friends and family to use your site and watch them while they do; note down where they have problems, and where they seem to be enjoying the experience. Set up an online survey, and link to it from your home page; if you have the option to add an incentive, do it.

Audience grouping

You'll find it useful to split your audience into groups, and identify three

categories of things for each group: their motivations, wants and 'don't wants'.

Here is an example:

Independent adults

Motivation:

1 They are planning a visit to the museum and are looking for information on opening times, what's on and costs.

2 They are looking for verified, trusted information on the history of medicine.

Want:

1 They want easily digestible information in a printable format about how to get to the museum and what's on.

2 They want visually appealing online interactives.

3 They want raw facts, available via a powerful search engine.

Don't want:

1 They don't want large chunks of text with no images or interactivity.

2 They don't want a complicated, academically focused search functionality.

User personas

You may find it useful to write *user personas* to support your audience section. A user persona is basically a fictional representation of a particular audience, and is an alternative way of representing who an audience is and what they represent.

Here's an example:

Anna Devon is a 35-year-old working mum. She spends around 2 to 4 hours a week on the web, and is confident about how to use it. She spends much of this time on Facebook, sharing pictures of her children with her family, who live overseas.

Anna is a teacher, and has two children. She is pushed for time, and is

therefore mainly goal-driven: she often starts her web surfing from a known point such as a recommendation, leaflet or institution she has heard of in the media.

When she arrives on the Fictional Library website, her main aim is to use the search to find some books for her children, check what books they currently have out and the return dates on these, and put a date in her diary when she is going to return them.

Although Anna is used to clunky interfaces, she is frustrated by websites which are over-complex, and would rather have a simple site which does what she expects than one with too much detail.

Creating a character in this way not only solidifies the wants and needs into more specific use cases, it also allows us to more easily reference this type of user throughout our project process. It may seem strange, but asking questions like 'Would Anna like this?' when a particular solution is proposed is a really easy way of working with audience types!

You can find a user persona template on the accompanying website at: http://heritageweb.co.uk/book/ch8/user-persona.

Audience prioritization

Once you've created audience groups, try to prioritize them according to importance. What you choose as 'important' will differ depending on your context: it may be the largest audience; it may be the one you are currently failing to appeal to at present but want to grow in the future. It may be – for example – a particular niche that you want to nurture.

Your primary audience should be the one which drives your main decisions, from visual look and feel to the functional aspects of your site. Be strong about defining audience priorities and groups: there is a tendency among cultural heritage organizations to try to appeal to everyone. Avoid this as much as you can: attempting to please everyone is likely to lead to a complicated and unfocused site which, ultimately, doesn't appeal to anyone at all!

You can choose to have a secondary audience if it fits with your particular context, but be clear – both in the brief document but also with yourself – about how the audiences might conflict. If, for example,

your primary audience is school age children and your secondary audience is working parents, you should be clear how the aims and needs of these audiences differ and will be met by your site.

Dependent documents

You'll probably find that you want to refer to external documents from your brief, for example, metrics, usability reports, policies and so on. You'll find it very much easier to keep these documents entirely separate and refer to them by name rather than including large chunks of duplicate information. When it comes to liaising with the agency or agencies that are going to take on the work, you can just package up all the relevant documents into a ZIP (compressed) file or put them in a hidden location on your external website as required.

The specification

The brief – as we've seen – outlines the problem which needs solving in some detail: an under-performing website, a bad visual design, a badly functioning catalogue search and so on.

The specification outlines a proposed solution to this problem – it is a set of *requirements* which must be met in order to satisfy the needs of the project.

The following are frequently used to help specify a web project:

Functional specification

There are two types of specification documents which are used when describing a web application or site. These are the *functional specification* and the *technical specification*, and some confusion exists around what the difference is between them.

Typically, a *functional specification* describes the application, website or whatever it is you are specifying from a *user perspective*. It outlines the way that the site will work *from their point of view*.

A typical functional specification may contain text like this:

When the user submits the form, the site will check that they are logged in. If they are, a message will be returned to them thanking them for their input. If not, they will be redirected to the login page.

As with anything else, the lengths to which you go in writing a full functional specification will depend on a number of factors: the size and complexity of the project; the technical ability and creativity within your team; the budget you have to pay an agency to do this work for you; and so on.

A functional specification is normally a collaborative piece of work – you as client would work closely with the agency to make sure that it matches your vision for the site, and also that it ultimately fulfils the requirement laid out in the brief.

Technical specification

A typical *technical specification,* in contrast to the functional specification, is about the *technology* which sits underneath the site: the database, coding language, scripts and so on which make the functional bit happen. Put simply, the technical specification is a detailed *how* response to the *what* of the functional requirement.

In a fairly typical scenario where the agency is providing technical input to the project, you as client won't have to worry too much about the technical specification: they are often documents written with a huge amount of detail for the developers who will actually sit down and build your solution.

Site map

The site map is a visual representation of all the pages of the site or project. Typically, this takes the form of an *organogram*-like diagram (similar to the kind most usually seen to represent the hierarchy of staff members in an organization); see Figure 8.1 on the next page.

Depending on the particular site, the site map might indicate template types for each page, links to global navigation, and other information. For larger sites, the site map can be divided up into several pages – each

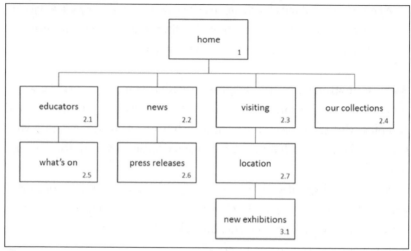

Figure 8.1 *A simple site map*

page possibly representing a 'layer' of the site. So the first page might show everything that can be found with a single click from the home page, the second page the layer underneath this, and so on.

Mark each page with a unique ID (identification) – preferably using 'dot notation' if the site is at all complex (so the home page might be 1, a page in the next layer down 2.1, a sibling to this page 2.2, etc.).

Site maps can be drawn up using tools like Microsoft PowerPoint, Microsoft Visio or Omnigraffle. So-called *mind-mapping* software like FreeMind[3] and MindMeister[4] can also be used for very rapidly sketching out site maps.

Wireframes

A *wireframe* is an abstract representation of the pages of a site and is an incredibly useful technique for helping to describe how a site will hang together. An example wireframe can be found linked from the site at: http://websiteroot.com/ch8/example-wireframe; see Figure 8.2.

The most important thing to stress about wireframes is that they are *abstract* rather than actual. A wireframe which shows a login box on the right-hand side of the page which is 100 pixels wide is *not* suggesting that the final site should have a 100 pixel-wide login box on the right-hand side of the page: it is merely illustrating that this page *has* a login box!

Figure 8.2 *An example wireframe page*

This is sometimes hard for people to grasp, and is worth stressing, particularly if you're user testing or working with other stakeholders who may not be familiar with this approach.

Wireframes can be put together for a whole site, or just used to represent various *templates* (page types); for example, a home page wireframe, a search results wireframe and so on. Carry on the page ID so that it matches your site map.

There are a number of different approaches and pieces of software for wireframing. The simplest, and often most effective, certainly in early brainstorming stages of a project, is gridded paper and a pencil. You might want to adapt your grid if you have a common known pattern to your wireframes; for example, the downloadable template at http://websiteroot.com/ch8/wireframe/templates has a left navigation, a header and a footer.

Once you've sketched out your wireframes by hand, you should then transfer them to a digital form. There are a range of tools available to you – some of them downloadable software, others web-based tools. Search the web for 'wireframing software' or see http://websiteroot.com/ch8/wireframing-software for a list of some of the better known ones.

Content inventory

A *content inventory* is often forgotten but is an incredibly useful tool for capturing what content is going to be included as part of the project or site. The inventory can be used to capture what you have on an existing site and this will then help inform what will be on the new one – or you can write it from scratch if that is more relevant. Your content audit from Chapter 1 'Evaluating what you have now' will probably be useful to help inform the direction of your inventory, too.

The inventory covers the following for each page on your site:

- the URL and page title
- page ID (which can be used to link to your site map and wireframes)
- a description of the page content (or you can link to a document containing the content itself if you are re-authoring)
- date and owner information: for example, when created, when modified, when due to expire and who wrote the content
- page status (for example, to keep, to delete or to modify).

It makes a lot of sense to use a spreadsheet or even a simple database to describe your content inventory – this will mean that you can sort by the factors above, search, add rows and so on.

A simple content inventory template is available for download at the accompanying website: http://heritageweb.co.uk/book/ch8/content-inventory.

MoSCoW

Across your specification you can use a technique called MoSCoW[5] to help you prioritize requirements:

M: Must have this.
S: Should have this if possible.
C: Could have this if it can be incorporated without adversely affecting anything else.
W: Won't have this but should be noted for the next version.

This is a useful technique not only for marking up requirements but also early in the project when you're brainstorming how best to proceed with your list of requirements – you can ask your stakeholders to identify how important they consider each facet of the new project and use this to inform how best to proceed.

Working with external agencies

If you're lucky enough to have a website project budget, then it is possible that you'll be looking to outsource some of your work to an external agency. This work might be creative, technical, or it may be a 'full-service' deliverable, where you basically want to take on an agency that can do the entire project for you, with you and relevant stakeholders holding the reins and guiding the process to completion.

Typically for a website project of any size, you'll be looking for a range of competencies from a range of people. The project deliverable will require a combination of inputs which include design, technology, content editing and photography. You'll therefore need to identify early on in the project process where you have internal resource and skills which you can put towards the project, and where you have holes which you need filling by an external agency.

Sometimes, you'll need to work with more than one agency. So-called 'full-service' agencies (for example, those which have competency in both design and development) are becoming more and more common, but you will often get better designs from a pure design agency and better development from a pure development agency. If taking on both a design agency and a development agency, do what you can to only employ a single 'primary' agency, and get the second one to subcontract to the primary one. This will massively reduce the complexity of your project and will help mitigate confusion about budgets, timelines and responsibilities.

The pitch process

When you are taking a project out to external agencies, you normally go through a *tender* process in order to choose which of these agencies to

work with. This can take a number of forms depending on your environment and the scale of the project, but typically culminates in a *pitch* process where a number of agencies present their response to your brief and you then make a selection between them.

Choosing the agencies that you want to pitch is a process that takes some time and practice, but start off by talking to your peers and asking them who they have worked with in the past on projects similar to yours. Posting to relevant mailing lists is another great way of soliciting feedback and suggestions for agencies.

Follow up any suggestions by calling both the person who recommended the agency and the agency themselves. Ask the former for any feedback they have – tell them it is confidential and won't be fed back to the agency. Ask about timelines, responsiveness, design skills, what they are like to work with, etc. When you speak to the agency, ask for telephone numbers for people they'd be happy for you to talk to.

There are also some suggested 'do's and dont's' for running a stress-free pitch process on the website at: http://heritageweb.co.uk/book/ch8/pitch-dos-and-donts.

You should obviously run the tender and pitch process in accordance with any legal and internal guidelines, but what follows are some additional pointers and suggestions which should help you run the process smoothly.

Pitch stages

The number of pitch stages, and the number of agencies at each stage, varies according to the size of the project and should be decided on a case-by-case basis.

For a typical redevelopment project involving both design and technical agencies, a first stage with five to six agencies followed by a second stage with two shortlisted ones is usually adequate, but you may well want to adjust this according to your particular circumstance.

Be clear about the stages right from the beginning of the process, both internally and with your bidding agencies. For the second stage you may find that you want to retain some flexibility: often the number of agencies depends on how they performed during the first stage. If this is the case, just make sure you are clear that this is a 'known unknown' when you communicate the process. . .!

Making a decision

Make sure that you have enough time during the pitch day to talk about each agency following their pitch. You may well want to do some scoring at this point in time, either collaboratively or separately. Do this while the memory of the agency is fresh in your mind – once you've seen a whole collection of agencies, they will all merge into one!

Once you've done your pitch day(s), you should convene a meeting with the internal people who took part in the interviews. You might want to do this on the same day(s) as the interviews, but more likely you'll be coming to it a few days later, once all the internal attendees have had a chance to write up their thoughts and consider exactly which of the agencies have impressed them.

Make sure that everyone who comes to the decision meeting has written up their notes into the criteria template. How you deal with the scoring against the various criteria is entirely up to you: you may want everyone to do this separately, giving their scores, and then being fairly mathematical about taking an average of all the people involved. Alternatively, you might want a single scoresheet which you fill in together, taking input from each of the stakeholders as you go.

The outcome of the meeting should be a decision on which agency (or agencies) you will be taking through to the next stage of the pitch – or, which agency you'll be taking on board to start the project!

Wherever you are in the pitch process – either early on (in which case you may well have a future stage of pitches) or making a final decision – you now need to let both the successful and the rejected agencies know your decision. This is best done by telephone, and should be carried out by someone who has not only been at the pitch meetings, but who understands the project and the process inside out. This person, really, should be you!

Be as honest as you can when talking to agencies that you have rejected. Make sure you have your criteria to hand, and make it clear to them why you have decided they aren't the right people for you. Mostly, agencies know where their weaknesses are, or understand when they've done a bad pitch, and as a consequence most will be gracious and understanding when you have this conversation with them! If for whatever reason they ask for further feedback, tell them that you can provide this by e-mail:

make sure that you provide this as soon as you can following the call while the conversation is fresh in your mind.

Talking to the successful agency is very much easier! You are either letting them know that they are your agency of choice for the project itself, or that they have been successful in proceeding to the next phase in the pitch process. If it is the former, arrange a *project start-up meeting* (see below) and go from there. If it is the latter, let them know what the next phase of the pitch entails.

The contract

Whatever work you do with any external agency or individual, you absolutely must make sure that you have some kind of written agreement which outlines exactly what it is they are going to deliver to you.

This written agreement will differ depending on a number of things: first, the scope and value of the project or piece of work that is being commissioned. A large, multi-hundred-thousand-pound website redevelopment project is likely to be complex, wide-ranging in scope and stakeholder involvement, and will require a correspondingly complex document which outlines the obligations of the organizations involved. Conversely, a sub-thousand-pound piece of work to deliver a Flash-based interactive or similar is likely to be easy to specify and as a consequence not something that requires a heavyweight legal document to support it.

Having said this, every single institution differs – you should first of all speak to your legal department or legal representatives (they may be an external law firm or individual), and ask them whether there is a standard contract used for outsourced work. Often, organizations have such a document as a template and modify it as required for each project.

If your organization doesn't have such a legal department or representation, you should next look for similar pieces of work which have been delivered and find out exactly what legal procedure these followed. You may find that they have 'cribbable' contracts which you can amend and then send out for a legally trained individual to ratify.

You may also find that the agency or agencies that you are going to work with have a standard contract which they are happy to re-purpose, but again, make sure that someone on your side of the deal who is

qualified to deal with such matters has a good look at the proposed contract and signs it off as being legally correct from your institution perspective.

You should make absolutely sure that you create or use a document which is signed off for your particular context by a legally trained individual. These details below purely constitute a general outline of what you should expect from such a document; they are non-specific and will require considerable changes in different countries, jurisdictions, institutions and contexts.

It also goes without saying that you should ensure that a contract is in place no matter how small the piece of work with an external person or company: although many projects are built on the back of good will, some do unfortunately fall apart for one reason or another, and having a firm and legal document which you have both signed up to can help immensely.

A standard web-project contract should contain the following information:

Contact information

- name and address details for the agency involved, including their postal address, postcode, e-mail address, fax and telephone number
- a contact at the agency, including their full contact details
- name and address details for your institution, including postal address and so on
- a contact at your institution (probably you!), including full contact details.

Deliverables

Often, it is easier to have your contract as a separate, legally binding document which has a reference to a separate deliverables document, rather than an inclusion of the deliverables within the contract itself. This just makes it easier to sign off and handle the document: you would have a line marked something like '*Services: consultancy as laid out in the attached Schedule of works, somedocumentname.doc.*'

Consultancy fee

The complete fee for the work would be specified, and any complexities (for example a staged-fee payment or monies to be paid up front) either set out or referenced (for example, '. . .*see section 3.2 of the attached Schedule document*').

Obligations

Following this general introductory section, there is usually a long (and fairly heavy!) piece of legalese which lays out the obligations of both the agency and your institution. It includes agreements such as:

- that both parties will work to the agreed timetable
- that the work is delivered as outlined in the detailed specification
- that subcontracting is permitted (or not, depending on the particular context of the work) as required by the agency
- that payment can be suspended should the work fail to meet these obligations
- that your institution will provide the necessary people, time and materials to the agency as and when required or laid out in the schedule and specification of works.

Delivery

This section outlines the specifics behind the handover and sign-off of the work which is going to be produced. It contains details such as how quickly the invoices will be submitted and should be paid, and also any clauses which outline what the procedure is for sign-off and what happens should this sign-off fail in any way.

Fee, expenses and tax details

This section details how or if VAT is added to the agreed fee, outlines additional expenses (if any) and how these are incorporated or not into the fee. It should also outline any required details about the institution or agency tax status, for example, charity status or income tax liability.

Confidentiality and warranties

These sections cover fairly standard clauses about the confidentiality of the various communications which will take place during the project process, and stops the agency from – for example – letting anyone outside the process know the various fees involved either during or beyond the lifetime of the project. The Warranties section ensures that the deliverables of the agency are original work and don't contain anything that is libellous or defamatory.

IPR

The Intellectual Property Rights section is an important one to get right, particularly where creative work is concerned. This clause basically sets out that whatever the agency delivers to you becomes your intellectual property ad infinitum. You will find that some scenarios – for example, the delivery of a bespoke piece of content management technology – will require a fair amount of additional work in this regard.

Whereas creative deliverables like logos, fonts, colours, templates and style guides should 100% belong to your institution following the successful completion of the project, technology is a much more complex scenario which will require specific examination on a case-by-case basis. For a content management solution such as the one outlined above, you would normally define the templates, stylesheets, content and so on as being your IPR, but the actual technology itself might be licensed to you on an annual basis. For open-source projects, this obviously differs again. Seek legal advice at the earliest possible opportunity to make sure that you get what is required for your particular scenario.

Liability and conflict of interest

These two standard clauses cover liability for any losses incurred as part of breaches in the contracted agreement, and asks the agency to put in writing any pieces of work which could be considered conflicts of interest to the project.

Termination

This section outlines the process should either the agency or institution fail to meet any of their obligations during the project process. Normally it would include the timescale and process by which the contract could be terminated. Typically this section would also have a clause which allows the institution to terminate the contract with – say – a week's notice, and be liable in this instance only for payments incurred up to that point in time.

Project start-up

Once you've either decided on an agency or made a decision as to which of your internal staff are going to be involved with your project, you are ready to begin defining some of the detail about how it is actually going to run between now and the end date.

Very early on in the process – preferably in the week following your decision about the agency – put together a *project start-up meeting*. Make sure you invite all the relevant stakeholders that you've already defined as part of the early stages of the project. Invite your chosen agency (or agencies) to the meeting, and request that they bring along the actual project managers and any other key people who will be working on your project – such as designers or lead developers. These people are sometimes different from the ones who came along to the pitch – you want to meet the ones who you'll be working with, day to day.

At this start-up meeting, your agenda should cover the following:

Project introduction

First, get to know the project team – their names, positions and involvement in the project. Although many of the people at this meeting will have been at the pitch process, it is worth doing for those that weren't, and also good to have a refresher for those that were. Use your brief document to rapidly outline the aims, scope and dates.

Project approaches

Spend some time talking about your preferred way of working: how you like to collaborate, how the agency collaborates, and how you can make your processes work together throughout the project timeline to ensure that things run smoothly.

Agree a series of follow-up actions with the relevant people to do whatever is required from whatever approach you choose. This might mean adding people to a Basecamp[6] project space, setting up an FTP account, and so on. Agree dates by which this will be done, and stick to them. . .!

Roles and responsibilities

Defining a single point of contact (POC) between your institution and the agency you're working with is one of the most important things to come out of this meeting. Many a project has been thrown badly off course by not having a defined line of communication between the people involved. Once you've determined your POC, also arrange for contingency people who become this point of contact when the primary person isn't available, for example when they're on holiday, off sick or otherwise engaged.

Whatever approach you take, choose an individual – either you, a project manager or – and this is a recommended approach, whichever kind of project you're embarking on – create an e-mail address which you agree to *always* copy in when a project-related e-mail is sent. This way, you always have a record of all conversations that have taken place. Note that some of the software we talk about in the next section have this functionality built in – Basecamp, for example, has a unique e-mail address that you can cc in. When you do this, a copy of your conversation will be made within your project space for later archiving, searching and tracking.

Have this e-mail address ready at your project start-up meeting: provide it to the relevant people involved in the project, and get them to agree to use it as outlined above.

If your project doesn't involve any external agencies, or perhaps only has minimal input from them, you should still go through this process

of determining exactly who is responsible for what, and who talks to who. One way of doing this is to consider different departments within your organization almost as if they are agencies: you might want, for example, to work out the number of hours required from people in each department, or even (although this is a bit formal for an internal situation!) to arrange an agreed Service Level Agreement with these people as you might with an external agency.

The fundamental reason for spending time on the people aspect of your project is actually incredibly simple: people are the ones *doing* your project! If you can understand exactly who is going to do what, how and by when, then you are very much more likely to understand any issues that you come across during the project process.

Project timelines

Use your start-up meeting to set out a raw timeline, including dates when key things are expected – or have – to happen. Have a frank and open discussion about these timelines: during the project bidding process, agencies are more than likely to be over-optimistic about what work they can commit to. You can ask them to stick to these timelines, particularly if you've been through the contract process at this stage, but you should also make sure that everyone is realistic about things like contingency: that is, if you have a key member of staff off sick, what possibilities are in place to replace them.

You should also use this meeting to sketch out a *critical path* – that is, a rough understanding of which bits of work can continue in parallel, and which have dependencies on previous pieces of work. While some bits of work can continue even if the previously mapped out segment of work has failed or is late in some way, others have an absolute requirement on another piece of work. A website, for example, can't be built unless there is the hardware in place upon which to build it; the hardware in this instance is said to be 'on the critical path'.

If you've taken an agency on board, or have dedicated in-house project management staff, they'll take these rough ideas about timeline with them and use them to develop something much more detailed like a *Gantt Chart* which outlines all the tasks, the owners of these tasks, and the

dependencies between them. Nonetheless (as you'll see in the following section), having a good high level understanding about the main dates is an absolutely key piece of intelligence when running your project.

Project meetings

Work out a regular time and place to have a project catch-up meeting. The frequency with which you have these depends almost entirely on your particular project and the people involved. A weekly catch-up is almost always a good idea; however, some people may find this to be overkill – particularly in the early stages of the project – and may prefer to meet fortnightly or even monthly. The benefit of a weekly catch-up is that it maintains momentum between meetings, and you'll remember exactly what went on at the previous one. If members are definitely opposed to weekly formal get-togethers, it may be a good idea to suggest regular rapid-fire online or telephone meetings – either involving the whole team or key team members – that can be interspersed with the more formal gatherings.

Payment schedule

Your initial meeting should also include an open discussion about the budget and payment schedule. This should include an understanding of the total budget available (make sure you remove 10–15% first and hide it for later use!), including VAT if applicable. You should already have worked out how the budget is going to be split across the project in terms of the various components (for example, design, technology, content authoring and content migration), but you should also talk to the agency about when their deliverables are and how the payment points are linked to these.

Normally with a medium- to large-sized project, you want to hook in stage payments to agreed deliverables. This sounds obvious, but a common occurrence in some project scenarios is payments based on date. As always, it depends on the particular scenario, but for the most part, this isn't a good idea. Basing your payments on deliverables not only puts pressure on agencies to deliver quality work on time, but also means

you get points of time during the project process where you can consider what has been delivered and assess quality along the way.

Some agencies ask for part-payment up front. This is more common with smaller agencies or freelancers than with bigger agencies. You will need to make a decision as to whether this is acceptable based on your own institution and experience. Don't ever pay the full amount up front; 10–30% is probably reasonable, but make sure you keep the majority of the payment back should the individual or agency fail to deliver in any way.

All of your budget details should be written into your contract. Make sure you include your stage payments, a rough date for these payments and a detailed description of what is required in order for this payment to be made. Should things go wrong in the relationship between you and the agency at any stage during the project, you will find that this kind of detail is absolutely crucial.

Budgeting

'Most of our web presence is either free to use – e.g. Freeware, Flickr, or other hosted services, or financed at a Corporate level. Discrete projects are funded by grants, and some development money is made available from service budgets.'

Paul McIlroy,
Warwickshire Library and
Information Service, UK

Project budgeting is a bit of a black art, and one that only really comes with experience of past successes and failures. There are a few things that will probably help whatever the project:

Have a contingency fund

First, make absolutely sure that you have allowed for a contingency fund of between 10 and 20% of the total project spend. Allow for this fund right at the beginning of the project: once you've allowed for it, put it aside and don't be tempted to chip into it.

The one time you may want to look at spending your contingency is toward the tail end of the project or project phases when it may have become clear (as it probably will!) that there is additional work required to improve that which has already been undertaken. The classic example in a web redevelopment project is the need for additional templates over

and above the ones which have been drawn out in the spec. Typically, these bits of work can be guessed at from a distance but aren't 100% clear until the work is actually being carried out. As always with project work, it is your call as project lead to decide which of these can be paid from contingency and which should be left for a future phase of some description.

Be transparent

Second, be absolutely transparent with any agencies you work with about what their day rates are, how these translate into the various people who are involved and ultimately how this maps onto your specification. For each item in your specification, get a quote for the number of days' effort and the day rate, and totals. Also, make sure all the calculations and totals are correct: if you spot anything at all during the contract phase that you don't understand, don't hesitate to ask either the agency involved or your finance department if they are helping you out.

Keep track

Third, keep a top line budget spreadsheet. This should contain details for each block of spend, the deliverables and any relevant dates associated with these deliverables. You should keep this spreadsheet up to date and close to hand - make sure you can at any time answer questions like: 'What is the total budget?'; 'How much have we spent to date?'; 'How much do we have remaining and what will we be spending it on?' Make this document as simple as you possibly can, and share it with internal stakeholders as relevant.

Pay on sign-off

Fourth, make sure that you only pay for pieces of work as you sign them off. This sounds obvious, but when finance departments and project teams don't work closely together bills can get paid before the specified bit of work has been agreed to. It helps to get the agency to put your name as a contact on their billing system: you'll therefore be the first

person to receive the bills as they come in and you can then act as a gatekeeper. Don't – of course – be afraid to ask questions if you get billed for a piece of work you feel hasn't been completed. Usually, such matters can be sorted out with a phone call or e-mail but you may find that a face-to-face meeting helps to nail down exactly what any issues might be.

Summary

The project process is very often quite different from the daily operation of looking after a website. The time and budget constraints, working with external agencies, sign-off, contractual decisions – all make for a sometimes highly charged environment. Having said that, the delivery of a new *thing* – whether it is a whole new website, a sub-site or something as small scale as a new newsletter template – is a very exciting process, particularly when the project has been run in a measured, strategic and forward-thinking way!

Now we've looked at the specifics of a project process, let's cast our eyes ahead and consider some of the ways in which the web landscape is changing.

References

1 Chamberlain, G. (ed.) (2011) *Museums Forward: social media, broadcasting and the web*, Museum Identity, www.museum-id.com/books-detail.asp?newsID=168.

2 www.prince2.com.

3 http://freemind.sourceforge.net/wiki/index.php/Main_Page.

4 www.mindmeister.com.

5 http://en.wikipedia.org/wiki/MoSCoW_Method.

6 http://basecamphq.com.

9 Away from the browser

Introduction

In this chapter, we'll look at two major trends which have enormous potential impact for cultural heritage organizations: Open Data and the mobile web. These two areas are both about ways of using technology to improve output and outreach, and they both use something different from a desktop browser to do this.

One of the most interesting things about these approaches - as we'll see - is that they give us the opportunity to reach new audiences in new places. These places don't any longer have to be the traditional ones we're used to - at a desktop, on a laptop, etc.; instead content can be authored once and then delivered to many channels: mobile devices, kiosks in museum and library spaces and so on. From a human perspective, this is important because desktops and laptops don't necessarily lend themselves to the 'invisible' or natural content experiences we've discussed already. Often, given the nature of our organizations, our users are visitors: they are already having a physical experience interacting with our objects, books and archives. Technology is often at its most powerful as an adjunct to rather than a replacement of those experiences.

Both these trends come from outside the cultural heritage domain - in some commercial organizations, for example, these approaches are quite mature and embedded. Cultural heritage organizations have also started embracing both, and (much as trend-spotting is a fool's game) it looks as if they will form an important part of our landscape in the coming few years.

Open Data

What is 'Open Data'? Wikipedia says this:

> Open data is a philosophy and practice requiring that certain data be freely
> available to everyone, without restrictions from copyright, patents or other
> mechanisms of control.[1]

As the quote above suggests, Open Data is as much a philosophical approach as anything else, and it is worth spending some time examining why any (cultural heritage) organization might want to make their data available in an open format in the first place, before looking more closely at some of the ways that this can be done.

Why provide Open Data?

At first glance it is hard to understand why an organization that has invested considerable time and effort into – for example – cataloguing their objects or listing their events should then relinquish control of that raw data in such a way that anyone can use it. This is, however, exactly what is happening in many organizations, cultural heritage and otherwise.

The investment required to digitize resources like museum, library or archive collections is huge. Traditionally, this investment has ended up as a series of web pages being exposed at a single place on the web – a collections search on a museum website, for example.

Open Data allows organizations to expose this data in ways such that it can be reused and re-surfaced via different, often multiple, channels. Although this necessarily means some relinquishing of control of this data – traditionally recognized as a primary asset in many organizations – it is also the case that reuse of these assets will drive considerably more traffic than locking them up inside a single website.

There are two important points to consider here.

The first is the *format* you use to publish your information. Formats like HTML or XML are *open formats* which can be read by anyone without proprietary software. Microsoft Word or PDF documents require the end-user to own a specific bit of closed software in order to read those documents.

The second is the *licence* under which you publish your information: the more open this licence, the more freedom the content has to move around the web in an open way. A Creative Commons[2] licence, for example, offers various ways for the end-user to repurpose content, whereas a copyrighted work is (at least, theoretically) safeguarded against this repurposing.

Philosophically, Open Data becomes about the *value* that you want to realize through your assets. Consider two possible scenarios: one where your organization publishes a PDF on your website describing an important object in your collection, and one where you instead add this same information to Wikipedia as HTML under a Creative Commons licence of some kind. The latter approach is *always* going to get more people finding, reading and using the information you've written than the former – this is the power of a huge, globally recognized brand like Wikipedia coupled with more open licensing.

Assuming that your reason for putting this information online in the first place is primarily *to get people reading and using it*, the more open example arguably demonstrates a considerably higher impact than the closed one.

This illustration highlights one of the key issues which many organizations are coming to terms with: providing data in a more open way tends to shift the value; the value in an Open Data world is *greater* than that in a closed data world, but not necessarily still measurable in the *same place* as it was. In the example above, the organization would benefit from having the object on both Wikipedia *and* on their own website collections pages. Extending the argument still further, they might benefit from having the object visible on Europeana (a 'search platform to a collection of European digital libraries'[3]) and other portals as well.

Providing Open Data

Open Data approaches are the means by which this kind of *distributed* content can be delivered. Typically, Open Data requires organizations to provide some level of *programmatic access* to their data – that is, access which is designed for machine rather than human consumption. Let's have a look at three of the most common ways that this can be realized.

RSS

Probably the simplest and most well known way of providing programmatic access to data on your website is through the use of RSS - *Real Simple Syndication.*[4]

As we've seen already (see Chapter 3 'Content'), RSS is a simple, common format which allows users to subscribe to frequently updated information like news headlines by using a feed reader. As a user, I can subscribe to many tens or even hundreds of different feeds from the sites I'm interested in and then quickly read headlines from all of these without having to go to each site I have subscribed to: I can do it all from a single place. As the organization who is publishing these feeds, you are essentially providing Open Data - content can be consumed and read away from your site, or remixed into other feeds and web services.

RSS can be used to provide different kinds of content, too. A great illustration is the implementation of RSS as part of a catalogue search system. There is an example of this in the Ann Arbor District Library (AADL) catalogue.[5] If you try a search using this catalogue, you'll notice that there is a link to an RSS version of the results on the results page; see Figure 9.1.

Here, users are given the option to track when new titles are added to the catalogue by subscribing to these results. More importantly, from a

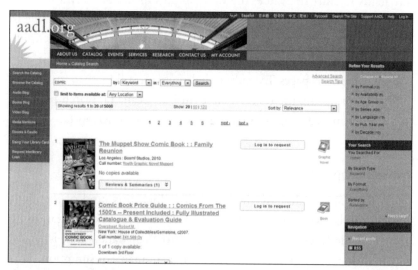

Figure 9.1 *AADL search results showing RSS option (see icon on bottom right) (from www.aadl.org/catalog/search/keyword/comic)*

Figure 9.2 *Mock-up of possible AADL mobile search results view*

web developer perspective, RSS provided in this way gives the option to access data remotely and then style it in new, innovative ways. As an example, it would be trivial for a developer to take the RSS results from the Ann Arbor District Library and build a simple mobile interface around the catalogue search - mocked up in Figure 9.2.

RSS is a very simple approach, which has been moulded through the means of tools like Yahoo! Pipes[6] to provide a surprisingly powerful feature set for developers. Many

> This example only scratches the surface of the possible uses of RSS in programmatic ways. For further reading and links, see the website at: http://heritageweb.co.uk/book/ch9/open-data.

developers, however, need to go beyond the capability provided by RSS.

API – Application Programming Interfaces

The provision of what is called an *Application Programming Interface* is - simplistically - the next step to RSS. An API gives developers powerful and customizable access to the underlying data of a system. Typically, an API will be queried for some information ('Find me articles which contain the keyword. . .' or 'What are the next five exhibitions?') and will then return some data in response. This data is often XML or JSON, but can be a whole range of formats.

Developers can obviously use the returned data in a huge number of ways. In-house, you may - for example - want to have your collections catalogue visible on a kiosk for the public to search, or you may decide to have a heads-up display of the latest exhibitions in your museum concourse. Providing an API can reduce development costs considerably: by allowing data to flow much more easily between systems, integration work is often much simpler and less time-consuming.

Externally, providing an API means that developers can consume and mix up your data in so-called *mash-ups*,[7] visualizing or displaying that data with other sources.

There are some examples of cultural heritage API approaches on the website.

Linked Data and the Semantic Web

At the top end of Open Data provision is access in which sites can pass data between them freely. This kind of interlinking between sites is part of a vision which has most famously been articulated by Sir Tim Berners-Lee, the 'inventor' of the world wide web:

> I have a dream for the Web [in which computers] become capable of analyzing all the data on the Web – the content, links, and transactions between people and computers. A 'Semantic Web', which should make this possible, has yet to emerge, but when it does, the day-to-day mechanisms of trade, bureaucracy and our daily lives will be handled by machines talking to machines. The 'intelligent agents' people have touted for ages will finally materialize. [8]

The vision, ultimately, is of a *Semantic Web*:

> Semantic Web is a group of methods and technologies to allow machines to understand the meaning – or 'semantics' – of information on the World Wide Web.
>
> The term was coined by World Wide Web Consortium (W3C) director Tim Berners-Lee. According to the original vision, the availability of machine-readable metadata would enable automated agents and other software to access the Web more intelligently. The agents would be able to perform tasks automatically and locate related information on behalf of the user. [9]

This vision, as Wikipedia goes on to note, has been largely unrealized to date:

> Many of the technologies proposed by the W3C already exist and are used in various projects. The Semantic Web as a global vision, however, has remained largely unrealized and its critics have questioned the feasibility of the approach. [10]

There are ongoing – and recently, more successful – efforts to take the broader vision of a more semantically rich and connected network of data forward. The most high profile of these is the so-called 'Linked Data'[11] approach. This, again, has Sir Tim Berners-Lee as a powerful advocate, and as of late 2010 is beginning to show some positive signs of take-up.

Perhaps the best way of understanding how this fits with the examples we've already seen earlier in the chapter is to consider the *Linked Open Data Star Scheme*[12] which sets each of these approaches in a scale from 1 to 5, where 5 is the most open and linked:

> 1 star: Make your stuff available on the Web (whatever format) under an open license.
> 2 stars: Make it available as structured data (e.g. Excel instead of image scan of a table).
> 3 stars: Use non-proprietary formats (e.g. CSV instead of Excel).
> 4 stars: Use URIs [Uniform Resource Identifier] to identify things, so that people can point at your stuff.
> 5 stars: Link your data to other data to provide context.

The Open Data conversation continues on many cultural heritage forums as institutions try to get to grips with what this shifting value might mean from their particular perspective. There are some examples of how Linked Data might be used in a cultural heritage context on the accompanying website at: http://heritageweb.co.uk/book/ch9/linked-data.

Let's look now at the second of our trends: mobile.

Mobile

As of the time of writing, delivery of content to mobile devices is – after many years of failed promise – finally starting to become a reality. Mobile traffic growth predictions are currently phenomenal, predicting that mobile will slowly become the preferred way for people to access the web. As of late 2010, according to a UN report: '. . .half the globe pay to use [a mobile phone] . . . there are now 4.1bn mobile subscriptions worldwide. . . .'[13]

Mobile has been promised as the 'next big thing' for a number of years now. Why is now the time?

Why now for mobile?

The popularity of mobile as a viable channel for delivery of web content is driven by the divergence of a number of factors:

Devices

The size of the market for mobile phones changes all the time, but almost every industry prediction is in agreement that there is phenomenal growth going on at this point in time. By 2008 in the UK, it was estimated that 120% of people own a handset (that is, on average, UK citizens own more than one handset each).[14]

Devices are becoming cheaper all the time, and as the cost lowers, so the replacement cycle speeds up. This is important not only from a growth perspective, but also because it means that new features that are introduced into leading edge phones (for example, location capability like GPS [Global Positioning System]) are quick to filter through the market onto cheaper phones.

In terms of capability, the current estimates (current handset installed base) are as follows: [15]

SMS (short messaging service): 100%
Browser (including WAP [Wireless Application Protocol]): 95%
MMS (multimedia messaging service): 80%
Camera: 73%
Modern browser: 71%
Bluetooth: 64%
Wi-Fi: 19%.

Of this capability, the ability to browse the web is probably the most important statistic from a content-rich cultural heritage perspective. As the figures above show, modern browsers (that is, a full featured web browser that is comparable with the browser on your desktop) are a feature of 71% of mobile phone handsets now, and this figure is growing all the time.

Services and content

As with any technology, there is an inevitable 'chicken and egg' scenario when it comes to the delivery of content and services. For some time now, the technical capability of mobile approaches has been well understood, but the lack of useful and compelling services has meant that adoption has been slow. Now, with adoption growing at huge rates, there has been a corresponding bloom of viable mobile services, some being hooked into existing networks such as Facebook[16] and Twitter,[17] others built solely for mobile – for example, Gowalla[18] and Foursquare.[19]

In line with this growth, the speed and availability of mobile networks has increased dramatically over the past few years, and will likely continue to do so into the future.

Location capability

Although there are many new hardware capabilities being provided by handsets now – high quality camera, accelerometer, Wi-Fi, and so forth – it is worth focusing on the location-awareness of devices purely because it has such obvious applications in the cultural heritage space.

There are really two main capabilities for location-awareness in current leading edge devices. First, the more cutting edge smart phones now contain their own GPS, which uses satellites to determine location. These devices can pinpoint the location of the user to within metres. The second capability is using the network 'cells' to triangulate user location. This doesn't require GPS capability on the phone, but the accuracy is much more limited and depends on where the user is. In urban settings where the cells are small and density is high, accuracy can be quite good (within metres) but in rural settings it can be as poor as hundreds of metres.

From a cultural heritage perspective, the lack of accurate mobile positioning capability when indoors is clearly a limiting factor, although there are ways around this.

Location Based Services (LBS)[20] can be built around these capabilities, and the possibilities for cultural heritage organizations are many. One possibility is the use of so-called Augmented Reality[21] (AR) applications which layer a virtual view onto a real-world environment. See, for

example, Figure 9.3, a screenshot from The Netherlands Architecture Institute AR application.[22]

There are a number of examples of this kind of approach being taken by cultural heritage organizations. See the accompanying website at: http://heritageweb.co.uk/book/ch9/mobile for links and examples.

Figure 9.3 *UAR (Urban Augmented Reality) application from the The Netherlands Architecture Institute - iPhone screenshot*

Marketing and awareness

Arguably as important as any technical capability is the market awareness of any technology. The current marketing push for web-enabled devices – often driven around social networks such as Facebook and Twitter – is such that awareness of the capabilities that these devices offer is very high, and growing all the time. In the UK, for example, advertising for mobile web browsing is prominent by all the major telephone companies. Deals around mobile browsing are hooked into standard device contracts: it is normal to buy a phone contract and have data access built in as standard, or at least available for an additional extra monthly charge.

This kind of marketing feeds back into the appetite for mobile content and services, and the growth of traffic in turn drives demand, in a kind of 'awareness cycle'.

Possible mobile options

One of the problems when considering how to deliver content for mobile devices is that the landscape is endlessly changing. Not only are there new devices being introduced on a daily basis, but the capabilities, platforms, browser and operating systems of these devices is always changing, too. Not only that, but things like screen size vary incredibly. If you've ever built a website which needs to validate in a variety of modern web browsers, you'll know the pain that these variations can cause. Now multiply these variations by a factor of ten or more and you'll begin to understand why this is a confusing and difficult platform to develop for.

When developing a mobile strategy, the single most important thing to do is to start off by asking the question: 'Why mobile?'

The first part of answering this is about an existing group of users: those who are already accessing your sites using their mobile devices. As more and more people are beginning to use mobile to access the web, you should make sure that you are in a position to serve content to these people in appropriate ways. The current estimate [23] is that from 2 and 5% of all *browsing* traffic is from mobile devices. This is small, but growing, and you need to make a call as to whether you want to service this slice of your users, or wait until their market share is more sizeable before making that move.

The second half of the question is answered by considering whether you want to build *new* mobile experiences for your audiences alongside your existing ones. This will depend on your particular content perspective as well as the time, resource and budget that you have available.

There are a number of possible approaches to mobile web development. These are changing all the time, so it is advised that you seek expert advice before making a decision, but the various approaches can be summed up as follows:

Mobile web

As indicated in the stats above, many modern phones have built-in web browsers which are increasingly capable of rendering ordinary websites in a satisfactory way for end-users. One possible approach as these so-called 'smart phones' begin to become more commonplace is to simply continue to develop your site as-is with the hope that mobile browsers will be able to cope with what you already provide. This is clearly the easiest and cheapest approach.

Considerable issues still remain, however; page size, both physical and in terms of download, is much more of a problem on a mobile device. You can take various steps to counter this.

First, consider having a mobile-only stylesheet on your existing sites. You can do this with what is called 'browser sniffing' – a way of detecting what kind of browser your user has, and adapting the response

accordingly – or you could now define alternative stylesheets for mobile, screen and print. The details about how to do this are available on the web: they change all the time so it is worth doing some research about the current best practice and to follow the advice accordingly.

The second mobile web approach is to build sites which are mobile only. In this instance, you don't just reformat existing content, but rather seek to provide a range of pages which are specifically pitched at a mobile audience. For a cultural heritage organization, this might be an extremely limited number of key 'visitor' pages – for example, location and contact information, current exhibitions or events, and opening times. Often, site developers put these pages at another domain or sub-domain – if, for example, the main site is at somelibrary.com, they'll have these mobile-specific pages at m.somelibrary.com, somelibrary.com/mobile or somelibrary.mobi.

As with the stylesheet approach, a browser sniff can be employed if needed on the main site. This detects an incoming mobile browser and either redirects to the mobile site or (and probably better) asks the user if they'd like to use the mobile site instead. Make sure either way that you offer the user the means to get back to the core site with a prominent link in the footer or elsewhere on the mobile site.

Mobile web applications

A more complicated approach is to develop 'mobile web applications'. Strictly, these are just web pages which are optimized for mobile, but are worth considering separately because they are typically used and presented in a slightly different way. A typical mobile web application – for example, a collections or catalogue search which has been optimized for mobile devices – has a more 'standalone' feel to it than a mobile website.

As of the time of writing, mobile web applications are written for two main types of handset: Android and iPhone. Because a mobile web application is just a series of web pages, it can of course also be seen on any device which supports rich internet browsing. However, the predominance of these two platforms has meant that the user interface design is usually pitched around them, with buttons, sliders and other elements mimicking that of the platform. Both these devices have large

touch screens where gestures are the primary user interface – another reason why these platforms are more often than not the target for mobile web apps.

Because mobile phone applications run in a mobile phone browser, the functionality provided by these browsers has a huge defining role in what can and can't be done by these applications. Again, as of the time of writing, the capability is there in some mobile browsers to provide things like local caching of data, a slimline local database and access to some of the hardware capabilities of the phone, for example GPS. Over time, it is likely that this capability will increase so that mobile web applications tend towards native mobile applications.

Native applications

The third option available to you is the development of specific – or, so-called *native* – mobile applications. Mobile applications can be built for a range of platforms: the main options currently include Android, iPhone, Blackberry, J2ME (Java 2 Platform, Micro Edition), Nokia Qt, Symbian and Windows.

When you develop a native mobile application, you have a huge advantage in one sense because you know exactly which device you're producing the application for. This means you know things like the exact screen size(s) and so on, but it also means that you can access the hardware as completely as you'd want: the camera, GPS, local file storage and so on are all available to you from within your applications.

The downside – and it is a considerable downside – is that a native application is entirely non-portable. If you build an application for iPhone, you cannot use the application on Android, Blackberry or J2ME phones; ditto if you develop for any of those other mobile platforms. This means that you have to make one of two fairly painful decisions:

1 build a separate application for each of these platforms and incur the not-inconsiderable cost of doing so

 or

2 decide that you are only going to build for one platform, and thus

deliver your application only for the specific sub-set of users who have that platform.

There is a 'third way' for building native applications which is to use a *framework* which allows developers to write native apps in 'normal' web languages like HTML and JavaScript. This theoretically means that institutions don't have to train developers up in new languages like Objective C but can reuse existing web skills. There are a number of possible solutions available to do this – for an up-to-date list and further information, see the website at: http://heritageweb.co.uk/book/ch9/mobile-frameworks.

Making a decision

Making a decision about how best to approach mobile can be very daunting, but is actually based on the very simple premise that underpins any successful web approach: do what works for your user and your content.

One possible strategy is this:

1 Develop a mobile-friendly web presence of some kind for your main site(s), or core sections of your main site. Usually this can be done either by styling your existing site in a 'mobile-friendly' way or by having a separate, simpler, mobile site which users are redirected to when they arrive at your site with a mobile device.

2 Undertake all additional development (web or native mobile applications) on a case-by-case basis, considering for each case exactly who the user is and why they would choose mobile over the (much more comfortable) experience of fixed browsing.

This approach is a good pragmatic one for the following reasons: Providing 1) to your users is low cost and almost trivially easy. You know that mobile browsing figures are going to rise; providing a small, friendly and useful mobile web presence is a sensible approach. Providing 2) requires much more investment, and as such should be thought about in much more detail before embarking on a potentially complex and expensive project.

As with any technical development, choose to do mobile not just because you *can* but because it offers something of real value to your users.

Summary

Both these themes – Open Data and the mobile web – look set to grow in the medium to longer term, and are both of particular interest to the cultural heritage community. As with any other emerging technology, however, you should do what you can to keep a close eye on these. Consider them in parallel with your strategy, continue to ask your peers what approaches they are taking, and keep an ear to the ground so that you know which technologies are emergent, which are hype and which are starting to see more widespread adoption.

In the next and final chapter, we consider the ways in which you can enable both users and internal staff to become involved in what you are doing online and help you evolve your thinking, your strategies and your ways of working so that your web presence remains relevant into the future.

References

1 http://en.wikipedia.org/wiki/Open_data.

2 http://creativecommons.org.

3 www.europeana.eu.

4 http://en.wikipedia.org/wiki/RSS.

5 www.aadl.org/catalog.

6 http://pipes.yahoo.com/pipes.

7 http://en.wikipedia.org/wiki/Mashup_(web_application_hybrid).

8 Berners-Lee, T. and Fischetti, M. (1999) *Weaving the Web: the original design and ultimate destiny of the world wide web by its inventor*, Orion, http://books.google.com/books?id=Unp4PwAACAAJ.

9 http://en.wikipedia.org/wiki/Semantic_Web.

10 http://en.wikipedia.org/wiki/Semantic_Web.

11 http://en.wikipedia.org/wiki/Linked_Data.

12 http://lab.linkeddata.deri.ie/2010/star-scheme-by-example.

13 www.guardian.co.uk/technology/2009/mar/03/mobile-phones1.

14 www.telecomsmarketresearch.com/resources/UK_Mobile_Operator_ Subscriber_Statistics.shtml.

15 The Tomi Ahonen Almanac 2010, www.tomiahonen.com/ebook/almanac.html.

16 http://facebook.com.

17 http://twitter.com.

18 http://gowalla.com.

19 http://foursquare.com.

20 http://en.wikipedia.org/wiki/Location-based_service.

21 http://en.wikipedia.org/wiki/Augmented_reality.

22 http://en.nai.nl/uar.

23 http://gs.statcounter.com/#mobile_vs_desktop-ww-monthly-200812-201004.

10 Bringing it all together

Introduction

Throughout this book, our focus has been on creating a more proactive approach to what we do online. The rationale behind doing things this way is that although it requires some initial up front investment (mainly time, rather than cash!), it ultimately puts you and your institution into a much stronger position in the medium to long term.

The challenge with being more strategic is that you can almost become *too* strategic! Flexibility with strategy is key. One of the hardest yet most vital functions when working online is to understand when strategy and policy should be updated, challenged and changed. This understanding will come through a number of avenues. As we've already seen in Chapter 2 'Building a strategic approach', for example, you should have regular *strategy reviews* where you take your strategy, critically evaluate it against any success criteria, and then use this review to amend and evolve your future plans.

Beyond the review, however, you also need the mechanics in place to allow people – users, staff and stakeholders – to provide you with ongoing feedback about what you're doing or any ideas that they think could improve this. Furthermore, you also need to make sure that you and anyone directly involved with the web at your institution are well informed and up to date with the latest developments in your particular sector.

With this in mind, let's have a look at some ideas for gathering feedback and staying informed.

Ongoing feedback

You can keep the feedback and engagement process alive between your strategy reviews by providing and maintaining some kind of mechanism to receive feedback and ideas about the strategy and the progress of your web presence on an ongoing basis. Do this both with your web strategy team – have an Any Other Business (AOB) which you actively maintain between meetings – but also make sure you have an avenue for capturing and gathering feedback from the organization *and* the outside audience.

There are a number of ways of doing this:

Ideas mailbox

Ask your IT team to set up a new mailbox which you and your team can get access to. This mailbox should be used for one purpose: to solicit feedback from internal and external people with ideas and suggestions for how you can improve your service. Give it a relevant address – for example: suggest@yourinstitutionname.com or ideas@. . .

You will probably have one or several e-mail addresses for your websites already (common ones include feedback@yourinstitutionname.com, webmaster@. . . and webteam@. . .), but creating a new one with a very specific purpose – suggestions and ideas – should make it easier to keep things focused.

Once you have this address, you can start to promote it both internally and externally. Do all the things you'd do with your URL – for example, put the address on your e-mail signature (but make sure you flag what it is for: 'Ideas or suggestions about our website? E-mail ideas@ yourinstitutionname.com'). You might also want to do things like run an internal poster campaign for staff: 'If you have ideas on how to improve our website, we'd love to hear from you. E-mail ideas@. . .'. Make sure you flag the fact that you have an ideas and feedback gathering process to the public too: have a page on your main website with a form that pushes anything submitted to this new e-mail address.

It is always good to feed back to people who have provided ideas. Consider sending an e-mail to these people at the end of the year thanking them for their input and letting them know which ideas have been implemented.

Web feedback

There are a number of ways of gathering user feedback on your site. At the very simplest, make sure you have a contact form which asks users for general feedback, and make sure that this is linked from every page on your site.

If you want to put together surveys, consider tools like Survey Monkey[1] or Google Doc[2] forms – these provide simple 'form builders' which let you put together questionnaires and surveys very quickly. Link to these from your home page, or particular areas of your site that you'd like to receive feedback on. Many of these kinds of tools have fairly sophisticated graphing to let you summarize user responses quickly – or you can download Excel or CSV files to carry out your own analysis.

Many other tools are also available to gather ideas and suggestions from your website users. These are very useful if you want more structured feedback and the means to allow other people to view (and vote on) ideas which have been submitted already. Some of these are free; some are available for a small monthly fee.

See www.uservoice.com, http://ideascale.com and www.getsatisfaction.com for three different approaches.

User groups

A slightly more intensive – but also more focused and useful – way of getting really good user feedback and ideas is to set up a strategy user group. This can be of whatever scope and size you feel would be useful in your particular context, but you'd probably want to keep it relatively focused – maybe 5 to 10 (non-staff) people who are passionate about your organization and what you do.

Create a page on your website saying that you have a strategy user group and are looking for people to come on board with their ideas. Meet at a mutually convenient time, and make it clear what the commitment is.

You might want to offer this group some incentives: at the easiest (and cheapest), you could have a page on your website with their names, explaining that they sit on your strategy user group. Often, this kind of association is enough! If it isn't, consider things like offering the group

cheap or free tickets, previews of your web developments before go-live and so on. Don't offer cash incentives: you won't get it past your finance department, and you're likely to get a more useful self-selecting group if they are genuinely interested in your organization and what they do than if they're purely in it for financial gain!

Having this kind of group is an effort to set up and maintain, but the benefits are many-fold: first, you will gain valuable insights into what you do online from a brand new perspective; second, you will likely build a passionate group of people who really feel that they have a stake in what you do; finally, it is a very strong selling point for your strategy if you can say that you work closely with your local online community.

Staff sessions

You may also want to do things like run an occasional lunchtime meeting for staff – provide them with sandwiches and ask them to come along and brainstorm any ideas they might have. Let them know about this via whatever channels you have available to you – an all staff e-mail, your intranet, and so forth. It is also worth sending an invite directly to your Director/CEO – make it very clear to them that you want to hear their feedback and that even if they can't make the meeting (which is likely!), you'd welcome any feedback they have via e-mail. Do the same with any other senior groups like trustees or executive boards.

Staying informed

One of the main things you need to be doing as a web team in a strategic environment is, as we have seen, making sure that you know what is going on out there in the world of cultural heritage online. It is your job as the driver of the web function to make sure that you have a good grasp of the approaches that are being taken by your peers in other institutions. At the same time, you should have your eye on the technologies that are being adopted at the bleeding edge: even if these are destined to take some time to be adopted into cultural heritage, or never hit the mainstream, it is useful to know what the general trends and directions of travel are.

There are many ways of staying in touch with the cultural heritage community – you probably do many of these already, but consider the following (and see: http://heritageweb.co.uk/book/ch10/staying-informed):

Blogs

Identify the leading blogs in your community: ask colleagues what they read, search Google (and Google Blog Search) for relevant resources, and when you find sites that are aligned with your area of interest, subscribe to them using a feed reader such as Google Reader.

Put aside some time each day (for example, half an hour every morning) and use this to get through the unread items in your feed reader. Try not to compromise this time: it is invaluable, and although you'll always be under pressure to do something else, try to keep it in your diary! Also, be ruthless in chopping and changing your subscriptions: if you find that you're not getting through your reading or that a particular blog posts too often or not enough, remove them from your feed reader.

In Chapter 3 'Content' we covered how to use various tools including feed readers to monitor conversations about your organization, but you can also add keywords that you are interested in ('augmented reality', 'website strategy', 'museum technology', and so on) and use Google Trends, Google News or other tools to follow any new stories or blog posts that are written about these topics. Often these alerts lead you to new articles, blogs and online communities about these topics.

Social networks

Identify whether there are social networks which are aligned to your particular area of interest. Look for those that show a fair amount of engagement – don't just check that they have lots of members, but look for how recent and how often the conversations are being held. Pick the ones which fit with your interests, and join in when you can.

If there aren't any social networks in your particular area of interest, consider setting one up.

Twitter

Twitter has become the network of choice for keeping on top of the latest movements in the world of the web and beyond. If you're not on Twitter already, create a new account by following the instructions at: http://twitter.com. Find people in the cultural heritage sector (a search for 'museums/libraries/etc. on Twitter' on Google is a good starting place) – and then look at who they are following and who is following them. Put aside some time to build up the list of people you follow. When you start, focus on who you follow rather than worrying about who follows you. In time, this will build: for now you are aiming to use Twitter as an information source rather than a marketing or messaging channel.

UKOLN have also published a range of guides[3] for social media in cultural heritage.

Once you've set up a Twitter account, there are various techniques for keeping on top of the conversation without it overwhelming you and becoming distracting. Twitter search is a useful tool – go to http://search.twitter.com and do searches for key phrases which you are interested in.

Note that once the search results are returned, you can grab the RSS feed and pipe this into your feed reader – now when anyone uses that phrase, you'll get a new notification in your feed reader. There are also a range of desktop clients which you can set to notify you when various things happen: a keyword match, a 'mention' by a follower, and so on.

See the accompanying website at http://heritageweb.co.uk/book/ch3/keyword-monitoring for further information on how to set this up.

Conferences and meet-ups

Getting together with your peers is probably the single best way of staying on top of what is going on in your sector. Cultural heritage has a huge range of conferences which are either partly or entirely pitched at digital and web approaches. There are also a number of smaller get-togethers: unconferences, barcamps, hack days, and so on.

Unconference/Barcamp: 'a facilitated, participant driven conference centered on a theme or purpose'.[4]
Hack Day: 'an event where developers, designers and people with ideas gather to build cool stuff'.[5]

Mailing lists

Online mailing lists are excellent sources of intelligence about how other people are managing cultural heritage web presences day to day. Ask your peers which mailing lists they frequent, or search the web to find some new ones.

As with other methods of keeping informed, be flexible and ruthless with joining and leaving these lists. Often they can look useful but fairly quickly it becomes obvious that they are either off-topic, too noisy or too quiet to be of any use. In this instance, don't hesitate to move on and find a better one, or even set one up yourself if you feel that there might be sufficient demand for it.

> You can use filters in your inbox to direct mailing list traffic into a specific folder for that list – this helps to reduce clutter; also, mailing lists often have an option to receive a 'daily digest' e-mail of activity (i.e. one e-mail a day) rather than receiving an e-mail each time one is sent to the list. Similarly, look for an RSS option against the specific mailing list, and use your feed reader rather than your inbox to keep track of the conversations that are going on.

Local cultural heritage groups

Finally, you may want to consider setting up a local group of people who are working with cultural heritage websites. Meeting on a regular basis with people who, like you, are struggling with similar issues, is an incredibly useful way of keeping in touch with some of the ideas, challenges and solutions needed. Cycle the meeting location and notekeeping around the group in order to share the workload, and have a regular agenda: you may want to regularly review your most recent website stats, for example, or talk about who is developing mobile or Open Data approaches!

Summing up

We've spent a lot of time throughout this book discussing ways in which you can take a more strategic approach with what you do on the web. Along the way, we've considered how you can not only develop a strategy document but a whole framework which shapes how you operate on a daily basis.

Hopefully, I've convinced you that the up front additional effort that is required to take a step back, stop being reactive and consider what you

do in a holistic way, will pay huge dividends in the medium to longer term. This time investment should put you and your colleagues in a position where you can not only plan your day-to-day activity in a more structured fashion but where you should also be able to think forward into the long term – one to three years hence – in a meaningful way.

The strategic framework which we've spent time considering is made up of the following core pieces:

- A strategy *document*, which is the backbone of your approach online. This contains, among other things, your primary mission statement or vision, and a solid plan for the coming year which outlines how you are going to implement this vision.
- A *collaborative* approach to this strategy which comprises a series of regular meetings with your stakeholders where you discuss how the strategy is developing and how it should change into the future.
- A framework for *communicating and collaborating* on your strategy with both the members of your team and stakeholders in the wider organization and beyond.
- The *scaffolding* to support your strategy on a daily basis, made up of policies and guidelines.
- A series of techniques for *monitoring and recording activity* around your web presence, particularly social media mentions.
- A known and measured approach to the *redevelopment process*, including how to interact with agencies, the pitch process and best practice for writing website brief documents.
- An approach to *measuring and communicating* important facts and progress about your site via use of analytics tools and a regular *Key Performance Indicator* e-mail to relevant stakeholders.
- A solid basis for considering when to use – and, as importantly, when not to use – *social media* to promote your organization online.

Your daily routine will of course be largely defined by your particular organization and your role within that organization. For some, the website and your pieces of web estate which make up your presence will occupy most of your time; for others it may well be only a minor part of your day job.

The essential common theme – finding some time to think about things in a holistic way – is the same whatever your environment. The ease with which – technically – content can be put on the web and changed at a moment's notice belies the effort that is required to write, maintain and plan, and it is ultimately the longer term planning which will create more solid, compelling and successful online experiences.

The final thought is possibly this: whatever you do, don't be limited by anything that you've read here. If you find things that are useful, take them and shape them and make them your own. For a strategic approach to really work, it needs to be owned and believed in by people in the organization, and they need to be empowered in such a way that they can take things forward in their own way.

Please make full use of the accompanying website http://heritageweb.co.uk/book (and the web in general!) as you go about developing your web presence, and don't hesitate to get in touch, either on Twitter (I'm @m1ke_ellis) or via e-mail at mike@heritageweb.co.uk.

References

1 http://surveymonkey.com.
2 http://docs.google.com.
3 www.ukoln.ac.uk/cultural-heritage/documents.
4 http://en.wikipedia.org/wiki/Unconference.
5 http://en.wikipedia.org/wiki/Hack_Day.

Bibliography

www.aadl.org/catalog.

www.aadl.org/catalog/search/keyword/comic.

Adams, D. (1979) The *Hitchhiker's Guide to the Galaxy*, Pan.

www.adobe.com/products/contribute.

www.adobe.com/products/dreamweaver.

www.alexa.com/topsites.

www.archimuse.com/mw2007/papers/peacock/peacock.html#
ixzz17Q3m847a.

www.archimuse.com/mw2008/papers/chan-metrics/chan-metrics.html#
ixzz17Q3FaFG3.

www.archives.gov/social-media.

www.artscouncil.org.uk/news/we-publish-digital-audiences-engagement-
arts-and-c.

www.askdavetaylor.com/does_googlebot_visit_more_often_because_of_
my_blog.html.

www.basecamphq.com.

www.bbc.co.uk/guidelines/editorialguidelines/page/guidance-blogs-
personal-summary.

www.bbc.co.uk/guidelines/futuremedia.

www.bbc.co.uk/guidelines/futuremedia/accessibility.

www.bbc.co.uk/guidelines/futuremedia/policy/tech_implement_
dpa.shtml.

Berners-Lee, T. and Fischetti, M. (1999) *Weaving the Web: the original
design and ultimate destiny of the world wide web by its inventor*, Orion,

http://books.google.com/books?id=Unp4PwAACAAJ.www.bing.com.

www.bing.com/community/blogs/search/archive/2009/06/01/
user-needs-features-and-the-science-behind-bing.aspx.

http://blogs.archives.gov/aotus/?p=1741.

http://blogs.talis.com/panlibus.

www.boxuk.com/blog/the-ultimate-website-launch-checklist.

www.brooklynmuseum.org/community/blogosphere/bloggers.

www.cabinetoffice.gov.uk/govtalk/schemasstandards/e-gif.aspx.

Chamberlain, G. (ed.) (2011) *Museums Forward: social media, broadcasting and the web*, Museum Identity, www.museum-id.com/books-detail. asp?newsID=168.

Chan, S. (2008) Towards New Metrics of Success for On-line Museum Projects. *Museums and the Web 2008: the International Conference for Culture and Heritage On-line, 9-12 April 2008, Montreal, Quebec, Canada.*

www.cmsmatrix.org.

www.thecoca-colacompany.com/socialmedia.

www.creativecommons.org.

www.drupal.org.

www.europeana.eu.

http://explainers.wordpress.com.

www.facebook.com.

www.facebook.com/artshare.

www.facebook.com/badges.

http://blog.facebook.com/blog.php?post=409753352130.

www.facebook.com/FacebookPages.

www.facebook.com/myflickr.

www.facebook.com/press/info.php?statistics.

http://developers.facebook.com/docs/authentication.

www.feedburner.com.

www.flickr.com/commons.

www.flickr.com/guidelines.gne.

www.flickr.com/services/api.

http://blog.flickr.net/2010/09/19/5000000000.

www.foursquare.com.

http://freemind.sourceforge.net/wiki/index.php/Main_Page.

www.getsatisfaction.com.

http://docs.google.com.

www.google.com/analytics.

www.google.com/support/websearch/?hl=en.

www.google.co.uk/adwords.

www.googleblog.blogspot.com/2008/07/we-knew-web-was-big.html.

www.gowalla.com.

www.guardian.co.uk/technology/2009/mar/03/mobile-phones1.

www.heritageweb.co.uk/book/.

http://weblogs.hitwise.com/heather-dougherty/2010/11/facebookcom_
 generates_nearly_1_1.html.

www.ico.gov.uk/for_organisations/data_protection.aspx.

www.internetworldstats.com.

www.kaushik.net/avinash/2007/08/standard-metrics-revisited-3-bounce-
 rate.html.

www.kk.org/thetechnium/archives/2008/02/the_bottom_is_n.php.

http://lab.linkeddata.deri.ie/2010/star-scheme-by-example.

http://marketshare.hitslink.com/search-engine-market-share.
 aspx?qprid=4&qptimeframe=M.

www.mindmeister.com.

www.museummarketing.co.uk/2010/01/15/tips-for-creating-more-
 interesting-tweets-for-your-museum.

www.museumscomputergroup.org.uk/2010/08/13/a-local-authority-
 museum%E2%80%99s-path-to-facebook.www.museumtwo.blogspot.
 com/2008/04/how-much-time-does-web-20-take.html.

http://en.nai.nl/uar.

www.oii.ox.ac.uk/research/oxis/OxIS2009_Report.pdf.

http://oreilly.com/web2/archive/what-is-web-20.html.

Peacock, D. and Brownbill, J. (2007) Audiences, Visitors, Users: re-
 conceptualising users of museum on-line content and services,
 *Museums and the Web 2007: the International Conference for Culture and
 Heritage On-line, 11-14 April 2007, San Francisco, California, USA.*

www.pepysdiary.com.

http://twitter.com/samuelpepys.

www.pewinternet.org/Static-Pages/Trend-Data/Whos-Online.aspx.

www.pewinternet.org/Trend-Data/Daily-Internet-Activities-20002009.aspx.

www.pewinternet.org/Trend-Data/Online-Activities-Daily.aspx.
http://pipes.yahoo.com/pipes.
www.powerhousemuseum.com/dmsblog/wp-content/powerhouse_
 museum_blog_policy_2007.pdf.
www.prince2.com.
www.readwriteweb.com/archives/google_losing_ground_as_users_spend
 _more_time_on_f.php.
www.ricg.com/marketing_articles/digital_marketing/yahoo_and_
 bing_gaining_ground_in_search_engine_market_google_still_
 dominates.
www.rijksmuseum.nl/widget.
http://royal.pingdom.com/2010/02/16/study-ages-of-social-network-
 users.
http://seoblackhat.com/2006/08/11/tool-clicks-by-rank-in-google-
 yahoo-msn.
www.articles.sfgate.com/2010-02-15/business/17876925_1_
 palo-alto-s-facebook-search-engine-gigya.
Shirky, C. (2008) *Here Comes Everybody: the power of organizing without
 organizations*, Penguin,
 http://en.wikipedia.org/wiki/Here_Comes_Everybody.
www.slideshare.net/dmje/the-benefits-of-doing-things-differently/71.
www.slideshare.net/george08/uk-museums-and-the-web/45.
www.socialmediagovernance.com/policies.php.http://spurspectives.com/
 why-every-nonprofit-needs-a-social-media-strategy.
Standage, T. (1998) *The Victorian Internet*, Berkley.
http://gs.statcounter.com/#mobile_vs_desktop-ww-monthly-200812-
 201004.
www.surveymonkey.com.
www.techcrunch.com/2010/06/08/twitter-190-million-users.
www.telecomsmarketresearch.com/resources/UK_Mobile_Operator_
 Subscriber_Statistics.shtml.
The Tomi Ahonen Almanac 2010,
 www.tomiahonen.com/ebook/almanac.html.
www.twitter.com.
http://twitter.com/towerbridge.
http://search.twitter.com.

www.ukoln.ac.uk/cultural-heritage/documents.

www.ukoln.ac.uk/interop-focus/gpg/IPR.

www.useit.com/alertbox/defaults.html.

www.uservoice.com.

www.w3.org/WAI/impl.

http://w3.org/wai.http://en.wikipedia.org/wiki/Affiliate_marketing.

http://websiteroot.com/ch8/example-wireframe.

http://websiteroot.com/ch8/wireframing-software.

http://en.wikipedia.org/wiki/Ajax_(programming).

http://en.wikipedia.org/wiki/Application_programming_interface.

http://en.wikipedia.org/wiki/Atom_(standard).

http://en.wikipedia.org/wiki/Augmented_reality.

http://en.wikipedia.org/wiki/Blog.

http://en.wikipedia.org/wiki/Facebook_features.

http://en.wikipedia.org/wiki/Freedom_of_information_legislation.

http://en.wikipedia.org/wiki/Geolocation_software.

http://en.wikipedia.org/wiki/Guideline.

http://en.wikipedia.org/wiki/Hack_Day.

http://en.wikipedia.org/wiki/HTTP_cookie.

http://en.wikipedia.org/wiki/Hype_cycle.

http://en.wikipedia.org/wiki/ICalendar.

http://en.wikipedia.org/wiki/Linked_Data.

http://en.wikipedia.org/wiki/Location-based_service.

http://en.wikipedia.org/wiki/Long_Tail.

http://en.wikipedia.org/wiki/Mashup_(web_application_hybrid).

http://en.wikipedia.org/wiki/MoSCoW_Method.

http://en.wikipedia.org/wiki/Network_effect.

http://en.wikipedia.org/wiki/Open_data.

http://en.wikipedia.org/wiki/Policies_and_procedures.

http://en.wikipedia.org/wiki/RSS.

http://en.wikipedia.org/wiki/Semantic_Web.

http://en.wikipedia.org/wiki/SMART_criteria.

http://en.wikipedia.org/wiki/Twitter.

http://en.wikipedia.org/wiki/Unconference.

http://en.wikipedia.org/wiki/URL_redirection.

http://en.wikipedia.org/wiki/Web_content_management_system.

http://en.wikipedia.org/wiki/Web_syndication.
http://en.wikipedia.org/wiki/Web_2.0.
http://en.wikipedia.org/wiki/WordPress.
www.wordpress.org.

Index